The book of Colossians will enlarge you
the great purpose He has given you. Gra
fullness of life Christ secured for you! Dr......pry or His love for you and refresh
your faith!

—**Erica Wiggenhorn**, national speaker with Aspire Women's Events
and author of *An Unexpected Revival*

In *Overflowing*, Carol brings the solid truths of hope and help from Colossians to
our lives today so we can live whole and holy in a broken and corrupt culture.

—**Pam Farrel**, best-selling author of 60 books, including coauthor of award-
winning *Discovering Hope in the Psalms* and *Discovering Joy in Philippians*

In *Overflowing*, Carol McLeod extends a biblically sound invitation, taking readers
by the hand to explore the depths of God's will in a complex world. With her
unique blend of personal stories and a profound biblical unpacking of the book
of Colossians, Carol not only guides us to understand the peace of Christ but
also imparts the wisdom needed to navigate the complexities of life. Through
this engaging and creative book, readers not only transform their own lives but
are empowered to impact the lives of others. This is the go-to book for anyone
wondering how to live out the beauty of Christ in a world that often feels broken.
Most importantly, Carol mentors us through *Overflowing*, leading us into deeper
intimacy with triune God.

—**Jenny Randle**, ministry founder of Freedom Creatives and
multipublished author, including *Flash Theology*

Carol's passion for the holy Word of God is infectious in *Overflowing*. When you join
this journey with the compassionate friend you'll find in Carol McLeod, you too
will gain refreshed affirmation of who and whose you truly are. Assurance that will
fuel certainty in your callings and purpose, allowing joy and the rich fruits of the
spirit to swell in, out, and all around you. Dive into this study, and God's Word will
become breathtakingly alive and active in your life through the biblically grounded
beauty of *Overflowing*.

—**Keri Eichberger**, author of *Win Over Worry*

If you're looking for ways to understand the confusion that permeates our lives
over what is real or what is truth, Carol McLeod's excellent study of Colossians will
help you see God's hand at work—back then and today. *Overflowing* is a seven-week
study that will show you what happens when faith collides with culture and the
Spirit of God prevails. Living abundantly, two thousand years ago or today, is all
about discovering the significance of trusting God no matter what happens. This
is more than a Bible study. It's a life-changing experience of God's incredible love.
You will be blessed with every lesson.

—**Karen Moore**, author of *Prayers to Strengthen Your Soul*

Do you desire to live an abundant life? We get caught up in the extravagance of a materialistic life and can never be fulfilled. Carol McLeod's *Overflowing* is a Jesus-focused guide to centering our lives on what matters. With intentional teachings through the book of Colossians, Carol walks us through the scripture, guiding us to God's grace and truth. This is an excellent resource to help us find the answers we've been aching for and live the abundant life Christ desires.

—**Billie Jauss**, international speaker, author of *Making Room, Distraction Detox,* and *Baseball Family,* and podcast host of *The Family Room*

If anyone was born to write about overflowing in our relationship with Christ, it is Carol McLeod. She lives the Bible she loves, and this study of Colossians is the gift you didn't know your soul needed. She reminds us not to play our call small but to live loved—to truly live overflowing.

—**Angela Donadio**, ministry leader, author, and host of the *Make Life Matter* podcast

Overflowing is both a timeless and timely book. The author, Carol McLeod, takes us on a deep walk through the book of Colossians, extending an invitation to live lives completely united with Jesus. If you're feeling pulled in every direction trying to live confidently as a Christ follower in today's culture, this book is for you. Carol is a warm and encouraging guide. Expect to be challenged, enlightened, and strengthened as you learn to live in a manner worthy of the Lord, ultimately understanding the joyful privilege of representing Him in a lost and hurting world.

—**Laura Acuña**, author of *Still Becoming*

Overflowing is a timely game changer for your Christian journey as it will revolutionize and deepen your desire to keep Christ at the core of who you are and who you were truly meant to be. This soul-searching, in-depth study exposes biblical wisdom in deeply practical and personal ways to help you live your life with hope, joy, and peace! I can hear Carol's encouraging yet firm voice in every word on every page as she calls us twenty-first-century Christ followers to wake up, discover God's goodness, and allow His holy Word to transform us from the inside out. This study is not any other book—it's a road map to rekindle the blaze of your faith and explode any limiting thoughts that may be holding you back—a must read!

—**Victoria D. Lydon**, author of the *Choose 2 Think Daily Devotional* and host of the *Choose 2 Think Inspirational Podcast*

Are you looking for an inspiring journey through the book of Colossians that speaks to your heart? Look no further than Carol McLeod's *Overflowing*. It's not just a study; it's your guide to living a joyful life, even in challenging times. Carol's warm and practical approach will encourage you to embrace regular scripture reading, deepening your love for God's Word. I highly recommend *Overflowing* to anyone seeking to strengthen their faith, find purpose, and experience the love of Christ.

—**Chris Busch**, founder and CEO, LightQuest Media

CAROL MCLEOD

OVER FLOW ING

Living Abundantly in a Broken Culture

IRON
STREAM

Birmingham, Alabama

Overflowing

Iron Stream
An imprint of Iron Stream Media
100 Missionary Ridge
Birmingham, AL 35242
IronStreamMedia.com

Library of Congress Control Number: 2023948767

Cover design by twolineSTUDIO.com

ISBN: 978-1-56309-698-3 (paperback)
ISBN: 978-1-56309-699-0 (eBook)

1 2 3 4 5—28 27 26 25 24

Lovingly dedicated to Joni Rebecca.

You were the best surprise I have ever received.

As the youngest of five, you have always been the one we have all found such delight in!

I love being your mom, your cheerleader, your prayer warrior, and your friend.

Now that you have Luca, you understand the depth of my unconditional love for you.

I wish you health and joy, purpose and strength.

But most of all, I wish you Jesus.

CONTENTS

INTRODUCTION

Is it possible to live abundantly in a broken culture? Is it possible to embrace unspeakable joy when truth is distorted, politics are compromised, and the entertainment industry seems evil? Is it possible to live a life of unmatched peace when the culture has been invaded by a mindset vicious and contrary to the Word of God?

The startling reality is that every generation has been invited to live fully and enthusiastically despite the lies and brokenness of the culture. Our generation is no different. We have been summoned by the Creator, by the One who knows us best and loves us most, to live a life of overflowing and perpetual hope in the face of compromise and deception.

You are about to embark on a seven-week, in-depth study of the book of Colossians in the New Testament. Bible scholars through the ages have believed this epistle, written by the apostle Paul, is the most Christ-centered book in the Bible. If that is true, and I believe it is, we, as twenty-first-century believers must intentionally study this book enthusiastically.

If you long to live a life of overflowing hope and joy, your life requires an intentional center. You see, all our lives have a center or a nucleus upon which we obtain our energy and discern our purpose. You may naively assume that your life has no such focal point but upon closer contemplation, you will find that you do, indeed, have a north star.

Perhaps you have built a life based on shopping, entertainment, or sports. Many people have centered their very existence upon family, career, or education. We each possess the God-given power to choose the center of our world: an identifiable substance that we have marked as the hub of everything else. One's center is the axel upon which life turns and the nerve center of all important decisions.

My prayer for you, my reader and fellow student of the Bible, is by the end of this deep dive into the sacred pages of Scripture, your life will shout to the world in which you live, "I am Christ-centered! He is my Source, my Joy, my all in all!"

Colossae and You

The city of Colossae was a minor city during the days of the early church. It had once been a popular commerce center but had found itself halfway between fame and failure. When Paul wrote his letter to the church in this ancient and dwindling municipality, this formerly thriving metropolis was now on a wretched and obvious decline.

Apart from receiving this amazing and dynamic letter written by the apostle Paul, the church at Colossae exerted no extraordinary influence on the early church world. Heresy within the church and societal pressures from the community hampered the church's impact. Paul wrote this riveting and essential letter to the believers in Colossae around the year AD 61, nearly thirty years after the death and resurrection of Jesus Christ. There is no historical evidence that Paul had ever visited the group of believers in Colossae. In fact, Colossae was the least important church to which any epistle of Paul is addressed.

This description of Colossae may describe your life as well. You might believe that your best days have passed by and that your life is now halfway between fame and failure. You also might erroneously yet passionately believe your existence is on the decline. You, like Colossae, might assume you have no current influence on the world, on your family, on your church, or on your community. You might feel as the least important spoke in the wheel of God.

My friend, Colossians was written for you! You may have just discovered your favorite book in Scripture. The book of Colossians has your unforgettable name written on every page; you are mentioned in every verse. If God cared about the church at Colossae, then He certainly cares about you.

The book of Colossians will enable you to finally understand who God made you to be and will help you live out that identity with courage and abandon.

Part One

The first two chapters of this book contain vital theology; theology is simply the study of God. Before you walk away intimidated by the word *theology*, I can assure you that you don't want your life to be a mile wide and an inch thick. We all need to be rooted and grounded in the study of God the Father and in the knowledge of Jesus Christ, His only Son. It is crucial we understand who the Holy Spirit is and why He was sent to us after Jesus ascended into heaven. Your life will be decimated by the first storm that blows your way if you do not take the time to know God in His fullness and power.

When my husband, Craig, and I were newlyweds, we lived in Mobile, Alabama, and felt right at home in the Gulf Coast region of the United States. We had only lived among the moss-draped oak trees and brilliant azaleas for about four months when Hurricane Frederic barreled down upon this gracious city. At the time, this September hurricane was known as one of the strongest hurricanes of the twentieth century.

As Craig and I hunkered down in our flimsy, one-thousand-square-foot home the night Frederic ravaged this iconic southern city, we heard what sounded like canons blasting in our backyard. "Boom! Boom! Boom!" was the eerie noise that filled the hallway where we spent the night with a mattress over our quaking, young heads.

The next morning, as we ventured outside, we saw hundreds of fallen pine trees in the woods behind our home; they were like mere toothpicks piled on top of one another. It looked as if a giant game of "pick-up sticks" had just exploded in the acres behind our newly built home.

Later that week, as we drove down Government Boulevard, in the heart of Mobile, the stately oak trees continued their regal watch over the city. Although ripped naked of their moss covering, these century-old trees had not moved during the massive storm.

The pine trees that had formerly graced our backyard were taller than any of the other trees growing in this southern city. However, pine trees easily fall during a storm because their root system only travels along the top of the ground and does not reach deeply into the soil. Oak trees, conversely, dig their roots deeply into the soil and are rarely toppled by a storm no matter how massive it might be.

Colossians chapters 1 and 2 will enable your spiritual roots to penetrate thoroughly into the wealth of all that Christ has for you. This study will equip your life with the strength it needs to make it through every storm in life.

Part Two

The third and fourth chapters of the book of Colossians make up the second distinguishable section of this book. These chapters are at once both painfully and joyfully practical. These final chapters will give you the life-long tools to live a life of Christ-like excellence. The blueprint to abundant living is found in these climactic chapters. Your life will be fit for a king, a life hidden with Christ in God (Colossians 3:3).

You will love the book of Colossians from beginning to end because it is all about Jesus—the One who knows you best and loves you most.

Notice the Symbolism

As you read *Overflowing*, you will often note the symbolism of a collision is used to make an astounding point. Paul's writing to this ancient church was meant to be abrasive, dynamic, and shattering; he intended to remind the church at Colossae that no culture should dictate one's Christianity. When the culture of any historic time period intersects with our faith, a collision begins.

Of course, I hope you also understand the collision of one's faith with the culture can result in abundant spiritual health, a new commitment to truth, and a heart overflowing with gratitude. The benefits of a well-handled collision, when faith conflicts with the culture, can set you solidly in a new direction with greater purpose and resolve.

Wake Up!

The book of Colossians is a wake-up call for Christians who live in these modern days. Every day, as you read the assigned passage and answer the corresponding questions, you will be awakened from your spiritual slumber and called to embrace a vibrant life.

We employ a variety of culturally acceptable tools to help us wake up in the morning, don't we? Caffeine may be your stimulating drug of choice while others might use exercise, vitamin supplements, or noisy alarm clocks to pep up their lives. I can assure you there is nothing like the effervescent, eternally lively Word of God to help you focus on the future and to wring the joy out of an ordinary day.

I hope you will take the time to carefully answer each question presented in the text of this book. I have found applying the principles in the Word of God personally provides revelation knowledge, which springs to energetic meaning inside of me. Answering the questions and learning how to navigate the collision with our culture that the Bible instigates might feel challenging to you at first, but I can assure you that God wants to know the deepest secrets of your heart. He is intently interested in your fears and questions. He is listening earnestly to your responses and thoughts. As you participate in this vital Bible study, you may just hear Him whisper peace and hope to your weary heart.

At the end of each day's work, you will find, as a gift, a quote to ponder. I believe as we choose to reflect on the thoughts of great men and women who have gone before us, we ourselves will begin to think greater thoughts.

Living Treasure

Each week, I will also urge you to commit a Bible verse to memory. I have titled this part of the assignment "Living Treasure." When we hide God's Word in our hearts, joy increases vibrantly, and wisdom flows unabated. God's Word is the key that unlocks the overflowing life for which we yearn.

I have often been known to say with a smile on my face and a twinkle in my eyes, "Memorizing scripture is not just for fifth graders." The delight of hiding God's Word in your heart cannot be overstated, and it will deliver to you a veritable bounty of peace, strength, and divine insight. Let's become a generation of women who treasure the Word of God in our hearts and in our minds.

The value of memorizing scripture will produce greater and more strategic blessings in your life than will winning thousands of dollars, living in your dream home, or having the ability to travel the world for pleasure. Committing the dynamic, never-changing, always-hopeful Word of God to memory is a gift to yourself and an astounding legacy for generations to come.

> *Your word I have treasured in my heart,*
> *That I may not sin against You. (Psalm 119:11)*

No Limits

Each day's reading concludes with a potent prayer. I hope you read this prayer out loud and humbly agree with its content. There is no limitation to the power of prayer. When we pray, not only do we grab God's attention but also our hearts are always transformed in the process. I have long believed that history belongs to those who pray.

Prayer is able to deliver you out of your doubts and can also miraculously transport you to the throne room of the King of all Kings. I am sure that you, like me, often pray silent prayers throughout your day. However, I hope you will join with thousands of other women who are determined to pray the prayers in this book aloud. You will discover many of the prayers are based upon the exact scriptures we have studied together. God's will is found in His Word; therefore, when we pray scriptures, we pray according to His will.

This is the confidence which we have before Him, that, if we ask anything according to His will, He hears us. And if we know that He hears us in whatever we ask, we know that we have the requests which we have asked from Him. (1 John 5:14–15)

An Explosion Resulting in the Overflow

I have often viewed the book of Colossians as an explosion of the very best kind. Colossians collides with the culture and delivers eternal, unchanging truth to every generation.

Colossians is where truth becomes apparent and where a life overflowing with God's goodness is discovered.

It's time to light the fire that will initiate the wonderful explosion that will be yours as you study the book of Colossians. Your life is about to collide with eternal truth and with the answers for which you have been aching. This collision will enlarge your faith, strengthen your resolve, and set you into your destiny in Christ. This is your moment, my friend, to shatter the doubts of yesterday and to smash limited thinking.

The book of Colossians will certainly clash with the broken culture, but it will also usher in an overflowing peace and joy into your life.

Let's pray.

Lord Jesus, we love You so much. We say a resounding yes to Your will, to Your ways, and to Your Word this day and every day. Father God, would You create in us a new heart? Jesus, would You teach us through the pages of Colossians? Holy Spirit, would You fill us with Your power to live a life of holy collision? Thank You, Father, for the Bible. We receive it as God's timeless and enduring Word. In Jesus' name, I pray. Amen.

Week 1

What Is God's Will?

Day 1

The Prison Years

Paul wrote this fundamental book, Colossians, during his longest tenure in a Roman prison. Although his arms and feet may have been in chains, his spirit was not fettered by the bonds that held him physically. Paul spent the years in prison encouraging an insignificant church located in a dying community. These prison years could have been wasted with complaining, panic, and frustration, but Paul determined not to squander one precious day of the redeemed life he had been given.

Spending time in an undeserved and putrid prison is on no one's list of travel destinations. There is nothing romantic about spending day after day, year after year, in a tiny cell with minimal human interactions. The food was likely horrid, the smell rancid, and the accommodations abhorrent. However, Paul modeled the miraculous possibility of turning the prison years into the most productive and purposeful time of one's life.

I believe how we choose to spend our days during our "prison years" may just determine the significance of our lives.

⏳ *Have you spent any time in a prison of the soul? Explain.*

⏳ *How can you make the prison years the most valuable years of your life?*

A Greater Good

Many women spend time in invisible yet very real prisons. These prisons might be difficult relationships, financial instability, or even addictions. Women of every age and generation are often held hostage by health challenges, rebellious children, or loneliness.

What one does during the prison years just may determine the future. If you choose to whine on social media, complain to anyone who will listen, or fill your cell with tears and frustration, no one would blame you for any of those valid reactions. However, from the life of Paul and others, we can quickly ascertain that there is a more redemptive way to while away the days in prison than with understandable human reactions.

If you desire to be used by Christ and to make a lasting impact for His unshakable kingdom, you will choose a different response altogether. If you long to walk in your God-ordained destiny and live beyond your time on earth, then you will use your prison years for the greater good. You will choose to encourage others regardless of how insignificant they may seem. You will not be hypnotized or held hostage by your prison, but you will live in complete freedom while keeping your eyes on Jesus. How you respond to the prison years just may change the world around you.

⧗ *How did you respond to the time you spent in an unfair prison experience? Be honest.*

⧗ *List three ways in which you can turn your time in prison into a season of preparation:*

1. _____

2. _____

3. _____

Resolve

Paul is not the only Bible hero who used his prison years as a springboard from which to change the course of human history. Joseph, the stellar and

wise leader from the book of Genesis, also spent time in prison. Joseph didn't deserve to be confined to prison but had been the victim of vicious lies and false accusations. This young man, who had lived a life of integrity and honor, was swept into an Egyptian prison with no hope of ever being released.

Although written six hundred to eight hundred years after Joseph lived, the book of Psalms recounts what happened to Joseph's soul while in prison.

They have afflicted with fetters his feet, Iron hath entered his soul.
(Psalm 105:18 YLT)

Other translations ignore the word for "soul" and use words such as "neck" or "he himself" was laid or put in irons. However, the Hebrew word *nepes* is most often translated as "soul, self, life, creature, person, appetite, mind, living being, desire, emotion, passion; that which breathes, the breathing substance or being, soul, the inner being of man."[1]

Joseph became stronger while in prison; resolve entered his young soul. He was not omitted from leadership due to his time spent in an ancient prison cell but was prepared for leadership. Prison did not exclude Joseph from playing a significant role in the plan of God; rather, it qualified him for an extraordinary calling.

From Joseph and Paul, we learn that how one responds in prison may determine future potential for ministry. I am resolved, just as Paul and Joseph were, to respond with faith and hope in prison. The invisible bonds that hold you in prison are no match for the power of prayer or for the purposes of God.

⌛ *What does the phrase "iron entered his soul" mean to you?*

⌛ *List three ways you can become stronger even when you don't like your circumstances:*

1. _____

2. _____

3. _____

Singing in the Cell

A Roman prison was no match for the power of God that lived inside of the apostle Paul. His life demonstrates how to meet the worst moment of life with a joy so pervasive and so authoritative that we explode into a rare and beautiful song. Paul was no stranger to prison, and we must learn from his example before we dig into the book of Colossians.

Prior to the prison experience in which Paul wrote the book of Colossians, he and his friend Silas were beaten and thrown into prison. Paul and Silas had been preaching the gospel and praying for people to be set free from the power of Satan. They were dynamic men intent on telling the ancient world about Jesus. However, the authorities of the day were threatened by these evangelists and decided to beat them with rods, rip their clothes from them, and throw them into prison.

> *The crowd rose up together against them, and the chief magistrates tore their robes off them and proceeded to order them to be beaten with rods. When they had struck them with many blows, they threw them into prison, commanding the jailer to guard them securely; and he, having received such a command, threw them into the inner prison and fastened their feet in the stocks. (Acts 16:22–24)*

Certainly, Paul and Silas had every right to complain and weep with frustration and outrage. They didn't deserve these accommodations, and yet they were held hostage by pain and loss. It seemed that the enemy had won a battle in the lives of Paul and Silas, and their ministry had been paralyzed.

Perhaps you have found yourself in an undeserving prison and wonder where God is amidst the pain and loss. Maybe, as you look at the conditions of your life, you feel beaten up by circumstances, stripped of hope, and even thrown away.

The story of Paul and Silas is not over yet and neither is yours. While living in unjust circumstances, continue to learn from the story of Paul and Silas.

> *But about midnight Paul and Silas were praying and singing hymns of praise to God, and the prisoners were listening to them. (Acts 16:25)*

At midnight, the darkest time of night, when most people are losing hope and giving up in despair, Paul and Silas made a stunning choice. They

determined to pray and sing hymns of praise while they were bruised and bleeding. These two ordinary men elected to open their mouths in worship rather than in frustration. Rather than blaming God, they resolved to bless God.

Paul and Silas found joy because they knew no prison had the power to hold them captive. They decided to worship and rejoice in the dampness of hopelessness. They chose not to worry, complain, rationalize, or weep, but to break out in song!

As Christians, we have a divine duty to meet the very worst that life presents with the joy of worship. This is the choice that men and women from every generation must make. Each of us will face a midnight hour in life and must select what activity we will involve ourselves in. Paul and Silas chose to worship. What will you do?

⧗ *What is your favorite worship song or hymn?*

⧗ *Why do you believe it is more powerful to sing than it is to weep?*

LIVING TREASURE

For this reason also, since the day we heard of it, we have not ceased to pray for you and to ask that you may be filled with the knowledge of His will in all spiritual wisdom and understanding, so that you will walk in a manner worthy of the Lord, to please Him in all respects, bearing fruit in every good work and increasing in the knowledge of God.

(Colossians 1:9–10)

PRAYER

Jesus, I love You so much. Help me to walk in a manner worthy of the Your name and to please You in every respect of my life. Help me to be a fruit-bearing Christian and to bring joy and peace to the world in which I live. I want to know You, Lord, in Your fullness and power. In Jesus' name I pray. Amen.

WORDS OF WISDOM

Without worship, we go about miserable.

—A. W. Tozer

Day 2

Confused at Colossae

The church at Colossae was in serious trouble; they had lost their focus on Christ Jesus. Paul wrote to this early church to address the false teachings that were running rampant among its members. The heresy that had infiltrated Colossae was a combination of pagan-occultism, Jewish legalism, and Christianity.[2] This confused group of people was embracing an early form of Gnosticism, which taught that salvation could be achieved through knowledge rather than through faith.

Many churches in the twenty-first century have the same problem that plagued the early church: we have lost our focus on Jesus Christ. Many churches today are no longer Christ-centered, nor do they revere the Bible as the uncompromising Word of God. Like the church at Colossae, they have mixed in other religions, thoughts, and philosophies with the gospel message of Jesus Christ, falsely believing we can "think" our way or "reason" our way to God.

⏳ *What are some of the issues that trouble you concerning the church's belief system in the twenty-first century?*

⏳ *Take some time today to pray for your church and for your pastor.*

The Bottom Line

The vitality of our faith is lit with the centrality of Jesus Christ. Jesus is not just one element of our belief system, but He is one with God the Father and the Holy Spirit, the essence of all that we believe and hold dear. Christianity is not the same as—nor is it equal to—other religions. There is only one way to heaven, and it is through the blood of Jesus Christ, our Savior.

There is a false teaching gaining popularity in the church today ascribing to the belief that everyone is going to heaven. The stirring truth is that everyone who has accepted Jesus as their Lord and Savior will indeed go to heaven for all of eternity. Jesus didn't need to die on the cross if everyone could go to heaven. Jesus died so we could be reconciled with God the Father, be forgiven of our sins, and enter heaven. The gospel message is the bottom line of our faith, which is why Paul wrote to the church at Colossae.

⧖ *Write out the five main tenets of your faith below. Share these tenets with someone this week.*

1. _____

2. _____

3. _____

4. _____

5. _____

Who You Are and Whose You Are

Paul began his letter to the confused church at Colossae with three strategic and specific introductions.

> *Paul, an apostle of Jesus Christ by the will of God, and Timothy our brother, To the saints and faithful brethren in Christ who are at Colossae: Grace to you and peace from God our Father. (Colossians 1:1–2)*

The first introduction is to the author of the letter. Paul was assured of who he was and whose he was; he was an apostle of Jesus Christ.

One of the most important aspects of life is identity—to know who you are. Knowing who you are anchors your life in strength and purpose in a way that nothing else can. However, perhaps the greater issue, other than knowing who you are, is to know *whose* you are. Whose you are may powerfully determine who you are. Your calling in Christ is the most potent feature of your identity. You will never know who you are apart from your ownership by the Lord.

Your calling in Christ should guide your life daily. We can ascertain our calling in Christ on the sacred pages of Scripture.

Therefore encourage one another and build up one another, just as you also are doing. (1 Thessalonians 5:11)

You are called to be an encourager, which will have a definite and resounding impact upon your marriage, family life, and relationships.

But in all these things we overwhelmingly conquer through Him who loved us. (Romans 8:37)

You are called to be more than a conqueror in Jesus Christ. You were created in the image of Christ and filled with the Holy Spirit for the express purpose of conquering discouragement, bitterness, and even depression.

But you, be sober in all things, endure hardship, do the work of an evangelist, fulfill your ministry. (2 Timothy 4:5)

You are called to be an evangelist and tell the old story that never grows old. Knowing you are an evangelist, you should also be determined to make the most of every opportunity given to you to share your faith. As an evangelist, you should intently pray for divine appointments to share the gospel message.

⧗ *Can you think of another scripture that defines your calling in Christ? Write it out below:*

When you are fully and gloriously aware of whose you are, your identity will quickly adjust to that wonderful knowledge.

You Need a Timothy

The second introduction that Paul makes is to a young man by the name of Timothy. Timothy was the son of a Gentile father and a Jewish-Christian mother named Eunice and the grandson of Lois (Acts 16:1; 2 Timothy 1:5). Paul

and Timothy clearly shared a father-son relationship (1 Corinthians 4:17; 1 Timothy 1:2). Timothy often accompanied Paul on his missionary journeys.

A significant facet of Paul's legacy was the attention and discipleship he freely bestowed upon Timothy. Paul poured his life into this young man who became the first bishop of Ephesus.[3]

We need to be discipling those younger members of the body of Christ as a rich part of our calling in Christ. Developing Christians need the leadership and wisdom that seasoned believers are able to impart. The Bible is clear concerning the calling of older women to those who are growing in their faith and in their calling.

> *Older women likewise are to be reverent in their behavior, not malicious gossips nor enslaved to much wine, teaching what is good, so that they may encourage the young women to love their husbands, to love their children, to be sensible, pure, workers at home, kind, being subject to their own husbands, so that the word of God will not be dishonored.*
>
> *(Titus 2:3–5)*

The phrase "older women" is referring not only to the number of years lived but also to the length of time spent serving Jesus Christ. These wise, stable women are instructed to encourage younger women to love their husbands, to love their children, and to guard their homes with love and purity.

⧗ *Who is your "Timothy"? Do you have a younger woman to encourage and offer wisdom to? If not, pray today for guidance from the Lord and pray that He sends you your "Timothy."*

⧗ *Perhaps you are a "Timothy." If so, who is your "Paul"?*

Our First Collision

The third introduction that Paul makes is the people to whom he is writing. Paul identifies his audience as *"the saints and faithful brethren in Christ who are at Colossae."* Although you don't live at Colossae, make no mistake; this letter has implications for all who read it. It is as if it was written *for* you.

If Paul were writing this message today, he might have addressed it to "the saints and faithful brothers and sisters who live in America" or "the saints and faithful brothers and sisters who serve God in the twenty-first century."

Saints are redeemed people bound for heaven but whose current address is planet earth. While it is true you belong to Jesus and are just passing through this temporary existence, you also have a place of residence while breathing oxygen. Every Christian has two strategic addresses, and we live at both addresses simultaneously. You are "in Christ," and you are "at Colossae." You can breathe in heaven while living on the shores of earth, and you are called to act like a saint while living stateside.

⌛ *Write your definition of the word* saint.

Because you know your identity and you joyfully realize whose you are, you are able to be an encourager while everything is conspiring to discourage you. You understand according to Scripture that you are a conqueror in Christ even though events are attempting to defeat you. You can be a bold evangelist although the culture is trying to convince you that Christianity is foolish or archaic.

⌛ *Why is it difficult to live out our calling in Christ in the midst of a compromised culture?*

You must remind yourself daily that you don't live and move and have your being based upon your earthbound existence; rather you extract abundant life from your eternal identity.

This is our first collision: between Colossae and Christ. When the temporary collides with the eternal, the eternal must always win. When our culture collides with our identity in Christ, who we are in Him must be victorious.

⧗ *In your life, where has the culture collided with your identity in Christ?*

LIVING TREASURE

For this reason also, since the day we heard of it, we have not ceased to pray for you and to ask that you may be filled with the knowledge of His will in all spiritual wisdom and understanding, so that you will walk in a manner worthy of the Lord, to please Him in all respects, bearing fruit in every good work and increasing in the knowledge of God. (Colossians 1:9–10)

PRAYER

Jesus, today I want to be more aware of and committed to You than I am to my culture. I pray that You will use me in my Colossae and that You will use me to encourage the next generation of believers in Jesus Christ. In Jesus' name I pray. Amen.

WORDS OF WISDOM

What a rich gain for this poor world, that they,
being in Him, are in it.

—H. Moule

Day 3

No Small Thing

One of the most profound choices given to us by our Creator is having the power of gratitude. A thankful heart is where peace is lavish and where hope is never destroyed. We must never underestimate the dynamic of embracing and expressing a grateful heart. We simply must be a people who are overflowing with gratitude.

A thankful person is a sheer delight to be around because you can be sure this person will always be looking for the best in you. Perhaps it should be our goal to be the most grateful people on the planet.

⧖ *Make a list of at least three things for which you are grateful today:*

1. _____

2. _____

3. _____

Live with Gratitude

Paul was a thankful leader, expressing his pleasure for this downtrodden church with sincere love and pleasure:

> *We give thanks to God, the Father of our Lord Jesus Christ, praying always for you, since we heard of your faith in Christ Jesus and the love which you have for all the saints; because of the hope laid up for you in heaven, of which you previously heard in the word of truth, the gospel.*
> *(Colossians 1:3–5)*

Paul began this difficult epistle with a heart of gratitude and intentionally communicated to this precious yet confused group of people just how grateful he was for them. Isn't that a good reminder? When you must have a difficult conversation, begin it with gratitude. It is a lovely and soothing idea to start a

challenging discourse with words of sincere appreciation. Paul is an astounding example of a caring leader; he not only was inwardly aware of but also verbalized those attributes in their lives for which he was thankful.

Mothers should tell their children daily the strengths they see in them; wives should be mindful to speak of what is good and admirable in their husbands. Employers should make it a daily practice to encourage those who work for them while employees must verbally inspire their employers and coworkers with words of affirmation.

As believers in Jesus Christ, we must mindfully and proactively be grateful for the people in our lives. I dare you to be the most thankful person alive in your generation!

⌛ *Make a list of three people for whom you are grateful today:*

1. _____

2. _____

3. _____

⌛ *Now, look for a way this week to tell them how thankful you are for each one of them.*

All You Need Is Love

As you go throughout life, don't focus on people's weaknesses or shortcomings, but always embrace a heart of genuine love. There is something lovable in every person you come across no matter how difficult it is to discover it.

> **Since we heard of your faith in Christ Jesus and the love which you have for all the saints. (Colossians 1:4)**

Love should be the distinguishing mark of a believer in Jesus Christ; we should enthusiastically love as well as encourage others no matter who the others might be. Jesus loved sinners, and so should we. Jesus loved difficult people such as Judas, and so should we. Perhaps we should make it our personal goal in life to find something lovable in the most fractious of people.

> **By this all men will know that you are My disciples, if you have love for one another. (John 13:35)**

According to Jesus, disciples are not known by their knowledge of Scripture, enthusiastic prayer life, or number of years they have volunteered at church. The one characteristic that believers in every generation, on every continent, at every time in history should have in common is their vibrant love for one another.

A convicting quote is attributed to Bara Dala, an Indian philosopher, whom I think of often when I am attempting to love an irritable person: "Jesus is ideal and wonderful, but you Christians—you are not like him."[4]

Oh! How I long to be like Jesus. Therefore, I must love the unlovable, the rude, and the argumentative. I must.

I have learned that "loving" someone doesn't start with "liking" them; rather, "liking" someone always begins with "loving" them. When struggling in a relationship, I look for proactive ways to demonstrate a loving attitude toward the problematic person. I have found that I can write a kind note, fix a meal, make a short but encouraging phone call, send a friendly text, or take this challenging person out for coffee. Small acts of love are persuasive in our marginalized world; the person persuaded just might be you.

I also believe Paul's words of sincere gratitude and lovely encouragement not only brought hope to the church at Colossae but also fertilized the hope in Paul's lonely prison cell.

⧗ *Make a list of three people who have been hard for you to love. Commit to pray for them this week and to ask the Lord to allow you to love them in a practical and personal way.*

1. _____

2. _____

3. _____

It's All True

Once you have asked Jesus to forgive you of your sins and have invited Him to live in your heart, you have been given the hope of heaven. Paul references this wonderful hope in the first few sentences in his letter to the church at Colossae:

> **Because of the hope laid up for you in heaven, of which you previously heard in the word of truth, the gospel. (Colossians 1:5)**

It is of great interest in these first three verses of Colossians that Paul references a triumvirate of Christian values: faith, hope, and love. Faith is simply believing that Jesus is the only Son of God, that He died in our place for our sins, and that he rose from the dead. Love is an active part of our Christian faith; we love others because He first loved us. Hope refers to our future as children of God; we will live with Him forever.

⧖ *Write out your definition of these three words:*

Faith

Love

Hope

It is vital in our Christian walk to make a nonnegotiable decision—a final and life-changing decision. We must intentionally determine to believe the Bible, or the gospel message of salvation, is valid. I believe every word of the God-inspired Scriptures holds eternal truth even today. The words we read on the sacred pages of Scripture were inspired by God, breathed by the Holy Spirit, and written down by men.

Peter, the disciple and the rock upon whom Christ built His church, was inspired by the Holy Spirit to write these words reminding us of the durability of Scripture:

> *For you have been born again not of seed which is perishable but imperishable, that is, through the living and enduring word of God.*
> **(1 Peter 1:23)**

The Bible is not a flat book that will lose its potency as the years pass by. The Bible is wonderfully alive and holds exciting truth for every generation. God's Word is eternally true and is the solid foundation upon which His beloved children have built their lives for thousands of years. His Word is His gift to us; it

is a fascinating blueprint for us to hold, read, and apply to our lives today in the twenty-first century.

⧗ *Do you believe the Bible is true? Why or why not?*

⧗ *What is your favorite Bible verse?*

It's Abundantly Fruitful

One of the most incredible aspects of daily committing to the truth of the Bible is what it will do *in* you. As modern-day believers in Christ, we do not read the Bible primarily for information but for transformation.

While it is true that the Bible is the historical account of God's people and how He worked in their lives, that is not the primary reason we should read it every day. Paul reminds us of the fruit that will grow in our lives as we ingest the magnificent pages of Scripture.

> **Which has come to you, just as in all the world also it is constantly bearing fruit and increasing, even as it has been doing in you also since the day you heard of it and understood the grace of God in truth. (Colossians 1:6)**

The Word does a miraculous and productive work in our hearts, attitudes, and emotions as we simply open the Bible and read it. As you commit to being a faithful reader of Scripture, you will notice the difference it makes in you.

Suddenly, you will realize, "My husband is not getting on my nerves anymore! What happened to me?" The Word happened to you!

Out of the blue, you will think, "My mom isn't as frustrating as she used to be! What happened to me?" The Word happened to you!

At the close of the day, you will remark to your husband, "You know, I didn't yell at the kids today. What happened to me?" The Word happened to you!

The Word acts as a vibrant and nearly instant fertilizer for the fruits of the Spirit in a person's life. We need the Word to stabilize our emotions and to help us exhibit love and kindness in difficult situations.

"It is constantly bearing fruit and increasing," is Paul's reminder to the church at Colossae and therefore to us as well. The Word of God possesses the astounding ability to grow Christian character in the life of a committed believer.

You will notice a profound and lasting difference in your emotional stability as you joyfully partake of the Word each day. There will be moments that you will not completely understand the Word with your mind, but don't despair when this happens. Your spirit will always catch what your mind is unable to comprehend. Your spirit is more apt to attract and connect with the principles of Scripture than is your mind.

If you are struggling with an addiction, open your Bible. If you are tormented by worry or anxiety, read the Word. If you are consumed by a constant bad attitude, be in awe of the sacred pages of Scripture. If you lack personal discipline, memorize a verse or two. If a certain person constantly frustrates you, read the Word out loud to yourself.

One of the spectacular facets of the Bible is that when you read it, believe it, and apply it to your life, the inside growth will become obvious on the outside of you! You will be a fruit-bearing and delicious Christian.

You Are Epaphras

One of the most stirring yet humble calls on the life of a believer is to continually serve the unshakable kingdom of Christ in ordinary and mundane ways, day after day after day. It is no small thing to be faithful in the little things. Although you might feel you are obscure and even invisible at times, as you serve the Lord faithfully and joyfully, you are making a profound difference in the lives of people around you.

⧗ *How are you currently serving in your church?*

⏳ *If you could do anything for the Lord, what would you want to do?*

When we read the Bible, we are very aware of the "home-run hitters" or the "Hall of Fame believers." We all know the stories of men and women such as Peter, Noah, Moses, Esther, and Mary. When we compare ourselves to David, Daniel, Deborah, or Joseph, we wonder if our miniscule lives are noticed by anyone at all.

We must never forget that there are others in the Bible, mentioned only once or twice, who had dedicated their lives to steadfastly following the call of Christ. One such person is Epaphras.

Just as you learned it from Epaphras, our beloved fellow bond-servant, who is a faithful servant of Christ on our behalf, and he also informed us of your love in the Spirit. (Colossians 1:7–8)

As far as we know historically, the only influence that Epaphras had was on the tiny church of Colossae in a run-down community. Epaphras wasn't a John, a Matthew, or a Jeremiah; he wasn't a Billy Graham, a Priscilla Shirer, or a Beth Moore. Epaphras was a common man serving God in uncommon ways. The truth is this, Epaphras was me and he was you.

He was just a man living wholeheartedly for the Lord in his minor sphere of influence. Although he could have given Paul a bad report about what was going on at the Colossian church, instead he told Paul how much they loved one another there.

Faithfulness and diligence are characteristics losing their noticeable value in the modern world. However, because the name of Epaphras is written in this Christ-centered book in the Bible, we know God notices faithful servants who refuse to gossip but look for the good in their church family.

⏳ *How are you like Epaphras?*

⏳ *How are you different from Epaphras?*

⏳ *Why was Paul moved to pray for the church at Colossae in Colossians 1:3–8?*

LIVING TREASURE

For this reason also, since the day we heard of it, we have not ceased to pray for you and to ask that you may be filled with the knowledge of His will in all spiritual wisdom and understanding, so that you will walk in a manner worthy of the Lord, to please Him in all respects, bearing fruit in every good work and increasing in the knowledge of God.

(Colossians 1:9–10)

PRAYER

Dear Jesus, I love You so much. Thank You for the hope of heaven and the truth of Scripture. Help me to love the difficult people in my life this week. Use me as Your vessel to love the unlovely and to care for the lonely. In Jesus' name I pray. Amen.

WORDS OF WISDOM

Down through the years, I turned to the Bible and found in it all I needed.

—Ruth Bell Graham

Day 4

I Will

I recently read a quote that has literally taken my breath away as I think about my love for the Bible and how I long for you to love it as well. I pray as we continue to study the truth and vibrant message of Colossians, you will understand the theme of this vivid quote: *"When God comes streaming into our lives in the power of His Word, all He asks is that we be stunned and surprised, let our mouths hang open, and begin to breathe deeply."*[5]

The next series of verses we will study together may be among the most influential verses in the New Testament, certainly in the book of Colossians. These verses are among my very favorite to teach, and I believe as you read and study them, you will experience a miracle in your soul.

⧖ *What are your favorite verses in Scripture? Write them out below.*

How to Pray

Have you ever pondered how to pray for the dearly loved people in your life? Have you ever wondered how to pray for people who were not completely following Christ? The answer is discovered as Paul writes to the early church.

> *For this reason also, since the day we heard of it, we have not ceased to pray for you and to ask that you may be filled with the knowledge of His will in all spiritual wisdom and understanding. (Colossians 1:9)*

Paul prayed that this floundering church would be filled with the knowledge of His will. What a glorious and life-changing prayer! I pray this prayer

daily over all five of my grown children, their spouses, and my grandchildren. I pray this prayer over newborn babies, over teens, tweens, and college students. I pray this prayer over my friends in a mid-life crisis, over young moms, and over women struggling with infertility. I pray this prayer over single women, over those who are widowed, over newlyweds, and over those who are celebrating decades of marriage.

How wonderful to know we can pray to be filled to overflowing with the knowledge of what God's will is for each one of our lives. I happen to believe that God loves it when we pray a prayer like this, "Lord, show me Your will. Fill my humanity with the knowledge of Your will for my fleeting life."

⌛ *Make a list of three people for whom you are currently praying:*

1. _____

2. _____

3. _____

⌛ *Now, write out Colossians 1:9 as a prayer and insert their names.*

God's Will Is His Word

Ascertaining the will of God is not a cosmic guessing game; it's not a hypothesis, an inkling, a suspicion, or even an educated guess. God's will is found in His Word; as you fill your mind with His Word, you will also be filled with the knowledge of His will. The Father reveals His phenomenal will most often through His Word.

The knowledge of anything is based upon facts and is not found by embarking upon a spiritual scavenger hunt. God's will will never be discovered by playing "twenty questions" with the Holy Spirit.

God's will is perceived, retrieved, and known when a beloved child of God opens the Scripture and then applies the holy verses to his or her own life. Therefore, we can answer the question, "What is God's will for my life?" with these amazing and biblical responses:

ᵓ₃ *God's will is to walk through tragedy and trauma with joy!*

ᵓ₃ *God's will is to refuse to gossip but to encourage one another day after day.*

ᵓ₃ *God's will is to wear a garment of praise.*

ᵓ₃ *God's will is to love the unlovable and to forgive those who don't deserve it.*

ᵓ₃ *God's will is to be generous.*

Often, I have been guilty of hoping that God's will would come with a precise date attached, a specific place to go, or an exact person to meet. Sometimes it is those things, but more often, I have found that God's will is found in this remarkable verse:

> **For the kingdom of God is not eating and drinking, but righteousness and peace and joy in the Holy Spirit. (Romans 14:17)**

⧖ *I made a list above of what God's will is according to Scripture. Can you add five of your own statements that you are convinced are God's will due to the truth of Scripture?*

1. _____

2. _____

3. _____

4. _____

5. _____

God's Will Is Accessed Through Prayer

One of the grand missions in the life of a believer is to discern what God's will for our life might be. James, the half-brother of Jesus, wrote these words:

> **But if any of you lacks wisdom, let him ask of God, who gives to all generously and without reproach, and it will be given to him. (James 1:5)**

In this verse penned over two thousand years ago, the Holy Spirit invites us to ask God for wisdom in every situation. You can simply lift your hands toward heaven and say, "Father, what is Your will? I need Your wisdom."

After you pray that simple yet profound prayer, expect God to answer. Perhaps the lyrics of a hymn will come to mind, or a verse of scripture, or the name of a person. God reveals His will to those who know His Word and to those who are brave enough to ask for wisdom.

⧗ *Take some time right now to pray for wisdom and then sit quietly for a minute or two in His presence.*

⧗ *Did God speak to you? What did He say?*

Walk Worthy

After discerning the will of God, the second great mission in life is to access the power that walking out the will of God will require. When you know God's will, you must pray for the strength and courage to walk worthy of His call.

So that you will walk in a manner worthy of the Lord, to please Him in all respects, bearing fruit in every good work and increasing in the knowledge of God. (Colossians 1:10)

While it is verifiably true that God has a perfect will for your life, never ignore the obvious fact that you have a will for your life as well.

ᴄ℥ *Will you set your will to walk worthy?*

ᴄ℥ *Do you have the deep desire to walk through life in the manner that Christ desires for you to walk?*

Every believer comes to the crossroads of the will of self and the will of God. At that crucial intersection, you must choose to lay down your will and choose His way above all else.

Paul calls the early church, and therefore us, to please the Lord in all respects. Obeying the Lord joyfully half the time is not the goal; obeying the Lord wholeheartedly *all the time* is the lifestyle to which we are called.

ᙏ *Am I willing to sing through sorrow?*

ᙏ *Am I willing to praise the Lord rather than whine?*

ᙏ *Am I willing to listen to a difficult person and not demand to talk about me?*

ᙏ *Am I willing to encourage and give a good report rather than to gossip?*

ᙏ *Am I willing to love the unlovable or the irregular people in my life?*

ᙏ *Am I willing?*

Once you discern the will of God, primarily through reading the Word and through prayer, you must be willing to *do* His will. God's will is that you become a fruit-bearing Christian every day, all the time, and in every circumstance. Because you have determined to walk worthy, you have decided to be a vibrant orchard overflowing with the fruit of the Spirit. People will know when their lives collide with your life, they will receive delicious and consistent fruit from your lovely garden of faith.

> **But the fruit of the Spirit is love, joy, peace, patience, kindness, goodness, faithfulness, gentleness, self-control; against such things there is no law. (Galatians 5:22–23)**

When people are easy to get along with and are kind to you, it is easy to respond in a fruitful way. However, when you are walking through the dry and arid conditions of a desert-like relationship, you must maintain a harvest of tasty and appetizing fruit. Are you willing to accept God's will?

Unfortunately, I have learned when the conditions are conducive for fruit and when relationships are easy and friendly, what I am exhibiting is not the fruit of the Spirit but the fruit of my personality. In that case, I am producing fake fruit. When everyone is sweet and kind to me, I can respond in the same manner. However, when a relationship is difficult and someone is unkind, I can't produce fake fruit. I need the will to walk worthy and I must have the power of the Holy Spirit.

⧗ *Choose one of the fruits of the Spirit from the scripture above and write a definition of it.*

⧗ *Perhaps you could look up another scripture that talks about the fruit that you have chosen.*

⧗ *Now, ask the Lord to help you produce this one piece of fruit in your life.*

Someone Will Get Hurt

As a young mom, I loved taking my little boys shopping with me. I thought it would prepare them for their future wives if they became accustomed to walking through department stores, the mall, and little gift shops.

One day, when I was shopping for a birthday gift for my mom, I decided to take my four-year-old son, Christopher, with me. It was nearly lunch time, and he continued to remind me how hungry he was. I wanted him to be patient because we had just entered a precious Southern gift shop and I knew at this particular store I would be able to find just the right gift for my mama.

As I was perusing ruffled curtains, painted tea kettles, and pictures with sweet sayings on them, Christopher started to whine, and he told me in a very loud voice that he was about to starve.

I knelt down beside him and said quietly, "Honey, you are fine. Mama is almost done and we will go to McDonald's and get lunch in just a few minutes."

As I continued to gaze at flower arrangements, beautiful artwork, and colorful pillows, Christopher spied a bowl of fruit on a table not far from where I was looking. He quietly inched away from me, picked up a beautiful red apple, and bit down hard on it. The wail that went through that gift store echoes still! Christopher broke a tooth on fake fruit because the apple was made of wood.

My friend, don't ever serve fake fruit on the buffet of your life; someone is sure to get hurt!

Authentic Fruit

When relationships are difficult and circumstances are ferocious, authentic fruit should always be offered from the abundance of your life. The fruit of the Spirit is not fertilized by circumstances or by people, but it is enriched by your effervescent relationship with Jesus Christ. If you desire to present authentic fruit regardless of your living conditions, you will need to press into Christ and into His wonderful Word.

When you know the will of God and when you choose to walk in the will of God, the blessing of Jeremiah will be upon your enriched life:

> *Blessed is the man who trusts in the Lord*
> *And whose trust is the Lord.*
> *For he will be like a tree planted by the water,*
> *That extends its roots by a stream*
> *And will not fear when the heat comes;*
> *But its leaves will be green,*
> *And it will not be anxious in a year of drought*
> *Nor cease to yield fruit. (Jeremiah 17:7–8)*

You will have nothing to fear when the heat is turned up in your life because you trust the Lord and because your roots are nestled in close to the wonderful River of Life. You will have no reason to be anxious during the driest season in life because you will continue to yield nutritious and evident fruit.

⧗ *What does it mean to you to "trust the Lord"?*

⧗ *Why is trust such a vital part of our Christian walk?*

The ability to bear fruit during a drought is impossible to achieve in the natural. When a drought hits South Florida, fruit trees stop bearing fruit. When a drought hits Iowa, the corn stops growing in the fields. However, when a drought hits the life of a believer in Jesus Christ, the fruit of the Holy Spirit continues to develop, the vines are loaded, and branches are dripping in abundance. The fruit of your life will be juicy and sweet despite challenging relationships, an unstable economy, a bad doctor's report, or a broken heart.

Jesus, the Chief Gardener, will ensure that you will have enough fruit to share with a hurting, broken world. You can experience a basket-breaking harvest of spiritual fruit even when your circumstances are traumatic. The fruit of your life will grow in direct proportion to your desire to walk in God's will for your life. As your life pleases the Lord, and as you choose to follow His will rather than your own will, you will have fruit to share with others even when the others don't deserve it.

Time Together

Paul prayed that the struggling church at Colossae would *"[increase] in the knowledge of God."* Paul was hoping the members of this early church would all become wise theologians. When a person chooses to study theology, they are electing to study God. Theology is, simply put, the study of God.

When Craig and I were dating in college, I ached to spend time with him. I deeply desired to know everything about this man of God with whom I was falling in love. I hoped to learn about his childhood, his family life, and what foods he enjoyed. We talked about sports, his calling, and music.

When you yearn to know someone, you want to spend time with that person and look in their eyes and hear their heart. You crave time alone, time with others, time in a crowd, time asking questions, and time talking and singing as you get to know this person. The same actions are necessary if you hunger to know God more intimately. If you, as Paul suggests, yearn to increase in the knowledge of God, make a date with Him this week and spend time with Him. Read His love letter that He wrote to you, sing to Him, talk to Him, and listen for His voice.

God's will for your life includes increasing daily in the knowledge of Him. If this is true, you must joyfully and passionately pursue Him. You will discover a treasure trove of wisdom, peace, and fulfillment as you spend time falling in love with Him.

⧖ *Look at your schedule for the week. Make it a priority to spend an hour or two with the Lord. Write about that experience below.*

LIVING TREASURE

For this reason also, since the day we heard of it, we have not ceased to pray for you and to ask that you may be filled with the knowledge of His will in all spiritual wisdom and understanding, so that you will walk in a manner worthy of the Lord, to please Him in all respects, bearing fruit in every good work and increasing in the knowledge of God.

(Colossians 1:9–10)

PRAYER

Jesus, I love You so much. I want to know Your will. I declare today that I will to do Your will. I pray You will fill me with the fruits of the Holy Spirit. Fill me with love, joy, peace, patience, kindness, goodness, faithfulness, gentleness, and self-control. In Your name I pray. Amen.

WORDS OF WISDOM

Commitment to the will of God—the purpose for which we are designed—offers freedom to become the person we are meant to be.

—Charles Hummel

Day 5

Super Power

When my grandson Ian was only four years old, we spent a glorious week together filled with ice cream cones, the playground, and an unending stack of books. I lived more than one thousand miles away from him, and as we were preparing to say goodbye, he wrapped his little arms around my legs. I was crying but knew that it was time to catch my flight.

I knelt beside him, took his little face in my hands, and said, "Well, buddy! Go change the world!"

He looked at me out of a shock of blonde hair and chestnut brown eyes, "I can't do that! I don't have superpowers!"

I wrapped this tiny piece of boy in my arms and whispered into his ear, "Oh, yes, you do, Ian! You have the power of the Holy Spirit!"

⧖ *If you could have a superpower, what would it be?*

A Boatload of Power

We are in the middle of a dynamic prayer that Paul prayed for the church at Colossae. After praying that this group of people would be filled with the knowledge of God, would know His will, would walk in a manner worthy of the Lord, and would bear fruit in every good work, Paul then prayed they would experience the power of God.

> *Strengthened with all power, according to His glorious might, for the attaining of all steadfastness and patience; joyously giving thanks to the Father, who has qualified us to share in the inheritance of the saints in Light. (Colossians 1:11–12)*

Paul believed that when people follow Jesus Christ, they instantaneously have an unlimited power supply at their disposal. We have that same power supply available to us today. He prayed believers in Christ would be *"strengthened with all power."* The small word that excites me the most in this four-word phrase is the word *all*. The possibility of being strengthened with all the power that heaven holds is infinitely more than a measurable boatload of power!

Paul was convinced that the power of creation, the power of holding back the Red Sea, the power that closed the mouths of the lions should be ours today. Paul stood firmly in his faith that the power for healing the sick, casting out demons, and raising people from the dead should be the power that we, as God's children, experience in the twenty-first century.

Paul's roar echoes through the centuries as he prays that we, the church of Jesus Christ, would be strengthened with all the power of the Holy Spirit.

⧗ *What do you need power for today? List the things that make you seem weak and incapable and then ask for God's amazing power to meet each need.*

1. _____

2. _____

3. _____

4. _____

5. _____

What Is This Power?

When Paul cried out to the Lord and asked that the church at Colossae—and therefore the church of the twenty-first century—be *"strengthened with all power,"* he used a very specific Greek word for "power." The word Paul selected was the word *dynamis*, from which we extract the English word *dynamite*. Paul believed the power given from heaven's unlimited resources should enable believers in every epoch to blow up earthly systems and decimate a compromised culture. Paul deeply yearned that God's children would tap into the power source that destroys depression, anxiety, and ravaging emotional pain. Christians should blast onto the scene of our society with uncommon strength and potency simply because we belong to Jesus.

Dynamis has several exciting meanings. I believe the Holy Spirit wants us to absorb these meanings, so we understand the difference this eternal power will make in our lives today. In its simplest form, *dynamis* means "strength, power, ability." You have abilities that others do not have and are able to plug into a power source only available to the redeemed.

The second rich definition of *dynamis* is "inherent power, power residing in a thing by virtue of its nature or which a person or thing exerts and puts forth." Solely because you are a Christian, you have power and influence in your very nature. It's inherent and it's yours.

Are you ready for the next definition of *dynamis*? This definition is so exciting and exhilarating that you might want to shout! *Dynamis* also means "the power for performing miracles." You, as a child of God, have been bequeathed the power for performing miracles. When you pray, power rushes forth from your prayers and miracles are unleashed. You have been given the extraordinary power to pray for, have faith for, and believe for the miraculous. What an amazing power!

Dynamis also means "moral power and excellence of soul." God's power is just one whisper away when you are in a moral dilemma or when you are tempted by sin. Life on earth is not easy, and even when our heart longs to obey, our flesh often screams out in defiance. *Dynamis* power offers the ability to live a morally immaculate life and to maintain an excellence in one's soul that is simply uncommon. I want that kind of power; do you?

We often view wealthy people as being more powerful than they actually are. We desire to be in close proximity with these well-to-do humans, just hoping their wealth might be contagious. My friend, *dynamis* power assures that type of influence. *Dynamis* is also described in this way, "the power and influence that belongs to riches and wealth." Because of the power that is now yours in Jesus Christ, you are the beneficiary of the power and influence reserved for the extremely affluent. This marvelous abundance is yours only because of Jesus.

Dynamis also ensures you will never again fight a battle alone; when you choose to fight on your knees, you are joined by the armies of the living God. *Dynamis* contains in its meaning "power and resources arising from numbers." As you walk into difficult situations and when your voice is needed in challenging conversations, all of heaven itself is on your side because of the *dynamis* power that resides inside your mortal being.

And finally, not only are you joined by the militia of the Lord, but also you *are* the militia of the King of the Ages. *Dynamis* power assigns you the very power given to those who fight on behalf of our awesome God. *Dynamis* also means "power . . . resting upon armies, forces, hosts."[6]

My friend, don't ever again say you are weak or that you are unable to accomplish something that seems difficult. You have been given every smidgeon of the miraculous power of God. Pray for the *dynamis* power of God to inhabit your very being and then walk in it.

⏳ *Write out the seven different meanings of the word dynamis below:*

1. _____

2. _____

3. _____

4. _____

5. _____

6. _____

7. _____

Every Kind of Strength

Paul informed the weakened, confused church at Colossae they have been "*strengthened with all power.*" In the Greek, he actually states that believers in Christ have been "strengthened with every kind of strength."[7]

Whatever you need, strength for today is yours in Jesus Christ and in the overwhelming power of the Holy Spirit.

> ○З *Single moms, you have strength for science projects, paying the bills, and staying up all night with a sick child.*

> ○З *Widows, you have strength to get through the holidays alone, to sleep peacefully at night, and to encourage others in times of grief.*

> ○З *Single women, you have strength to go to a friend's wedding, to rejoice with a friend who is having a baby, and to sit in church alone.*

ଓ *Moms of toddlers, you have the strength to make another grilled cheese sandwich, to potty train a strong-willed two-year -old, and to rock a baby to sleep.*

ଓ *Moms of teens, you have the strength to stay patient when your teen rolls his or her eyes at you, brings home an abysmal grade on a report card, or leaves a mess in the family bathroom.*

ଓ *Empty nesters, you have the strength to plan a hopeful future, to invest in new assignments and activities, and to disciple young mothers.*

ଓ *Divorced women, you have the strength to believe in yourself, to open up your heart to God's plan, and to forgive those who have rejected you.*

The Measurement of Power

The power on earth is measured in watts, hertz, or amps. It is also expressed in joules per second or even in horsepower. God's power, however, is measured much differently. God's power is measured *"according to His glorious might."*

Perhaps the prayer that we should be praying is this, "Father God, could I have every kind of strength you have to offer according to your glorious might?"

Are you brave enough to pray that prayer? That prayer is what I like to call a "wow prayer!" If you and I were brave enough to pray that particular prayer every morning of life, we would go around blowing things up!

We might blow up cancer and diabetes when we lay our hands on people and pray for them. We might obliterate depression, discouragement, and generational curses. We might decimate divorce, abortion, and bankruptcy as the power of His glorious might flows through our human constitution. We were made to overflow with the power of God.

⧗ *Why is it vital to know that God's power is measured by "His glorious might"?*

The Result of Strength

Paul specifically guaranteed what happens in the life of a child of God when they have been *"strengthened with all power according to His glorious might."* Let's read on in the words of Paul:

> **Strengthened with all power, according to His glorious might, for the attaining of all steadfastness and patience. (Colossians 1:11)**

As you are empowered with His dynamic ability, a miracle will happen in your life; you will attain the character traits of steadfastness and patience. What used to cause frustration in your life will no longer be an emotional trigger. Your unstable emotions will come into alignment with God's power and now you will become a woman filled with patience and godly emotional responses.

As hard things and difficult people enter your life—and they surely will—you will be strong enough to stay steadfast and to remain patient. Theologians have defined these two words—*steadfastness* and *patience*—in two very different, yet interesting ways.

Steadfastness is the refusal to be daunted by hard times, while patience is the refusal to be upset by perverse people.[8] I need them both; don't you? I need to be steadfast when my circumstances are cruel and unrelenting, and I need patience when fractious people enter my life. His amazing power makes it all possible: I am powerful, steadfast, and patient all because of Jesus.

⏳ *In what area of your life do you need steadfastness? Be specific.*

⏳ *For whom in your life do you need patience? Ask God to give you patience for this person.*

⧗ *Read once again Colossians 1:9-11 and make a list of the things that were on Paul's prayer list for the church at Colossae.*

The Grand Finale

Strengthened with all power, according to His glorious might, for the attaining of all steadfastness and patience; joyously giving thanks to the Father, who has qualified us to share in the inheritance of the saints in Light. (Colossians 1:11–12)

When you know your life is the perfect receptacle for God's incredible power and when you grow into a steadfast and patient Christian, you are able to *"joyously [give] thanks to the Father."* Now, due to His astounding power and the miraculous work it has done in you, you are a woman of remarkable joy that is overflowing on the world around you. As patience and steadfastness anchor your heart, you realize no longer do you whine about challenging times, nor are you offended by disagreeable people. Your life has become a song of joy and an anthem of undiluted praise. Your heart wells up with a glorious song of thanksgiving because of His power and presence in your life.

The power of Christ inside of you will always burst forth into a rare and glorious demonstration of praise. The power that is yours because of Jesus is not silent, nor is it dormant. It is a power expressed by explosive praise.

⧗ *What three things are you most thankful for today?*

1. _____

2. _____

3. _____

LIVING TREASURE

For this reason also, since the day we heard of it, we have not ceased to pray for you and to ask that you may be filled with the knowledge of His will in all spiritual wisdom and understanding, so that you will walk in a manner worthy of the Lord, to please Him in all respects, bearing fruit in every good work and increasing in the knowledge of God.

(Colossians 1:9–10)

PRAYER

Father God, could I have every kind of strength you have to offer according to your glorious might? I thank you, Jesus, for stabilizing my life with steadfastness and patience. I commit today to be a woman of remarkable joy overflowing on the world around me. In Your Mighty name I pray. Amen.

WORDS OF WISDOM

Our high and privileged calling is to do the will of God in the power of God for the glory of God.

—J. I. Packer

Week 2

First Place in Everything

Day 1

You Were Worth It

I am amazed at your bravery! You have decided to continue in the second week of study in this formidable book of Colossians. Are you beginning to overflow with all that Christ has given to you? Our twenty-first-century lives are crashing into this timeless book in Scripture. However, rather than being harmed by the crash, we are being healed and becoming more like Jesus in the process. This stunning collision instigates an eternal and glorious overflow!

A Rescue Mission

Giving thanks to the Father, who has qualified us to share in the inheritance of the saints in Light. For He rescued us from the domain of darkness, and transferred us to the kingdom of His beloved Son, in whom we have redemption, the forgiveness of sins. (Colossians 1:12–14)

Last week in our study, we began to understand the great joy of being called to give thanks to God the Father. Being a woman of vibrant and unequaled worship is one of our assignments as we breathe in earth's oxygen. God is honored when we choose to sing in the storms of life and as we lift our hands in resplendent worship.

We have so much for which to show our gratitude to God, and His eternal rescue of us is chief among the blessings. God sent Jesus, His only Son, on a rescue mission. You were the intended target of this mission. Jesus Christ broke the evil power of Satan, snatched us out of the domain of darkness, and deposited us eternally in the kingdom of light.

The Greek word for "rescue" Paul uses in this passage is *harpadzo*, an extremely strong and aggressive word that describes a desperate and forceful action. *Harpadzo* includes passion, fervency, urgency, and action in its meaning. One Greek expositor asserts that *harpadzo* carries this idea, "He grabbed us by the back of our necks and snatched us out of danger just in the nick of time."[9]

I have a dear high school friend who served in the military for nearly thirty-five years. He loves America and was proud to serve our nation across

many continents and during different conflicts. At our recent high school class reunion, he told me whenever someone thanks him for his service, he simply replies by saying, "You were worth it."

You were worth rescuing, my friend. You were worth it. In the heart of God the Father, you were worth it. In the eyes of Jesus, the Son, you were worth it.

⧗ *What does the phrase "you were worth it" mean to you?*

⧗ *Do you feel worthy of the love of God? If not, why not?*

⧗ *What does it mean to "be worthy"?*

Afraid No More

During my formative years, I dealt with fear nearly every day of my life. Around the neighborhood of my small town, I was known as a "scaredy cat." I was afraid of spiders, mean people, and the neighbor's dog. I was afraid of walking alone, the mice in our barn, and riding my sister's horse. I was terrified of spending the night at a friend's house, riding my bike on a friendly country road, and what not eating vegetables might do to me. But most significantly of all, I was afraid of the dark.

I could not fall asleep unless someone was in the room with me. My parents left a small light on in every room of the house, so if I got up to go to the bathroom, I wouldn't be frightened. The dark seemed evil and foreboding; I just knew that I, as a small child, was no match for the dark.

As an adult woman, I still don't much care for the dark but no longer am I intimidated by it. The reason for my change of heart is an obvious one: Jesus rescued me from darkness and transferred me to the kingdom of light. Now, I live and move and have my being in Him and in all that He is.

I have learned on my journey through life when light and darkness battle against each other. light always wins. Always. Darkness is unable to prevail against one small match, a tiny candle, or even a wee lamp. You and I now live in that victorious kingdom of perpetual and brilliant light!

⧖ *What were your fears as a child?*

⧖ *What are your current fears?*

Rich and Old

There are some Bible words that might be considered "Christianese," archaic, or even coldly religious. *Redeemed* might fit under that austere and antiquated category unless, of course, you are willing to take the time to understand its meaning and appreciate its wealth.

> *Giving thanks to the Father, who has qualified us to share in the inheritance of the saints in Light. For He rescued us from the domain of darkness, and transferred us to the kingdom of His beloved Son, in whom we have redemption, the forgiveness of sins. (Colossians 1:12–14)*

Redemption has a rich meaning retrieved from the earliest pages of the Old Testament. Israel had been held hostage in Egypt for more than four hundred years and their lot was to serve as slaves in this foreign nation. God sent ten plagues upon this heathen nation to convince the leadership to let His people

go. The final scourge that visited Egypt was the death of all their firstborn sons. While every firstborn son in every Egyptian family died, the children of the Israelites were rescued because the Israelites had placed the blood of a lamb upon their doorframes. This is when the story of redemption begins in Scripture.

Redemption means to "buy back" or "to save from captivity by paying a ransom."[10] God chose to repurchase us by offering His Son as the sacrifice. The blood of Jesus is on the doorpost of your life; you have been marked as "saved" or "redeemed" by the One who knows you best and loves you the most.

⏳ *Write out your own definition of the word* redeemed.

What a Difference!

What we have learned thus far studying only fourteen verses in this Christ-centered book of the Bible can only be described as life-changing. Is your heart overflowing yet?

Perhaps I could remind you of the astonishing difference Christ has made in your life. Let's title this list "What A Difference He Has Made in My Life!" I dare you not to weep for joy as you read it.

 ᄸ *We have hoped laid up for us in heaven.*

 ᄸ *We know the Word of God is true.*

 ᄸ *We have been appointed by our Creator to bear delicious and extravagant fruit that will sustain others during times of drought and pain in life.*

 ᄸ *We show grace and love to everyone we meet because we have been showered with the grace and love of Jesus. What He has done for us we are now privileged to do for others.*

 ᄸ *We are filled with the knowledge of His will. We can know His will beyond a shadow of a doubt!*

 ᄸ *We are walking out His will in our lives daily, and as we do so, we please Him.*

 ᄸ *Our assignment is to do good works this side of heaven and to know Him intimately.*

⅓ *We are strengthened with dynamis power, and we should go around blowing things up!*

⅓ *We are steadfast and we are patient no matter what comes our way or who interrupts our life.*

⅓ *We love to worship! Praise explodes out of our very pores.*

⅓ *We are no longer afraid of the dark but live in the kingdom of light.*

⅓ *We have been redeemed because of love.*

⅓ *We are worth it.*

⧖ *Of the thirteen wonders that are a central part of your life in Christ, choose two that mean the most to you and write them below. Think about these two wonders every day this week and ask the Lord to make them a substantial demonstration of your kingdom life in Christ.*

1. _____

2. _____

LIVING TREASURE

He is the image of the invisible God, the firstborn of all creation. For by Him all things were created, both in the heavens and on earth, visible and invisible, whether thrones or dominions or rulers or authorities— all things have been created through Him and for Him. He is before all things, and in Him all things hold together. (Colossians 1:15–17)

PRAYER

Jesus, I thank You today that I no longer have to be afraid of the dark or of anything else that comes my way. Thank you for redeeming me with Your precious blood and for the joy that comes with living for You. In Your name I pray. Amen.

WORDS OF WISDOM

If the Lord be with us, we have no cause of fear. His eye is upon us, His arm over us, His ear open to our prayer—His grace sufficient, His promise unchangeable.

—John Newton

Day 2

Songs with a Purpose

I have often thought if I could travel through time to any other period in history, I would certainly want to experience the days of the early church. Wouldn't it be amazing to experience the joy that was captured in a first-century worship service? I wonder if they used musical instruments as we do today, if they took up an offering, and how they prayed for the sick in their midst. I have often wondered how loud they prayed and about the vitality that must have filled those ancient yet active churches.

Are you ready to travel through time with me? Through the words of Scripture, we will experience a worship service typical of a first-century gathering. The verses we will embark upon today are the actual lyrics to one of the most popular hymns during this time period. I hope your heart is beating wildly, as mine is, as we eavesdrop on the hymnology of the early church.

More Than Music

Music is a highly controversial matter in the church today. Most of the younger generation prefer their music loud with a strong beat while the older members of a congregation may lean toward the hymns accompanied by only a piano or organ. In some regions of the country, churches tend toward a jazz flair; while in other regions, the worship may sound closer to a folk or country sound.

I have always been rather eclectic in my taste in music. As a pianist, I have learned there is enormous beauty in a variety of styles, tempos, and sounds. However, one aspect of Christian music in which I am uncompromising is the lyrics. It is vital that the lyrics sung by believers in the car, in a concert, in the shower, or in a church setting must communicate solid, biblical theology.

We will discover wonderful theology in the lyrics of this glorious hymn sung by believers in the first-century church:

He is the image of the invisible God, the firstborn of all creation. For by Him all things were created, both in the heavens and on earth, visible

and invisible, whether thrones or dominions or rulers or authorities—
all things have been created through Him and for Him. He is before all
things, and in Him all things hold together. He is also head of the body,
the church; and He is the beginning, the firstborn from the dead, so that
He Himself will come to have first place in everything. For it was the
Father's good pleasure for all the fullness to dwell in Him.

(Colossians 1:15–19)

The hymns sung by the followers of "the Way" two thousand years ago were more than conduits of music; the lyrics of hymns were tools of instruction and a declaration of belief. As the persecuted Christians in the early church sang hymns of praise and faith at their weekly gatherings, they loudly proclaimed, "This is what we believe!"

⏳ *What worship song or hymn sung at your church truly resonates with your belief system? Write both the name of the song and a few of the lyrics below.*

⏳ *Are you familiar with a worship song or hymn whose lyrics contain questionable theology? Write the name of the song below and why you might disagree with the lyrics.*

The Power of Lyrics

Andrew Fletcher (1653–1716) was a hot-headed patriot who stood against the tide of corruption in Scotland's last parliament. He wrote on a range of topics and quickly became known as one of the most astute political thinkers of the time. Sir Walter Scott described Fletcher in this way: "One of the

most accomplished men, and best patriots whom Scotland has produced in any age."[11]

One of Fletcher's keen perceptions, which is as fresh and meaningful today as it was three hundred years ago, is this:

Let me write the songs for a nation and I can determine the history of that nation. I don't care who writes it laws.

Andrew Fletcher was deeply aware of the power that lyrics of anthems had on the soul of a nation and upon its churches.

Fletcher is not the only philosopher who pointed out this same dynamic inclination.

The words hymn writers and liturgists put on our lips in worship affect us profoundly: they teach us what to think and feel, the more effectively as they are put to music so we can hum them to ourselves whenever we are inclined.

—Gordon Wenham

Isn't it true that on Tuesday morning or on Thursday afternoon, you are quietly singing the worship song you sang on church the preceding Sunday? When you are in the shower, you likely find yourself inwardly singing a song you heard on Christian radio just the day before.

Often, when I am dealing with a painful situation or a challenging person, it is the lyrics of the great hymns of faith that I sang as a child in church that become my constant and my hope.

The leaders of every great movement of God and the hearts of those behind every significant revival understand that hymns and spiritual songs are among the most valuable tools available to prepare people to live wholeheartedly for the Lord. The composers of classic hymns and contemporary worship music also know the lyrics of their compositions have the innate power to instill solid theology into the hearts and minds of congregations both large and small.

⧖ *Do you agree with Andrew Fletcher's words? Why or why not?*

⧗ *Do you agree with Gordon Wenham's words? Why or why not?*

Be Careful

This chapter is, at its heart, an invitation to carefully consider the lyrics of the songs that fill your soul. Lyrics intrinsically hold the power of creation; they create the person you are becoming. The songs you sing today prophesy the theology you will adhere to tomorrow. Choose well, my friend. Choose well.

⧗ *What would be an appropriate action to take if you heard a song with warped theology?*

⧗ *If you could write a hymn or a worship song, what would its theme be?*

Once Again

Before we go any further in this week's study, let us once again read the lyrics of this first-century hymn of faith:

> *He is the image of the invisible God, the firstborn of all creation. For by Him all things were created, both in the heavens and on earth, visible and invisible, whether thrones or dominions or rulers or authorities— all things have been created through Him and for Him. He is before all things, and in Him all things hold together. He is also head of the body, the church; and He is the beginning, the firstborn from the dead, so that He*

Himself will come to have first place in everything. For it was the Father's good pleasure for all the fullness to dwell in Him. (Colossians 1:15–19)

Would you pause in wonder with me for just one more moment? Read the words of Colossians 1:15–19 aloud and remind yourself these were the lyrics sung by Christians who faced imminent persecution, separation from their families, and even a horrifying death. And yet, these Christians chose to sing their theology for all to hear. Will you do the same?

⧗ *What does the "firstborn of all creation" mean in verse 15?*

LIVING TREASURE

He is the image of the invisible God, the firstborn of all creation. For by Him all things were created, both in the heavens and on earth, visible and invisible, whether thrones or dominions or rulers or authorities— all things have been created through Him and for Him. He is before all things, and in Him all things hold together. (Colossians 1:15–17)

PRAYER

Jesus, I pray that my heart and mind will stay purely focused on you and firmly fastened on the theology found in Scripture. Today I do pray for my brothers and sisters across the world who are suffering. Be very close to them, Father God, and give them the power of the Holy Spirit to stand strong in their faith. I need that same power. In Jesus' name I pray. Amen.

WORDS OF WISDOM

It is not sufficient to offer the empty vessel of our joy unto God, or our singing voice in musical tune only; but also it is required that we fill our joyful voice with holy matter and good purpose, whereby God only may be reasonably praised.

—David Dickson

Day 3

We Believe!

Paul was fighting a battle against a false teaching that declared, "Jesus is good, but He is not the only god to worship." This same false mindset pervasive in the church of Colossae promoted that all spiritual beings were equal to Jesus. Unfortunately, it is a destructive teaching that has reared its hideous head again, and we must be prepared to counter it with biblical and eternal truth.

⧗ *What false teachings are you concerned about in the church today? List a few below:*

1. _____

2. _____

3. _____

Who Is Christ?

Paul, through the inspiration of the Holy Spirit, calmly but forcefully asserted that Christ is not only prominent but also preeminent. Jesus not only is the most important person to ever walk upon the sands of time but also is far above all human rulers and authority. Jesus is God in the flesh.

> **He is the image of the invisible God, the firstborn of all creation.**
> **(Colossians 1:15)**

Jesus walked among humanity; He talked with human vocal cords. Jesus ate, laughed, and cried among His disciples. I have often wondered, did Jesus snore? Did He burp after a good meal prepared by Mary and Martha? What did Jesus say when He stubbed His toe or hit His thumb with Joseph's hammer? I might never know the answers to those insignificant questions, but I do

know that tens of thousands of people saw Him, experienced Him, and were changed by God in the flesh.

⏳ *What does it mean to you to know that Jesus is the image of the invisible God?*

Jesus, the Son of God, came to reveal His Father.

He who has seen Me has seen the Father. (John 14:9)

Jesus is the show and tell of who God the Father is. Jesus is the clear window through which we can observe the very nature of the God of Creation. Jesus, in every way possible, is the mirror image of God.

When you or I look into the bathroom mirror on any given morning, we see our sleepy selves staring back at us. If Jesus were to look in the mirror, He would see God staring back at Him. Imagine that!

Humankind had a spiritual malfunction; we weren't "getting" God. We didn't understand who He was and what He was able to do. God's solution for our malfunction was to send Jesus as His mirror representation. Jesus is the manifestation of God in the flesh; Jesus helps us to "get" God.

When Jesus came to earth, He calmed storms, forgave sins, and multiplied provisions. Jesus performed miracles, healed the sick, and raised the dead. That is what God the Father does as well.

⏳ *How does your life reflect the character of God the Father?*

⌛ *List three characteristics of God below:*

 1. _____

 2. _____

 3. _____

⌛ *Now choose one of those characteristics to demonstrate through your life.*

More Than That

While it is undeniably true Jesus came to reveal the Father, He also came for more than that. Jesus demonstrated to all of humanity in every epoch of time it is possible to have a love relationship with God the Father. The life of Jesus is a beautiful illustration of what friendship with God in heaven should look like and how to live in daily intimacy with the One who created you.

I have also heard it said Jesus proved that God wasn't mad at us, but He was mad about us. What an amazing thought!

Paul also reminded the Colossians church that Jesus was "the firstborn of all creation." In these five precious yet powerful words, Paul assured the church that not only does Jesus exhibit who God is but also He came to show us who we are meant to be (Colossians 1:15–19).

Jesus was just like God the Father; and we are invited to live just like God the Son. We are the ones alive at this moment in history. We are called to calm people's storms, pray for miracles, and stand in faith for others. Jesus reveals the wonder of human possibility: it is possible for an ordinary man or a common woman to emulate the life of Jesus and to walk in His power. It is possible, indeed. When Jesus lives inside of us, we are meant to be overflowing with His character and goodness.

Neither you nor I will ever live a sinless life as Jesus did, but we are beckoned to live with the indisputable power of the living God.

⌛ *If you could do anything that Jesus did, what would you choose to do?*

A Conversation

Jesus was conversing with His disciples one day, explaining to them the relationship He had with God, His heavenly Father. As He wrapped up this enlightening discussion, I imagine Peter was ready to jump up and give Jesus a high five. Perhaps John was aching to wrap Jesus in a loving embrace, and Thomas may have been scratching his head, wondering if it was all true. And then Jesus said this:

> *"If you had known Me, you would have known My Father also; from now on you know Him, and have seen Him." Philip said to Him, "Lord, show us the Father, and it is enough for us." Jesus said to him, "Have I been so long with you, and yet you have not come to know Me, Philip? He who has seen Me has seen the Father; how can you say, 'Show us the Father'? Do you not believe that I am in the Father, and the Father is in Me? The words that I say to you I do not speak on My own initiative, but the Father abiding in Me does His works. Believe Me that I am in the Father and the Father is in Me; otherwise believe because of the works themselves. Truly, truly, I say to you, he who believes in Me, the works that I do, he will do also; and greater works than these he will do; because I go to the Father." (John 14:7–12)*

With these words, Jesus firmly announced that not only would His disciples do the works He had accomplished such as raising the dead, casting out demons, healing sick people, and multiplying provisions, but also that his disciples would do greater works than He did. You and I are His disciples of the twenty-first century and are called to overflow with the works of Jesus.

Jesus indeed was the firstborn of creation and He bids us to be like Him. We are also petitioned by Him to believe for the greater works. He calls us to be like Him in nature and to join Him in His power. What a marvelous invitation!

⧗ *List three attributes of the character of Jesus:*

1. _____

2. _____

3. _____

⧗ *Now choose one of these attributes to demonstrate in your life.*

LIVING TREASURE

He is the image of the invisible God, the firstborn of all creation. For by Him all things were created, both in the heavens and on earth, visible and invisible, whether thrones or dominions or rulers or authorities— all things have been created through Him and for Him. He is before all things, and in Him all things hold together. (Colossians 1:15–17)

PRAYER

Thank You, Jesus, for coming to earth to reveal the Father to us. Help me to live like You, dear Lord, and to stand in faith for miracles. I want to be just like You in everything I say, think, and do. In Jesus' name I pray. Amen.

WORDS OF WISDOM

We are never more like Jesus than when we are serving Him or others. There is no higher calling than to be a servant.

—Nancy Leigh DeMoss

Day 4

Oh, Yes! He Does

As a little girl, I loved Sunday school, vacation Bible school, and prayer meeting every Wednesday night. I was an active and enthusiastic participant in Bible memorization, in placing my dime into the offering plate as it passed by, and in answering all questions a beloved Sunday school teacher might present. But what I loved most of all was the singing.

Deep and Wide! Deep and Wide!
There's a fountain flowing deep and wide.

My blonde ringlets likely bounced up and down as I sang not only with my voice but with my entire body.

So rise and shine and give God the glory, glory!

But my favorite children's song of all was undoubtedly this one. The repetitive lyrics reminded me that as long as the world was in my Father's hands, I had nothing to worry about.

He's got the whole world in His hands,
He's got the whole world in His hands.
He's got the whole world in His hands.
He's got the whole world in His hands!

Even today, as I cycle those very familiar words through the recesses of my brain, I want to stand up and shout for the world to hear, "Oh, yes! Yes! He does!"

⧗ *What Sunday School song do you hold most dear?*

Everything

For by Him all things were created, both in the heavens and on earth, visible and invisible, whether thrones or dominions or rulers or authorities—all things have been created through Him and for Him. He is before all things, and in Him all things hold together. (Colossians 1:16–17)

God made it all and He has the authority to take care of it all. God is interested in all of creation because He was the One who thought it all up. The creative genius of God conceived of orchids, laughing hyenas, and Niagara Falls. It was God who threw stars into the sky, carved out the Grand Canyon, and created the brilliance of a diamond.

 ☙ *If you think Walt Disney had the market on creativity, think about God!*

 ☙ *If you think that genius who invented Apple computers is someone special, think about God!*

 ☙ *If you think the United Nations holds final authority on everything that happens on this planet, think about God!*

 ☙ *If you think that Edison or Einstein or Jefferson were the smartest men to ever have lived, never forget for one minute that God made them all in His own image.*

This is not the only place in Scripture where the Holy Spirit reminds God's children that He created the entire universe with all its facets, wonder, and beauty.

All things came into being through Him, and apart from Him nothing came into being that has come into being. (John 1:3)

The reason it is important to know that God was behind every minute detail of creation is because Paul was coming against the false teachers of the day. These deceived voices believed the physical world was evil and therefore God could not have created it. They also believed if Christ were truly God in the flesh, He could only have authority in the spiritual world.[12]

Paul clearly explains:

> *For by Him all things were created, both in the heavens and on earth,*
> *visible and invisible, whether thrones or dominions or rulers or authori-*
> *ties—all things have been created through Him and for Him.*
>
> *(Colossians 1:16)*

According to Paul, who received his information from the Holy Spirit, all things are under the authority of Jesus Christ Himself. Christ has no equal nor does He have a rival. He is above all.

⧖ *Would you take time this week to read the Creation story from Genesis 1 and 2? As you read, remind yourself that this account is true and that God is still on the throne.*

The writer of the book of Hebrews also confirmed the creative powers of eternity are manifest in the Godhead.

> *God, after He spoke long ago to the fathers in the prophets in many por-*
> *tions and in many ways, in these last days has spoken to us in His Son,*
> *whom He appointed heir of all things, through whom also He made the*
> *world. And He is the radiance of His glory and the exact representation*
> *of His nature, and upholds all things by the word of His power. When*
> *He had made purification of sins, He sat down at the right hand of the*
> *Majesty on high. (Hebrews 1:1–3)*

He holds all things together under His authority and by His expansive love. We must never ignore the joy of taking a deeply theological scripture such as this one and applying it in a personal and practical sense to our own life. How wonderful to realize the One who holds the universe together is able to hold your life together as well. He will not allow your life to disintegrate or fall apart. You can trust Him with your deepest pain and your greatest need.

⧖ *What area of your life do you need the Lord to "hold together" for you? After you identify that area or areas, write a prayer below inviting the Lord to hold it together for you.*

An Unknown Force

There is a force in atomic structure that holds the atom together. Scientists are unable to identify what this force is or where it comes from. It is one of the great mysteries of modern science. The eternal truth I am about to explain to you is so invigorating and so thrilling, you might want to shout. Even if you are not a scientist, this incredible information will place an exclamation point upon your understanding of this passage of scripture. I am by no means a scientist so I will try to explain it to you in the simplest way possible.

The nucleus of the atom contains positively charged as well as neutral particles. Between the like-positive protons there is a mutual electrostatic repulsion. This repulsion would drive the nucleus apart were it not for the "strong force" that continuously binds the nucleus together.

Plainly stated there is an active and monumental force imposed on the molecules of the universe that energetically binds the atoms of the material world together. This force never diminishes, nor does it wane. It is a perpetual, unexplainable force that holds the world together every moment of every day of every year of every century. Are you astonished yet?

The mystery of this unseen and unknown force is also observed in the accelerated electrons that circle the nucleus. These lively electrons in actuality should rapidly radiate all their energy away and then fall into the nucleus unless there exists an invisible energy source to counteract this.[13]

He is before all things, and in Him all things hold together.

(Colossians 1:17)

Based on our understanding of Colossians 1:17, we can make an educated and wise guess as to what the unseen force is which holds the universe together. It is surely Jesus! He holds this universe together with His power. Secular scientists may grumble and disagree, but you and I know what they might ignore: the Bible is the source of all truth. If the Bible states Jesus holds all things together, then it is sure and certain truth.

⏳ *Why is it important to believe that God created the world? We may have differing ideas about the time it took to create the world as we know it and how it exactly came into being, but believing that God holds creative powers over everything is a vital part of our faith. Why is that?*

LIVING TREASURE

He is the image of the invisible God, the firstborn of all creation. For by Him all things were created, both in the heavens and on earth, visible and invisible, whether thrones or dominions or rulers or authorities— all things have been created through Him and for Him. He is before all things, and in Him all things hold together. (Colossians 1:15–17)

PRAYER

I thank You today, Lord Jesus, that You are holding my life together. I declare that You are the Head of my life and I will joyfully give you first place in everything. In Jesus' name I pray. Amen.

WORDS OF WISDOM

He is the heir of all things, Lord of all lords, head of the church, firstborn of the new creation. He is the way to God, the life of the believer, the hope of Israel, and the high priest of every true worshiper. He holds the keys of death and hell and stands as advocate and surety for everyone who believes on him in truth. Salvation comes not by accepting the finished work or deciding for Christ; it comes by believing on the Lord Jesus Christ, the whole, living, victorious Lord who, as God and man, fought our fight and won it, accepted our debt as his own and paid it, took our sins and died under them, and rose again to set us free. This is the true Christ; nothing less will do.

—A. W. Tozer

Day 5

The Father's Good Pleasure

When our children were growing up, we made it a well-loved practice to visit different types of church services. Although my husband was a pastor and we were all involved in the worship service at our own church, we found creative ways to visit various denominations with different expressions of worship. We were able to visit a Saturday evening service at a Roman Catholic church, and on Wednesday nights we went to a Bible study at a Baptist church or a prayer meeting at a Pentecostal church. When my husband had a rare Sunday off, we attended an African Methodist Episcopal Church or a Church of God in Christ. Oh! How we loved those lively services!

As we drove home from those various churches that expressed their love for Jesus in vastly different ways, I invariably asked my children what they noticed at each church. It was always a delight to me when one of the children would notice, "They loved Jesus like we do."

⧖ *Is the name of Jesus honored at your church?*

⧖ *Is the Bible regarded as eternal truth at your church?*

All believers, regardless of preference of the expression of worship, should find unity in the Lordship of Jesus Christ. In Colossians 1:18, Paul lists four

decisive characteristics of Jesus that should be evident in each one of our lives regardless of denominational choice.

> *He is also head of the body, the church; and He is the beginning, the first-born from the dead, so that He Himself will come to have first place in everything. (Colossians 1:18)*

The Head

Paul informs the struggling church at Colossae that Jesus is the *"head of the body."* The Supremacy and Lordship of Jesus includes His authority in the church. Paul is not merely referring to the church you attend every Sunday morning, but he is attributing this power to the worldwide church that is known as "the body of Christ."

Every organization must have a leader who sends messages, casts vision, makes decisions, and leads the corporation into a healthy and vital existence. Jesus is the ultimate leader of the church, and as such, He is our head.

In the human body, the brain is located in the head; the head brings together all forces of the body. The head is the seat of life; it energizes the body and gives life and power to all body systems and parts. So it is with Jesus Christ and His body, the church. In Jesus, we discover abundant life, power, and function.

⧗ *What does it mean to you that Jesus is the Head of the body of Christ?*

Let's Start at the Beginning

> *He is also head of the body, the church; and He is the beginning, the first-born from the dead, so that He Himself will come to have first place in everything. (Colossians 1:18)*

Paul reiterated the magnificent fact that Jesus Christ is the beginning. Nothing existed before Jesus; He started it all and is the page upon which history is written. John, the beloved disciple, also gave confirming truth:

> *In the beginning was the Word, and the Word was with God, and the Word was God. He was in the beginning with God. All things came into being through Him, and apart from Him nothing came into being that has come into being. In Him was life, and the life was the Light of men.*
> *(John 1:1–4)*

Jesus is the source of all that is good, true, and right. There would be no joy without Jesus because He is the spring of joy. If you long to live a life of peace, it all begins with trusting Jesus who is the Prince of Peace. Every resource you desperately yearn for is found in Jesus; He is the starting block for fulfillment, purpose, love, hope, and power. James, the half-brother of Jesus, reminded the early church where good gifts came from:

> *Every good thing given and every perfect gift is from above, coming down from the Father of lights, with whom there is no variation or shifting shadow. (James 1:17)*

It is because of Jesus that anyone can discover the joy of being a Christian. He is the beginning of the church because of His resurrection from the dead.

⧗ *What does it mean to you that Jesus is the beginning of all that is good?*

The Firstborn

> *He is also head of the body, the church; and He is the beginning, the firstborn from the dead, so that He Himself will come to have first place in everything. (Colossians 1:18)*

Paul has already taught that Jesus is the firstborn of creation (verse 15), and now he informed the Colossian church that Jesus is the firstborn from the dead. Jesus died first so you could live eternally with Him. He died first so you would not have to experience the sting of death. The death of Jesus paved a glorious way for you to spend eternity in heaven.

Jesus is the only person who rose from the dead and never died again. Others in the Bible, such as Lazarus, rose from the dead but eventually died a physical death. Without the resurrection of Jesus from the dead, there would be no resurrection to new life for you and me.

> *But now Christ has been raised from the dead, the first fruits of those who are asleep. For since by a man came death, by a man also came the resurrection of the dead. For as in Adam all die, so also in Christ all will be made alive. (1 Corinthians 15:20–22)*

⧖ *What does it mean to you that Jesus is the firstborn from the dead?*

Eternally First

> *He is also head of the body, the church; and He is the beginning, the firstborn from the dead, so that He Himself will come to have first place in everything. (Colossians 1:18)*

First place will always go to Jesus Christ; He will never lose a battle, He will never die, and the devil is always under His nail-scarred feet. Jesus always wins and we who love Him follow Him in triumphant procession.

> *But thanks be to God, who always leads us in triumph in Christ, and manifests through us the sweet aroma of the knowledge of Him in every place. (2 Corinthians 2:14)*

The divine plan has always been Jesus. When Adam and Eve sinned in the garden of Eden, God didn't throw His holy hands up in the air and cry, "Now what should I do?"

Jesus has always been in the heart of the Father and He has always been the victorious plan for humanity.

> *Being found in appearance as a man, He humbled Himself by becoming obedient to the point of death, even death on a cross. For this reason also, God highly exalted Him, and bestowed on Him the name which is above every name, so that at the name of Jesus* EVERY KNEE WILL BOW, *of those who are in heaven and on earth and under the earth, and that every tongue will confess that Jesus Christ is Lord, to the glory of God the Father (Philippians 2:8–11)*

Perhaps we should consider the following translation of this stunning verse in Colossians:

> *And He is the head of the body, the church, who is the beginning, the firstborn from the dead, that in all things He may have the preeminence.*
> *(Colossians 1:18 NKJV)*

When God wrote human history, it was always His magnificent plan for Jesus to be the main character in every chapter, on every page, and in every sentence. Jesus is the Champion and the Victor; He is the King of Glory and the Prince of Peace. No one is His equal and He is supreme in all respects.

⧗ *What does it mean to you that Jesus is preeminent or supreme?*

Who Is Jesus to You?

Now that we know who Jesus is, it's time to make it personal in your life. Who is Jesus to you?

He is also head of the body, the church; and He is the beginning, the first-born from the dead, so that He Himself will come to have first place in everything. (Colossians 1:18)

Jesus is your Head. You should not make a decision without consulting your Head; you should not speak without consulting your Head. You should not make plans without consulting your Head, and you certainly should not spend money without consulting your Head.

Jesus is your Beginning; it is vital to acknowledge the fact that you would not exist without His plan and His love. He holds your life together. Jesus begins every good work in your life, and He is your source for joy, wisdom, peace, and hope.

Jesus should always have first place in your life. In every decision you must place Him first. Decisions should not be made based upon your emotions or even your desires but should honor Him completely.

Jesus is in charge of every day of your life. Every decision—both large and small—should be based upon His strategy in the Word of God.

⧗ *Write your name in every blank below:*

Jesus is the Head of _____.

Jesus is the Beginning of _____.

Jesus died so that _____ could live!

Jesus has first place in _____'s life.

First Place in Everything

Would you linger with me for a moment more over the last phrase in this staggering verse?

So that He Himself will come to have first place in everything.
(Colossians 1:18b)

I wonder if some of the items on your "everything" list might look different than mine. As I evaluate who I am, what I treasure, as well as what my weaknesses might be, I realize these are the issues or habits in which I still need to give Jesus first place:

- Emotional responses
- Family
- Eating
- Spending habits
- Thought life
- Discipline with time

I must remind myself daily that I can trust Him to do what is best in my life; I must also remind myself to surrender the things I hold most dear. Jesus is interested in every area of my life and has only good plans for me. I must let go of my control until I willingly and joyfully give Him first place in everything.

⧗ *What challenging habits or attitudes are on your "first place" list?*

1. _____

2. _____

3. _____

4. _____

5. _____

The Heart of the Father

Whenever the Bible references the pleasure of God, it is a wise idea to take note and to understand what brings pleasure to the heart of the Father.

> *For it was the Father's good pleasure for all the fullness to dwell in Him.*
> *(Colossians 1:19)*

The Father enthusiastically gave to Jesus the fullness of His power. It never ceases to amaze me that this one intentional decision brought pleasure to God. As I have prayed over this passage, wondered over it, and wrestled with it, there has been a relentless question that has utterly consumed me: Why was it the Father's good pleasure for all the fullness of the Godhead to dwell in Jesus?

I have read commentaries trying to resolve this dilemma and spoken with theologians and pastors. Although some of their responses were riveting and even wise, nothing satisfied the conundrum in my soul. I've asked myself again and again and again, "Why was it the Father's good pleasure for all the fullness of the Godhead to dwell in Jesus?"

Can I be honest about this quandary that paralyzed me for months? Early one morning, I heard the voice of the Holy Spirit whisper to me, "Carol, you have asked everyone else, but you haven't asked me yet."

After I repented, I humbly asked, "Holy Spirit, why was it the Father's good pleasure for all the fullness of the Godhead to dwell in Jesus?"

The answer I was given certainly brought substantial peace to my soul, and I believe it will to yours as well. The sweet Holy Spirit, who is the most fabulous teacher in all of eternity past and in all of eternity yet to come, patiently and kindly responded, "The Father gave Jesus the fullness of His power and authority so that Jesus could bring it to you."

Jesus brought the fullness of heaven as well as the fullness of God the Father to earth and He gave it to us. Could there be anything more wonderful than that?

God desired His completeness to live permanently in Jesus Christ. Paul was endeavoring to explain to the church at Colossae that Christ is indeed God's dwelling place. Every aspect of God the Father dwells in Jesus Christ the Son. Christ is able, then, to ultimately reveal all the characteristics and undertakings of God to His children. Christ has always been God and will always be God.[14] All of God dwells in Jesus, His Son; this includes God's attributes, His nature, His power, His design, His love, His glory.

⏳ *Why do you believe it was the Father's good pleasure for all the fullness to dwell in Christ Jesus?*

There Is More

My friend, as we conclude this staggering week of study, I hope you will always remember the truth, wisdom, and hope we studied in these early verses of Colossians:

- ☙ *No matter how wonderful your life is, there is more! Infinitely more!*

- ☙ *No matter how terrible your life might be, God has not forgotten you. You are on His mind and in His heart.*

- ☙ *God has a plan for your life just as He does for atomic structure. We must not limit the Lord with our small thinking or underestimate Him because we don't understand Him. We simply must know Him.*

- ☙ *We are called to be fruitful Christians during the difficult days in life.*

- ☙ *When you don't know what to do, joyously give thanks and give Him first place in everything!*

⧗ *Is there anything else you learned this week you would like to add to my list?*

1. _____

2. _____

3. _____

LIVING TREASURE

He is the image of the invisible God, the firstborn of all creation. For by Him all things were created, both in the heavens and on earth, visible and invisible, whether thrones or dominions or rulers or authorities— all things have been created through Him and for Him. He is before all things, and in Him all things hold together. (Colossians 1:15–17)

PRAYER

Jesus, today I declare that I will give you first place in everything, and I promise not to take it back into my own hands. Father, I thank You that it

was Your pleasure to give Your fullness to Jesus so that He could bring it to earth and give it to me. In Your wonderful name I pray. Amen.

WORDS OF WISDOM

To be filled with God is a great thing, to be filled with the fullness of God is still greater; to be filled with all the fullness of God is greatest of all.

—Adam Clarke

Week 3

The Mystery Is Solved

Day 1

A Do-Over

Everybody has a "just one thing." A "just one thing" describes one's value systems and passions; your "just one thing" is likely your first thought in the morning and your last thought at night. Your "just one thing" is different than mine because we are different people with varying interests and contrasting personalities. I can assure you that my "just one thing" truly is the unrivaled focus of my life. My "just one thing" is that I love the Bible.

I am head over heels in love with the Bible—with every page, every word, every chapter, and every verse. Because of my deep and vibrant love affair with Scripture, my passion in life is to help the women of my generation love the Bible as much as I do or maybe even more.

On the sacred pages of Scripture, there is no exaggeration, no mere hypothesis, nor are there any random thoughts. Every word of Scripture is eternally true. The Bible is powerful; it holds more power than an atomic power plant, than the cure for cancer, or than the media gurus of the twenty-first century think they hold.

The Bible has the power to heal your heart and to change you from the inside out. As I read the Bible, I can assure you it never fails to make a resounding difference in my life. The Bible is a healing balm to bad attitudes and to festering emotional wounds.

> *Then they cried out to the Lord in their trouble;*
> *He saved them out of their distresses.*
> *He sent His word and healed them. (Psalm 107:19–20a)*

The Bible offers direction to confused travelers and points toward a healthy destination in life.

> *Your word is a lamp to my feet*
> *And a light to my path. (Psalm 119:105, emphasis added)*

One of the aspects I love passionately about the Bible is it causes me to inspect difficult things and contemplate that which I don't understand.

The Bible invites me to remove my focus from my on self-centered ways and to set my mind on things above. Later in the book of Colossians, Paul teaches of this eternal truth:

> *Therefore if you have been raised up with Christ, keep seeking the things above, where Christ is, seated at the right hand of God. Set your mind on the things above, not on the things that are on earth. (Colossians 3:1–2)*

I will admit, there are times when my brain aches after meditating on a passage of scripture, but I can also quickly say that it is a "good" ache.

Perhaps I have just described your experience as you study the book of Colossians with me. We are studying difficult concepts and challenging theology in this letter Paul wrote to the church at Colossae. Although our brains may be aching with thoughts and ideas ricocheting off the canyons of our brains, our spirits should be leaping! We are learning more about God the Father, about Jesus Christ the living Lord, and about that wonderful and mighty Holy Spirit through this intentional study of His Word.

⧗ *What is your "just one thing" that defines your value system and passions?*

Re-Created

As we begin the next series of verses, it is essential to include the verse we ended with last week. You will understand why we must review as you read this stirring passage.

> *For it was the Father's good pleasure for all the fullness to dwell in Him, and through Him to reconcile all things to Himself, having made peace through the blood of His cross; through Him, I say, whether things on earth or things in heaven. (Colossians 1:19–20)*

One of the infinite number of accomplishments observed in God the Father is that He is the member of the Godhead who creates. By the power of His Word, He threw the sun, moon, and stars into the sky. He separated the land from the water and brought into existence deserts, canyons, and mountain ranges. His genius spawned emeralds, bunny rabbits, and hyacinth.

The Father is the Creator and, according to Paul in this passage, the Son is the member of the Godhead who reconciles. The Greek word *apokatallasso* is translated as "reconciles" in this strategic verse. *Apokatallasso* can also be translated "to reconcile completely, to reconcile back again, to bring back to a former state of harmony." As you read the various meanings of this Greek word, perhaps you will realize an amazing aspect of this ancient word as I have. The Father *created* and the Son *re-created*; isn't that remarkable? Jesus Christ brought God's children back into relationship with Him; Jesus recreated the way for humanity to reach God the Father.

The death of Jesus Christ on the cross of Calvary made it possible for you and me to rekindle our intimate friendship with God. When Jesus shed His powerful blood, the war stopped and a peaceful relationship was recreated.

⧗ *List three words that describe your relationship with God the Father:*

1. _____

2. _____

3. _____

⧗ *Why is "the blood of His Cross" (verse 20) so important to the Christian?*

A Second Chance

Do you remember when you were just a child playing games in your yard with the neighborhood kids? I recall playing hopscotch and kickball and jumping rope for hours every day after school.

One of my most vivid childhood memories is of playing kickball with a friend named Rich in his front yard. Although we were the same age, almost

to the day, he was taller than I was, stronger than me, and definitely more athletic. Whenever Rich didn't like the direction he kicked the ball, or thought he could have run faster, he yelled, "Do-over!" When he did that, it was understood that he could take an extra turn. I loved being on Rich's team because I knew that his team would always win.

I never felt brave enough to shout, "Do-over!" I always felt as if I didn't deserve a second chance because I wasn't as coordinated or as athletic as the others in my neighborhood. I always thought I should just take what I deserved. I was usually called "out" at first base.

My friend, regardless of what you deserve or don't deserve, you have been given a do-over by the One who knows you best and loves you most. You have been granted the grandest do-over in all of eternity past or all of eternity yet to come.

The glory of it all is that you weren't required to yell, "Do-over!" You were not the one who had to determine if you deserved a second chance or not. It was decided for you.

Jesus looked at your life from the cross and cried, "Do-over!" He shouted it loud enough for Satan and all his ugly little demons in hell to hear. Jesus yelled it loud enough for heaven to applaud in awestruck wonder.

What God created in the garden of Eden, Jesus re-created on the cross of Calvary. The Father knew you in your mother's womb and wept for joy at your first birth. Jesus made a way for you to be born again and to live a life free of bondage and shame.

> ⏳ *If you could have a do-over concerning one event or one decision of your life, what would it be?*

⧗ *Now, can you surrender that decision to Jesus? Write a prayer below as you ask the Lord to work your mistake together for good.*

Confused No Longer

The Greeks of Paul's time argued that no one could be fully divine and fully human simultaneously.[15] Paul contested that Jesus was indeed fully God and fully man. Furthermore, Paul reminded this confused church that because Jesus lived in human flesh yet never sinned, He could clearly die for the sins of the world. Paul was making a case against the false teachers who had infiltrated the church at Colossae.

> *For it was the Father's good pleasure for all the fullness to dwell in Him, and through Him to reconcile all things to Himself, having made peace through the blood of His cross; through Him, I say, whether things on earth or things in heaven. (Colossians 1:19–20)*

Paul is further stating the not only was Father satisfied when He bequeathed all His power to Jesus, but also it brought him pleasure when His Son re-created our relationship with the Father. The death of Jesus paved the way for sinful men to return to an eternal and loving friendship with God the Father.[16]

This re-creation enacted by the death of Jesus on the cross and the resurrection of His earthly body was not limited to humanity's relationship with the Father. Not only was sinful man brought back into a right relationship with God, but so did the created order share in the fruit of this absolute work of the cross.[17]

⧗ *Go back to Colossians 1:15 in your Bible and each time you see the phrase "all things," underline it. How many times did you see it? _____*

We can be sure because of the life, death, and resurrection of Jesus Christ, *all things* have been reconciled to God the Father. Relationships can be made

right, health can be restored, finances can be re-created when we submit our will and our way to the One who made us and loves us with an everlasting love.

⌛ *Who or what requires reconciling in your world? List those things below:*

1. _____

2. _____

3. _____

4. _____

5. _____

LIVING TREASURE

That is, the mystery which has been hidden from the past ages and generations, but has now been manifested to His saints, to whom God willed to make known what is the riches of the glory of this mystery among the Gentiles, which is Christ in you, the hope of glory. (Colossians 1:26–27)

PRAYER

Jesus, You truly are the sweetest name I know. Thank you for reconciling me to God the Father. I pray now, in Your mighty and holy name, that all things in my life and under my sphere of influence would be reconciled to Your will and Your way. Amen.

WORDS OF WISDOM

We need never shout across the spaces to an absent God. He is nearer than our own soul, closer than our most secret thoughts.

—A. W. Tozer

Day 2

Jesus Depends on You

One of my benign addictions in life is to look through old pictures and dusty photo albums from long ago. I laugh at old hairstyles, shake my head at the length of my skirts, and wonder where that girlish figure went. Honestly, as I observe the old me through the decades, I simply wonder, "What in the world was I thinking?" Often, I don't like what I see. Can anyone else relate?

Paul is about to open a photo album of who we used to be before Christ "recreated" us. I need to warn you before we digest these next few scriptures, you might not like what you see.

⧗ *When you look at old pictures of yourself, what are some changes you notice in your physical appearance?*

⧗ *What are some changes that have happened internally since those pictures were taken?*

A Vivid Picture

And although you were formerly alienated and hostile in mind, engaged in evil deeds. (Colossians 1:21)

Paul begins this passage of scripture by describing who we used to be and what we used to spend time doing. The verb tense Paul intentionally chose established the undebatable fact that those actions are over; this lifestyle will never again be part of who you are in Christ.

Because of the marvelous and magnificent "do-over," you will never again be alienated from Jesus Christ. You have been reconciled and re-created in Him; nothing will ever keep you away from God the Father again.

Paul, by the unction of the Holy Spirit, states, before Christ, we were hostile in our minds toward God. This ugly phrase implies those thoughts kept us in a civil war with God. We, by our former actions and horrible thoughts, chose to be an enemy with the One who created us and loved us with an everlasting love.

Now, because of the radical reconciliation, we have been given the mind of Christ and have the propensity to think the very thoughts of God Himself. Paul reminded us of this glorious possibility in his letter to the church at Corinth:

But we have the mind of Christ. (1 Corinthians 2:16)

We must not ignore the civil war that was being fiercely fought in the battlefield of our minds. Jesus died in that war and He reconciled us to Himself. Even though we were on the losing team, He, by His forgiveness and His blood, transferred us to the winning team! I just want to stand up and cheer; don't you?

We were formerly engaged in evil and despicable deeds. We chose, by our own volition, to participate in actions that instigated fierce pain, unbelievable stress, and unnecessary hardship. The blood and power of Jesus Christ has washed away the pain, stress, and hardship. Even if we choose to once again participate in sin, we can run to the Father, where we find forgiveness and grace. Our actions are now and forever washed away by the blood of Jesus. Sin no longer has power over us because Christ has overpowered our sin.

Many of us continue to wrestle with sin that periodically knocks on the door of our heart or forces entrance into our thought life. We know we have been redeemed and forgiven, yet there are certain behaviors or attitudes that rear their ugly heads in our weakness. As we battle these unwelcome transgressions, we must continuously return to the heart of the Savior. We must remind ourselves daily that when we are weak, He is strong in us.

Therefore I am well content with weaknesses, with insults, with distresses, with persecutions, with difficulties, for Christ's sake; for when I am weak, then I am strong. (2 Corinthians 12:10, emphasis added)

⧗ *What one sin still torments you even though you have been reconciled?*

⧗ *Write out a prayer below asking God to give you the power to walk away from that sin.*

Welcome Home

Yet He has now reconciled you in His fleshly body through death, in order to present you before Him holy and blameless and beyond reproach. (Colossians 1:22)

Your relationship with your loving heavenly Father has been restored regardless of what evil deeds you formerly engaged in. It doesn't matter how angry and hostile you used to be toward Christ. It doesn't matter how far you had alienated yourself from the God who loves you. It doesn't matter.

We were the ones who broke fellowship with the Father, and yet Jesus, God's Son and our elder brother, invited us to come home. We ran away from the safety of God's arms, and Jesus relentlessly pursued us. We spit in the face of God, and Jesus wiped it all away. We pushed God away, but Jesus pulled us back. Even though there were many times when we didn't want God, He has always wanted us.

Although we used to be alienated, now we are holy. We were formerly known for our hostility, but now we are known as blameless. We used to engage in evil deeds, and yet now the Father sees us as beyond reproach. What a wonderful change has occurred in our lives—all because of Jesus.

⌛ *How did God reconcile us to Himself according to this passage?*

It's Important

You might wonder why it is important to know what it means to be reconciled and that we are the beneficiaries of this marvelous action. I believe the following passage, also written by Paul, will help you to understand its precedence:

> *Now all these things are from God, who reconciled us to Himself through Christ and gave us the ministry of reconciliation, namely, that God was in Christ reconciling the world to Himself, not counting their trespasses against them, and He has committed to us the word of reconciliation. Therefore, we are ambassadors for Christ, as though God were making an appeal through us; we beg you on behalf of Christ, be reconciled to God (2 Corinthians 5:18–20)*

You were reconciled to become a reconciler. Jesus depends on you to be His representative of reconciliation on earth during your life span. Although the reconciled will spend eternity in heaven with God the Father and with Jesus the Son, we don't want to go alone. We long to ensure that our children, family members, high school friends, neighbors, and even those we have not met yet have been reconciled through Jesus to God. Perhaps the reason you are still alive today is to make hell smaller and heaven bigger.

⌛ *Has God given you the responsibility of being a reconciler to some in your world? Make a list of five of those people below:*

1. _____

2. _____

3. _____

4. _____

5. _____

⌛ *Now, beside each of their names, write a possible way you could approach them and share your faith. A coffee date? Invite the person to church? Send a heartfelt letter? Invite them into your home for a meal? Ask the Holy Spirit to show you how to approach each person.*

LIVING TREASURE

That is, the mystery which has been hidden from the past ages and generations, but has now been manifested to His saints, to whom God willed to make known what is the riches of the glory of this mystery among the Gentiles, which is Christ in you, the hope of glory. (Colossians 1:26–27)

PRAYER

Jesus, I praise you today that I have been reconciled and welcomed into Your marvelous family. I pray You will give me the courage and the boldness to be a reconciler with those in my life. In Jesus' name I pray. Amen.

WORDS OF WISDOM

There can be no peace between you and Christ while there is peace between you and sin.

—C. H. Spurgeon

Day 3

The Big "If"

I've never really liked the word *if*. It's a wishy-washy word and yet certain issues in life seem to depend upon its instability. Let me explain my internal obstinacy to this perfectly conditional word.

- ☙ *You can go to your friend's house IF you do your homework first.*
- ☙ *You will feel good about yourself at your class reunion IF you lose twenty pounds first.*
- ☙ *You will be considered a wonderful wife IF you clean your house and cook three meals a day.*
- ☙ *You will be chosen for the position IF a committee of people who don't know you decide you are qualified.*

Do you see what I mean? Sometimes the word *if* can be a "sick-to-your-stomach" kind of *if*.

Human Nature

Paul was well-acquainted with human nature and therefore realized not every believer in Christ would hold fast to the Word of truth. In this next passage, we will read about the awful "sick-to-your-stomach" kind of *if*.

> *If indeed you continue in the faith firmly established and steadfast, and not moved away from the hope of the gospel that you have heard, which was proclaimed in all creation under heaven, and of which I, Paul, was made a minister. (Colossians 1:23)*

Paul knew some of those who had been reconciled would likely move away from the hope of the gospel.

⧗ *Do you know of any person who once was a committed Christian and then moved away from the truth of the gospel? If so, write their name below and spend some time in prayer for this person.*

I have a dear childhood friend who was a dedicated believer in Jesus Christ throughout her childhood years and continued to live for the Lord all during high school. When she went to college, she held Bible studies and prayer meetings in her dorm room. Now, she lives an alternate lifestyle and worships other gods. She is in a very dark place, and I pray for her daily.

I often have wondered how this happens in the life of a believer. How does a person who loved Jesus enthusiastically decide to walk away? Paul, in his letter to the church at Colossae, warns there will be those who no longer adhere to the hope of the gospel. Although I do not have an answer to the "why" of this dilemma, I can assure you the Holy Spirit is relentlessly pursuing these dear ones.

⧗ *Since you have already prayed for the person who has walked away from his or her sincere faith, now ask the Lord to show you how you can be a loving witness in his or her life. Write some ideas below:*

1. _____

2. _____

3. _____

Not Me

I am wholly dedicated to Jesus Christ and daily I long to guarantee I will not be one of those who are tempted to walk away from my first love—Jesus Christ. Perhaps you, like me, desire that same insurance and therefore you declare, "No matter what storm I go through, regardless of how I am treated at church, even when I walk through a horrific fire in life, I will cling to my faith in Jesus Christ." I yearn to have the assurance that I will not fall away, and I will not be moved regardless of what happens in my life.

There are a few disciplines, when incorporated into the life of a Christian, that will give the assurance of a solid foundation and a solid faith that will not be moved. Our faith must be firmly established so we are steadfast when the storms of life rage and the winds of life blow.

⧗ *Have you ever been tempted to walk away from the Lord? Why did you decide to stay in your faith or perhaps come back to your faith?*

Firmly Established

Over the years, I have incorporated a few disciplines into my Christian walk that have anchored me through every storm and windy gale. If these habits have safeguarded me, they will do the same for you.

The first and primary discipline is to read your Bible daily. If you miss a day, please do not let that day become two days, a week, or even a month. If you do neglect to read your Bible due to busyness or forgetfulness, pick it right back up the next day. The most encouraging and beautiful moments of your day always are found in reading the sacred pages of Scripture.

I also hope you faithfully attend a church where the Word of God is honored and preached enthusiastically, where worship is heartfelt and sincere, where missionaries are supported, and where children are loved. There is nothing—this side of heaven—like a joyful, peaceful, missional, loving church.

I always encourage both men and women to attend a weekly Bible study. The Bible study can be small or large in attendance, but it must be a place where Scripture is studied verse by verse, where questions are welcomed, and where community is warm.

Do you have a mentor or someone to whom you go with your questions? Discipleship is a must for the body of Christ. We all need someone who is more mature in the faith and whose wisdom will enhance our walk in Christ.

My faith is solidified by reading books rich in theology by men and women who are recognized leaders in the body of Christ. I choose books that make the Bible come alive and that encourage me to live enthusiastically for Christ

during my tenure on earth. I read Christian books that tackle difficult subjects and are written from a biblical worldview.

⌛ *Is there another discipline you have incorporated into your life that has helped you to build a firm foundation of faith?*

⌛ *What is the most meaningful Christian book, other than the Bible, you have ever read? Why don't you buy an extra copy of it this week and give it to someone who needs encouragement.*

It's Up to You

Jesus has reconciled you to God the Father, but you are the one who chooses to be firmly established in your faith. If your faith is weak and you find yourself wavering with doubts and discouragement, it is not God's fault, your pastor's fault, or your parents' fault. We all choose how deeply we will go into the soil of our faith. It's an individual choice to read your Bible or not, to go to church or not, to attend Bible study or not, to have a mentor or not, and to read great books or not. You choose if and how you will fan the flame of your faith. One great truth I have learned along the pathway of my faith journey is this: you will find more joy and stability the deeper you go.

⌛ *Why do some people choose to go deep in their faith while others are content with a shallow faith?*

⧗ *What could you do to go deeper in your faith?*

⧗ *Why?*

Now I rejoice in my sufferings for your sake, and in my flesh I do my share on behalf of His body, which is the church, in filling up what is lacking in Christ's afflictions. (Colossians 1:24)

How do we explain suffering to a world in pain? This simple yet complicated thought consumes my heart and mind. I think about it nearly every day and ask the Holy Spirit to give me wisdom as I minister to women whose lives have been torn apart by trauma and horrific circumstances. I have realized that the greatest theological minds of the ages don't agree on why the beloved children of God must suffer.

 ᗧ *Why do mothers die and leave their children as orphans?*

 ᗧ *Why do parents lose their beautiful children to early death?*

 ᗧ *Why are men unfaithful to their wives?*

 ᗧ *Why do the good die young?*

 ᗧ *Why do bad things happen to good people?*

 ᗧ *Why are women and children abused?*

These and other questions have tormented me year after year in my Christian walk. I have watched a young man, married for only nine months, succumb to cancer, leaving behind a broken-hearted bride. I have held the shaking

hands of sobbing mothers whose children have died in their infancy. I have stood by friends who have valiantly battled cancer, lupus, and heart disease.

I have finally found a measure of peace in a three-word answer to the question, "Why do the beloved children of God suffer?" My answer is this: I don't know.

I don't know why there is such appalling pain this side of heaven's shores. But I do know this: there is a perfect place and we are going there someday. I also know suffering is not a punishment; rather it conforms us to the very image of Christ.

That I may know Him and the power of His resurrection and the fellowship of His sufferings, being conformed to His death (Philippians 3:10)

I also know when a saint suffers, God weeps. When a child dies, God holds the little one in His loving and eternal arms. Where there is pain and agony, the presence of God is sure and strong.

⧖ *What is the worst experience you have ever gone through in life?*

⧖ *What did you learn from this experience?*

The Benefits of Suffering

There have been times when I have been afraid to talk about suffering, somehow believing that if I ignored it, suffering wouldn't come toward me. However, after suffering from years of depression, infertility, and then cancer, I have now identified the blessings that are mine when I suffer.

Suffering is an opportunity to worship the Lord sincerely and fervently. Worship is the purest and the most heartfelt at the very worst moment in a Christian's life. If we only rejoice when our lives are easy, our relationships are in order, and our finances are abundant, that is not true worship; that type of rejoicing might be categorized as thanksgiving. Our instinctive reaction to suffering and hardship should be a song of genuine joy and praise. The intentional choice to worship the Lord when one's world has fallen apart, is a theme throughout the pages of Scripture. From Genesis to Revelation, God's people have had to make this determinant:

⅓ *Will I worship, or will I wail?*

⅓ *Will I bless the Lord, or will I blame the Lord?*

⅓ *Will I glorify His name, or will I gossip?*

The second benefit of suffering is that it places us in deeper fellowship with Christ. Suffering comes with a beautiful invitation, likely engraved with His blood.

> **You are lovingly invited**
> **To come closer to Me**
> **While you are suffering.**

Pain often serves as the calling card of Jesus when we are invited into His presence where there is always fullness of joy. Pain also serves as a fertilizer for growth and strength. I know I would not be the woman I am today were it not for the suffering I have gone through and grown through.

I can assure you although I would never choose to experience infertility, depression, or cancer again, those three dark and terrifying times in my life ushered me into His presence in a fresh and even exciting way.

Surely the third benefit of suffering is we become more like Jesus. We are conformed into His image as we rest in His care and drink of His cup. Suffering is often the fire that burns away my weak flesh and then polishes His reflection in my life.

LIVING TREASURE

That is, the mystery which has been hidden from the past ages and generations, but has now been manifested to His saints, to whom God willed

to make known what is the riches of the glory of this mystery among the Gentiles, which is Christ in you, the hope of glory. (Colossians 1:26–27)

PRAYER

Jesus, I don't want to suffer, but I do want to be more like you. I pray today You would confirm, strengthen, and establish my faith. In Your wonderful name I pray. Amen.

WORDS OF WISDOM

For many of us, the great danger is not that we will renounce our faith. It is that we will become so distracted and rushed and preoccupied that we will settle for a mediocre version of it. We will just skim our lives instead of actually living them.

—John Mark Comer

Day 4

A Mystery and a Miracle

My stepfather, whom I love dearly, loves breathtaking, heart-stopping mystery novels. He met my widowed mother online at seventy-two years old, and they have been happily married for sixteen years. Leo always has his reader in his hands and invariably is reading a "who-done-it." This man who spent his life as an engineer working on projects around the world is not a casual reader, but he generally reads three to five books a week. Whenever I visit their cozy little Pennsylvania home, he is sitting in his big green chair reading a suspense novel from about 10:00 a.m. to 10:00 p.m. Mom and Leo do, of course, take a short break during the day to go to one of their favorite restaurants.

I've never really been a fan of mysteries; my blood pressure soars and my heart shakes with adrenaline if there is the tiniest bit of tension or uncertainty between the pages of a chosen book. A mystery is something that needs either solving or explaining, and I like all my books to follow a sweet pathway strewn with roses, music, and laughter.

⧗ *What types of books do you like to read?*

Solved

There is, however, one mystery that makes my heart quake for joy and my eyes shine wide with wonder. This mystery is explained in the following passage:

> *Of this church I was made a minister according to the stewardship from God bestowed on me for your benefit, so that I might fully carry out the*

preaching of the word of God, that is, the mystery which has been hidden from the past ages and generations, but has now been manifested to His saints. (Colossians 1:25–26)

The mystery that has plagued the universe for ages has finally been solved in the kingdom of God. No longer does the conundrum of life, eternity, sin, and shame frustrate humanity at every turn in life. Now that the paradox no longer lingers, we have been given vibrant hope, inexpressible joy, and the peace that passes all understanding. The riddle has been answered and we have been given the promise of abundant life on earth and eternal life in heaven. We are able to live exuberantly in the worst of human situations and to walk confidently in meaning and purpose all because of Jesus.

The mystery has been revealed and His name is Jesus—the name above all names.

To whom God willed to make known what is the riches of the glory of this mystery among the Gentiles, which is Christ in you, the hope of glory.
(Colossians 1:27)

From the garden of Eden to the garden of Gethsemane, God had been working out His plan. From Creation to Calvary, there was no panic in heaven but a strategic and intentional plan conceived in the heart of the Father. God's majestic design to deal with sin, death, and separation was birthed in the heart of the Father because of love. The glorious strategy waiting for the fullness of time had your name written on it.

God's plan for salvation was Christ in you—the hope of glory.

The Father's divine design for reconciliation was Christ in you—the hope of glory.

His joyous strategy to give you strength to deal with suffering was Christ in you—the hope of glory.

Nothing is hopeless any longer because Christ now lives in you, and He is your hope of glory. Every Christian should take the word *hopeless* out of our vocabulary list; for a Christian, hopelessness no longer exists. Hopeless behavior has been banished and hopeless situations are extinct. We are the people of hope, and we serve the God of all hope.

God has given to us unexplainable yet substantial hope for our health, for eternity, for abundant life, for unconditional love, for mercy, and for grace.

More Than a Mystery

The devil is a liar and the father of all lies; he will daily try to convince you a situation is hopeless. However, my friend, when this ridiculous wimp of a prevaricator informs you that your life is hopeless, start jumping up and down because you have hope! There is indeed hope for the people of God. His name is Jesus and He lives in you and therefore hope lives in you.

The hopes that courses through your spirit is more real than your blood, nerves, or brain. The Christ who lives in you:

> ೞ *Is the Firstborn of all creation.*
>
> ೞ *Is before all things.*
>
> ೞ *Holds all things together.*
>
> ೞ *Is the Head of the body.*
>
> ೞ *Is the beginning.*
>
> ೞ *Is the Firstborn from the dead.*
>
> ೞ *Has first place in everything.*
>
> ೞ *Has all the fullness of the Father dwelling in Him.*

This magnificent and merciful Christ lives in you. The hope He has brought to all our lives is powerful, magnetic, and restorative. My friend, this is more than a mystery solved; this is a miracle!

LIVING TREASURE

That is, the mystery which has been hidden from the past ages and generations, but has now been manifested to His saints, to whom God willed to make known what is the riches of the glory of this mystery among the Gentiles, which is Christ in you, the hope of glory. (Colossians 1:26–27)

PRAYER

Father, I thank You today that Christ lives in me and He is my hope of glory. I determine today the word hopeless will never be spoken by me again. Thank You for Your great and unconditional love. In Jesus' name I pray. Amen.

WORDS OF WISDOM

Our world today so desperately hungers for hope, yet uncounted people have almost given up. There is despair and hopelessness on every hand. Let us be faithful in proclaiming the hope that is in Jesus.

—Billy Graham

Day 5

How Can I Keep from Singing?

I have often envied others with great musical talent or obvious artistic flair. I was not given the pipes of Sandi Patti, and I certainly am no Rembrandt when it comes to artwork. I've never been a good dancer although I do know how to clap on the beat. I play the piano adequately, am a so-so athlete, and am an abysmal crafter. I often say, tongue in cheek, that whenever I go to a craft show, the words, "Oh! I could make that," have never crossed my mind.

While it is true that some people sing, others dance, while still others sculpt, I talk. I am a communicator to my very soul. I would rather express the truth in Scripture to my generation than go to Hawaii, win an Academy Award, or sing with the Metropolitan Opera.

My singular call in life is to tell others about Jesus in a hopeful, practical, and engaging manner. I will broadcast the good news of the gospel through blogging, podcasting, publishing, social media, and on radio and on television.

⏳ *What is your singular call in life?*

⏳ *List three things that you are good at:*

1. _____
2. _____
3. _____

Sing It!

Paul continued in his glowing and astonishing instruction exactly how the truth of hope should affect each one of us:

We proclaim Him, admonishing every man and teaching every man
with all wisdom, so that we may present every man complete in Christ.
(Colossians 1:28)

We are not only the recipients of hope but also called to be the communicators of hope. Announcing hope is not only our commission but also our job description. We are here because there is a world that needs the hope that has been lavished upon us.

The proclamation of hope that we offer should be loud, enthusiastic, and life-giving. Just as the angels proclaimed the birth of Jesus on the hillside in Bethlehem so long ago, we, too, have been assigned to sing a song of hope in the darkest of nights. Our anthem of hope should permeate the lies of the culture, the discouragement of politicians, the terminal status of the economy, and the gap between generations. The symphony of hope that rises within the soul of a believer is not just for one month of the year but for every day of every year. It is a song that never grows old and forever restores lost dreams, broken hearts, and desperate individuals. Our lives are the resounding announcement of the hope of Jesus Christ.

My friend, live your life so that people are aching for what you demonstrate. Travel the road of suffering in such a way that people are drawn to your joy and peace. Treat your family in a manner that all the contentious opinions are drawn together in a sweet illustration of unity.

The lyrics of the old hymn "How Can I Keep from Singing," published in 1868, have brought untold gladness and purpose to my heart over the years. The author of the lyrics is known only as Pauline T. I can't wait to meet this irrepressible woman someday on the streets of heaven.

My life goes on in endless song
Above earth's lamentations,
I hear the real, though far-off hymn
That hails a new creation.

Through all the tumult and the strife
I hear its music ringing,
It sounds an echo in my soul.
How can I keep from singing?

While though the tempest loudly roars,
I hear the truth, it liveth.
And though the darkness 'round me close,
Songs in the night it giveth.

No storm can shake my inmost calm,
While to that rock I'm clinging.
Since love is lord of heaven and earth
How can I keep from singing?

When tyrants tremble in their fear
And hear their death knell ringing,
When friends rejoice both far and near
How can I keep from singing?

In prison cell and dungeon vile
Our thoughts to them are winging,
When friends by shame are undefiled
How can I keep from singing?

⧗ *How do the words of this hymn affect your life today?*

⧗ *Choose a favorite line or two from this hymn and underline those lines.*

Talk About It

Paul commanded the church at Colossae to *"proclaim Him."* The word Paul used for "proclaim" is the Greek word *katangello*, which can be translated "to announce, declare, promulgate, make known" or "to proclaim publicly, publish."[18]

Your choice to follow the Lord and to live your life based upon the truth of the Bible should not be a well-kept secret, but you are instructed by the

apostle Paul to publish it publicly. Your faith is not something you whisper into selected ears, but you *are* the publication upon which people set their eyes as they search for truth. You, my friend, are a walking, talking advertisement of hope. You are a joyful billboard that your friends and family observe with great interest as they travel through life. You are a well-read newspaper established to print stories of encouragement and goodness exclusively. You are Christ's love letter written to the world who is desperate for forgiveness and meaning.

> *You are our letter, written in our hearts, known and read by all men;*
> *being manifested that you are a letter of Christ, cared for by us, written*
> *not with ink but with the Spirit of the living God, not on tablets of stone*
> *but on tablets of human hearts. Such confidence we have through Christ*
> *toward God. (2 Corinthians 3:2–4)*

There is a further, more intense meaning of the word *katangello* that causes my heart to break out into a jubilant song of praise. *Katangello* is more specifically rendered as "with the included idea of celebrating, commending, openly praising."[19]

One's relationship with Jesus should never be covert during the week and then exuberant on Sundays. Your life is a joyful parade of good news, celebratory songs, and rich hope. It is time for us, as the public demonstration of all that is wonderful, to proclaim the message of Jesus and to become a celebration of hope.

I have decided I no longer have to "pray" about proclaiming or witnessing but I must just do it. Paul states God's will for our lives on the pages of Scripture and we must obey. We use wisdom, but we proclaim. We don't shake a Bible in someone's face, but we proclaim. We don't condemn, but we proclaim with joy. We simply can't keep from singing!

⧗ *If you could tell the world one thing you have learned about your Christian faith, what would it be and why?*

Truth and Kindness

The instruction of Paul to the church at Colossae is specific and strong. Paul not only directs his fellow believers to proclaim Christ but also charges them to *"[admonish] every man"*:

> *We proclaim Him, admonishing every man and teaching every man with all wisdom, so that we may present every man complete in Christ.*
> *(Colossians 1:28)*

We must also wisely yet humbly tell our world the truth about God's love, the wages of sin, the power of the cross, the certainty of heaven, and the resurrection of Jesus. The word that Paul tactically chose to communicate the meaning of "admonishing" is the Greek word *noutheteo*. This word can mean to "put in mind" and always carries with it the idea of repentance; it refers to a person's conduct and heart attitudes.[20]

As I ponder whom I have been called to *noutheteo* and the eternity of the people whom I love dearly, I am also reminded of the manner in which God approaches those He is warning:

> *Or do you think lightly of the riches of His kindness and tolerance and patience, not knowing that the kindness of God leads you to repentance?*
> *(Romans 2:4)*

Your kindness and encouragement may lead someone to repentance; your simple acts of compassion may change someone's heart toward Christ.

You don't have to preach to admonish, but you must be kind.

You don't have to correct to admonish, but you must be kind.

You don't have to criticize to admonish, but you must be kind.

⧗ *Think of someone who has been especially kind to you over the past few weeks. How can you return the kindness?*

⏳ *Think of someone you know who does not know Jesus as their Lord and Savior. How can you extend kindness to this person this week?*

You Are a Teacher

Paul also identified the body of Christ as wise teachers; your classroom is simply everyone with whom you come in contact. Your students will glean good theology from your insight as you train them in faith and Scripture.

Please don't be intimidated by this part of the assignment; it is unnecessary to be a Bible scholar to teach your friends and family members that Jesus loves them and that God has wonderful plans for their lives. You only need to teach them what you yourself have learned from sitting in the classroom of God.

Every wise teacher prepares their lessons in an interesting and practical manner. We, as the followers of Christ, should do no less. We must always be ready to share about the Lord and even have verses from Scripture to communicate with a person in need.

⏳ *What is the one lesson from Scripture that you might feel qualified to teach with those in your life? Be specific. Is it a parable? An Old Testament story? The fruits of the Spirit?*

⏳ *Now, prepare your lesson plan. Take the time to write out an interesting one- to two-minute lesson that you can be ready to share with those in your life.*

Complete

There is an eternal purpose for your decision to proclaim, admonish, and teach; it is our job, as twenty-first-century believers, to present every person from our generation complete in Christ.

> **We proclaim Him, admonishing every man and teaching every man with all wisdom, so that we may present every man complete in Christ.**
> **(Colossians 1:28)**

Ours is a holy and high calling; we have been summoned by our Creator and our Father to lead people to Jesus Christ. We must not take this assignment lightly, nor should we be intimidated by it. God's will for your life and for my life is to publish hope to a world in pain. We can be both winsome and wise about it, but we must make the most of every opportunity given to us.

> **Conduct yourselves with wisdom toward outsiders, making the most of the opportunity. (Colossians 4:5, emphasis added)**

I understand it is easy to be intimidated by political correctness or inhibited by strong personalities, but all effective witnessing begins with simple acts of kindness. We can all be kind and then ask God to open the door to share our faith. As we demonstrate genuine compassion and tenderness toward others, they will begin to ask questions of us. You and I need to be ready to answer their probing questions.

I have discovered I don't need to inform people they are bound for hell; instead, I can simply ask what they may think happens after life on earth. We are all capable of instigating a healthy discussion.

The secular workplace has become obstinately, and sometimes viciously, opposed to discussing matters of faith and Christianity at work. My friend, I have never known anyone to be fired for just being kind at work or for encouraging people. Your kindness today may open a door for a thorough and longed-for conversation about Christ tomorrow.

⧖ *Do you work in a secular job? If so, who needs to know more about Jesus in your workplace?*

⧗ *If you work in a Christian environment or do not work outside the home, it is so important to develop friendships with people who don't yet know Christ. How can you do this in an intentional way?*

Purpose and Power

Even the great orator and respected scholar Paul needed the power of the Lord to proclaim, admonish, and teach at his moment in church history. What Paul was desperate for two thousand years ago, we need today in gargantuan amounts. We need the power of the Holy Spirit to work mightily within us.

> **For this purpose also I labor, striving according to His power, which mightily works within me. (Colossians 1:29)**

Paul was poignantly aware what his personal calling would require: it would require the superhuman power of the Lord he willingly served. If Paul was unable to walk in his God-ordained purpose without divine power, neither will you or I be able to accomplish our assignments without this power.

Perhaps you could pray this prayer today:

> *God, give me Colossians 1:29 power today. I need your power to proclaim your wonderful name, to be kind, to ask probing but purposeful questions, and to give wise answers that You would give if you were here today. And you are here. You are here in me and with me. Thank You for this mighty power. Amen.*

The wonder of praying a prayer such as this is that you will soon discover you are most the person God created you to be when you are least dependent upon your own resources. God calls His children to difficult tasks and arduous responsibilities; He bids us to accomplish what we are unable to do without His vital power.

There is a world who needs what you have been given; our world urgently needs Jesus. You, my friend, are privy to the solved mystery that is Christ in you, the hope of glory.

LIVING TREASURE

That is, the mystery which has been hidden from the past ages and generations, but has now been manifested to His saints, to whom God willed to make known what is the riches of the glory of this mystery among the Gentiles, which is Christ in you, the hope of glory. (Colossians 1:26–27)

PRAYER

Jesus, I need your power to tell the story that never grows old. Would you give me divine appointments so I can share the hope that lives within me? Give me the courage and boldness of Paul. In Jesus' name. Amen.

WORDS OF WISDOM

We are no muttering mystery-mongers. From full lungs and in a voice to make people hear, we shout our message. We do not take a man into a corner, and whisper secrets into his ear; we cry in the streets, and our message is for every man.

—Alexander Maclaren

Week 4

Completely in Charge

Day 1

Praying Fiercely

Have I mentioned to you yet that Colossians just may be my favorite book in the entire Bible? Not only are we reading Colossians together, but also, as I like to say, we are mining for gold in the storehouse of God. I can assure you we are about to discover a massive vein of gold in this book.

Perhaps I could describe it like this: it's as if I have accompanied you to one of my preferred vacation spots or to my beloved childhood home. As we tenderly turn the pages of the letter Paul wrote to the church at Colossae, it's as if time is standing still and we are exploring a beloved location together. I, as your tour guide, have the privilege of pointing out the wonder and sweetness of each place I hold so dear.

Thank you for joining me on this enthralling journey; I believe we will both be changed for all of eternity as we gasp in amazement at the power and heart of the Father.

A Generational Challenge

Paul's dear friend, Epaphras, had sent word to Paul that the church at Colossae was struggling; Paul was in prison when he received the disturbing news. The believers in this first-century church were mixing Christianity with the temporary philosophy of the day. What was true then is true now: it is impossible to blend Christianity with any idea inconsistent with the Word, including the feel-good thoughts of the day.

Every generation faces this complicated challenge; if it happened in Colossae it can happen in your home church as well. Christianity cannot—must not—be merged with universalism, materialism, humanism, or a woke mindset.

Perhaps it would be a magnificent idea to remind ourselves daily that we are complete in Christ. He is truly all we need this side of heaven's shores; His presence and His promises are enough to build a solid life upon.

⧖ *What are some danger signs that might signal that a church or a denomination is mixing Christianity with a non-biblical philosophy?*

1. _____

2. _____

3. _____

⧖ *How would you handle it if you saw your church begin to walk down the road of non-biblical beliefs?*

⧖ *What are some steps you can take to prevent this in your church?*

1. _____

2. _____

3. _____

In Agony

Paul was heartsick at the condition of the Colossian church; his grief knew no bounds as he prayed in prison for this group of believers who were contending for their faith.

> *For I want you to know how great a struggle I have on your behalf and for those who are at Laodicea, and for all those who have not personally seen my face. (Colossians 2:1)*

Paul confessed to his brothers and sisters living at Colossae that he was in deep intercession in response to their theological choices. The word *struggle* is the Greek word *agon*, from which we extract the word *agony*. Paul wasn't merely thinking about these wandering Christians from time to time, but his prayers for this confused group of believers were prolonged and penetrating.

What a stunning "show and tell" of how to pass the time while in prison. You might be in a prison of depression, financial challenges, or relationship dysfunction; the prison that has you in chains might be depression or grief or lack of purpose. While you spend time in this prison not of your own choosing, you can pray for others.

Paul had never been to Colossae, therefore he was unable to picture their dear faces; he did not know their individual names, yet still he interceded with great emotion and intention. I can easily pray for my family or for someone I love passionately who is struggling, but to pray for those whom I have never met is an embarrassing challenge for me. I want to pray for them, but generally I quickly lose interest and move on to other things. The example of Paul praying resolutely for a people group whom he had never met is at once stunning and convicting. We all must evaluate our hearts and our calendars and then elect to spend time weekly in extended and piercing prayer.

⧖ *What friend or family member are you currently praying for?*

⧖ *Ask the Lord to give you an assignment to pray for a people group or nation you have never met. When you hear Him whisper this assignment in your heart, write the name of the people group here:*

Paul Cared

One of the most compelling aspects of this first verse of the second chapter of Colossians is how greatly Paul cared for a people group he had never met. Paul not only loved this misguided church deeply but also put wings on his love as he prayed for them with profound emotion.

Paul's example, once again, touches me profoundly, but it also constrains me to pray for the people in my life who have gone astray from the gospel of Jesus Christ. Paul was keenly aware of the result of false teaching in the lives of those who had decided to follow Jesus. When we are distracted by hollow and self-centered philosophy, our ardor for Christ will wane. When we listen to the world more than we read the Word, our belief system will weaken.

Perhaps we should take upon ourselves the mantle of Paul and pray for pastors, churches, denominations, and believers whom we have never met. Prayer is the most dynamic way to change a situation and we must not take this assignment lightly. You don't need to have a doctorate degree in theology to pray for the church; you just have to care.

⧗ *What denomination will you commit to pray for this month?*

⧗ *What pastor will you commit to pray for this month?*

⧗ *What church will you commit to pray for this month?*

⧖ *What individual, who has left the faith or who has doubts, will you com-mit to pray for this month?*

The Prayer of Paul

After Paul admits his prayer life has kept him in a state of agony over what was happening in the churches at Colossae and Laodicea, he then informs this wavering church precisely the manner in which he was praying for them. The prayer Paul prayed nearly two thousand years ago holds authority and divine energy even today. If you are wondering how to pray for people who have gone astray, read the prayer of Paul:

> *That their hearts may be encouraged, having been knit together in love, and attaining to all the wealth that comes from the full assurance of understanding, resulting in a true knowledge of God's mystery, that is, Christ Himself, in whom are hidden all the treasures of wisdom and knowledge. (Colossians 2:2–3)*

Paul prays in three specific ways for this church that had broken his heart and whose members displayed some confusion in their belief system. Paul's hopeful yet fervent prayer calls us to pray in the same manner:

- ⟿ *Pray their hearts would be encouraged.*
- ⟿ *Pray their hearts would be knit together in love.*
- ⟿ *Pray they would attain the wealth that comes from the knowledge of Christ Himself.*

We will continue to study this passage in tomorrow's lesson, but for today, we can view these verses as a solid and mountain-moving prayer outline.

⏳ *Spend a few minutes praying the prayer of Paul over someone you love.*

LIVING TREASURE

Therefore as you have received Christ Jesus the Lord, so walk in Him, having been firmly rooted and now being built up in Him and established in your faith, just as you were instructed, and overflowing with gratitude. (Colossians 2:6–7)

PRAYER

Jesus, how I love Your church! It is Your bride and You love this imperfect group of people dearly. Father, I pray for Your bride today and I ask that she will cling to the truth of Scripture and she will fall in love with You all over again. In Jesus' name I pray. Amen.

WORDS OF WISDOM

An unschooled man who knows how to meditate upon the Lord has learned far more than the man with the highest education who does not know how to meditate.

—Charles Stanley

Day 2

It's a Wonderful Life

What does it mean to you to be wealthy? It's a valid question, isn't it? Perceived wealth is a matter that has distracted many men and women from pursuing eternal riches with reckless abandon.

Many people attach the attainment of stocks, bonds, and an enormous retirement account to securing the status of a truly wealthy person. Others might believe that a six-figure income, winning the lottery, or being able to afford vacations on exotic islands is the stellar definition of affluence.

For others, prosperity is not as tangible but lies in the intangible treasures of life. I count my life as bountiful because I was raised in a loving, Christian home; I also am daily aware of the assets bequeathed upon my life due to my husband, children, and grandchildren.

Some people affix a wealthy mindset to the luxury of a stellar education, traveling around the world, or being schooled in culture, music, art, and history.

Each one of us must determine for ourselves what it means to live a life of wealth and influence. There is no measuring tape, no gauge, and no container that gives an accurate evaluation of resources apart from Jesus.

⌛ *What does it mean to you to be wealthy? Be honest.*

⌛ *Who is the richest person you know? Why is that?*

The Richest Man in Town

Each year at Christmastime, my family gathers in the living room with overflowing bowls of freshly-made popcorn, festively decorated cookies, and piping hot chocolate with marshmallows melting on top. The adults sit on the pillow-laden couch or on overstuffed chairs, while the children gather on the floor with cozy blankets to snuggle under.

When everyone is warmly settled, my husband begins a holiday movie every age will enjoy. We might view a dearly loved movie such as *White Christmas*, *Miracle on 34th Street*, or *Polar Express*. It matters little what we watch; all that matters to this Marmee is that it is Christmas and we are all together in a glorious McLeod pile.

It's no secret to my people that my favorite Christmas movie is *It's a Wonderful Life*. Who can resist George Bailey, Bert and Ernie, and a hilarious angel named Clarence? But it is the message proclaimed at the end of this heart-touching movie that never fails to bring me to tears.

George Bailey lived in a broken-down old house forever in need of repairs. He had married the wife of his dreams, and they had three lively, healthy children. The Bailey family business was about to be in financial ruin because of a serious blunder made by George's uncle. The stress continued to lash at George until he thought his only option was to jump off the village bridge into the frigid water. George, however, was miraculously intercepted by a bumbling but lovable angel, Clarence, who was trying to earn his wings.

Clarence, straight from heaven, showed George what Bedford Falls would have been like without George's influence. When George realized although he had never traveled around the world, gone to college, or made a million dollars, he was truly the richest man in town because of his friends and his family.

We all need to realize that simple truth, don't we?

⧖ *What is it that has made you wealthy?*

⧖ *What is one of your earthly treasures?*

⏳ *Define the word* wealth.

Wealth Defined

Paul stated, in this prayer that he prayed fervently over the confused Colossians, his definition was of the word *wealth*.

> *That their hearts may be encouraged, having been knit together in love, and attaining to all the wealth that comes from the full assurance of understanding, resulting in a true knowledge of God's mystery, that is, Christ Himself, in whom are hidden all the treasures of wisdom and knowledge. (Colossians 2:2–3)*

There is a fullness and abundance to life that is impossible to be bought, sold, or earned. There is an eternal prosperity that bursts into our earthly existence, which is impossible to be gained or obtained through the earthly economic system. My friend, all the wealth you need for living is found in Jesus Christ. Any treasure for which you ache is found in His infinite wisdom and boundless knowledge.

> ∞ *Do you need to know how to raise your children? It's in the Bible.*
>
> ∞ *Do you need to learn how to be a good steward of your money? It's in the Bible.*
>
> ∞ *Do you need to understand how to love a difficult person? It's in the Bible.*
>
> ∞ *Do you need advice on how to walk in your destiny? It's in the Bible.*

⏳ *What do you need to know about a situation today?*

⧖ *Ask the Holy Spirit to give you a verse that will help you with this situation. Write the verse below.*

Eternal Assets

Paul states in this jaw-dropping verse, *all treasures of wisdom and knowledge are hiding in Christ Himself* (see verse 3).

The word that Paul purposefully chose to communicate "treasure" is the Greek word *thesauros*, which means:

- the place in which good and precious things are collected and laid up
- a coffer, or other receptacle in which valuables are kept
- a treasury
- storehouse, repository, magazine
- the things laid up in a treasury, collected treasures

The wise Holy Spirit has kept every treasure of wisdom and knowledge in a most secure place. For those of us who name Jesus Christ as the Lord of our lives, it is not a secret where this inexpressible treasure has been stored. We are welcome to unlock the treasure chest and to go digging for wisdom and knowledge every day in every situation.

The name *Jesus* is the combination that unlocks this storehouse of wealth and treasure. When you say "Jesus, I need your wisdom," you have just inserted your personal key into the latch that will open this amazing repository.

When you know Jesus, you have hit the mother lode of wisdom and knowledge. As a believer in Jesus Christ, you have hit a vein so rich with eternal resources that you will never be the same again. You will be able to share joy, hope, truth, and peace with the world around you when you open this cache of eternal jewels.

My friend, if you don't know Jesus Christ, you are dirt poor in everything that actually matters. There is no earthly fortune that could ever make you rich

without Christ. Conversely, if you do know Jesus as your Lord and Savior, you are rich in every way that matters. You are, quite simply, the richest person in town.

LIVING TREASURE

Therefore as you have received Christ Jesus the Lord, so walk in Him, having been firmly rooted and now being built up in Him and established in your faith, just as you were instructed, and overflowing with gratitude. (Colossians 2:6–7)

PRAYER

Lord Jesus, thank You for every blessing in my life. Most of all, thank You for the wisdom and knowledge that is mine simply because I know You and love You. Help me to share my great wealth with others today. In Jesus' name I pray. Amen.

WORDS OF WISDOM

He is a poor man who can only measure his wealth in dollars.

—Woodrow Kroll

Day 3

Deeply Rooted

My dad was raised on a farm, and although he eventually went to college and became a computer engineer, his avocation through the years remained digging and planting the two-acre yard on which sat our family home.

I was a daddy's girl from the start. Saturday mornings, as well as every day after school, found me in our large garden, whistling, watering, and weeding. Everything I know about farming, I learned from my dad. He taught me that weeds must be taken care of immediately and that when the sun is hot, the water must be abundant. I also learned from this general of the faith and of the field, that where we planted our garden was of the utmost importance. The roots of our plants must be given the opportunity to nestle deeply into the rich, nutritious soil where growth—although it might be hidden—would initially take place.

⧗ *What did you learn from your father or mother? Sometimes we learn the right way to live from our parents, and at other times we might learn how not to approach life. Feel free to write either one in the space below.*

Flourish

Paul now employs picturesque language to encourage the wavering church at Colossae to grow a faith that is lavish and prolific.

I say this so that no one will delude you with persuasive argument. For even though I am absent in body, nevertheless I am with you in spirit, rejoicing to see your good discipline and the stability of your faith in

Christ. Therefore as you have received Christ Jesus the Lord, so walk in Him, having been firmly rooted and now being built up in Him and established in your faith, just as you were instructed, and overflowing with gratitude. (Colossians 2:4–7)

Paul's use of words throughout the entire book of Colossians is at once artistic, intentional, and creative. To communicate the importance of the word *rooted*, Paul selected the Greek word *rizoo*, which means "to cause to strike root, to strengthen with roots, to render firm, to fix, establish, cause a person or a thing to be thoroughly grounded."[21]

In the ancient world, a farmer would understand this agricultural word to mean, "to become stable or to take root." Paul, in his own ingenious yet deliberate manner, invites believers to become farmers in the matter of faith. Paul realized, by the unction of the Holy Spirit, that Christians would not have a chance of maturing in wisdom or producing vibrant fruit unless we established our lives deeply in the unshakable kingdom of Jesus Christ.

Paul's selection of the word *rizoo* vividly paints the word picture of a strong tree that has developed over the seasons of life as a demonstration of vibrancy and stability. This massive tree possesses a root system that thoroughly penetrates the soil for a source of nourishment. This particular tree does not extract nutrients from the surface but from the rich, dark dirt located well below the shallow ground. The massive root system is what holds this giant of a tree in place regardless of the weather or environmental opposition that might come against it.

This word picture, penned nearly two thousand years ago, was meant to be a picture of your life in Christ. Our lives will never be fertile or rich without the deliberate choice to tap into the strength of God's Word and the fertilization that takes place when we pray. As we lift our hands in worship, our roots burrow even more deeply into the nutrients of God's presence; when we ask for the strength of the Holy Spirit to meet our daily needs, our roots shoot rapidly yet surely into the deep places of God Almighty. As you opt for this type of lifestyle, you, like the enormous tree Paul has written of, will outlast every season, every fierce climate, and every unwanted storm. If you will do this—that is, nestle deeply and choose Christ—you will enter an unmatched season of fruit-bearing. Your life will be a rare and uncommon masterpiece of harvest and blessing.

⏳ *What is one Christian discipline to which you faithfully adhere?*

⏳ *What is one Christian discipline you need to develop?*

⏳ *What can you do in a practical sense to develop this discipline?*

A Prosperous Life

Paul was not the only biblical scribe who wrote of the necessity of maintaining a healthy spiritual root system.

> *But his delight is in the law of the Lord,*
> *And in His law he meditates day and night.*
> *He will be like a tree firmly planted by streams of water,*
> *Which yields its fruit in its season*
> *And its leaf does not wither;*
> *And in whatever he does, he prospers. (Psalm 1:2–3)*

As you discover new-found delight in the Word of God and as you determine to memorize and meditate on the Word, you will have a root system that is rare to find among men or women. The psalmist states that as you firmly plant your life by the One who provides living water, you will not wither no matter what life brings. Your life will be a living, vigorous demonstration of a prosperous believer in Jesus Christ.

I remind myself daily that growing a firm set of roots is not done overnight, but it requires time, discipline, and faithfulness. Tenaciously desiring this immense root system demands hard work and unending perseverance. Another important note is not many will notice your well-developed root system because it is underground. Your spiritual root system is only known to you and the Father. However, what others will be aware of is the fruit being produced by your luscious life. The people around you may just be in awe of the joy you maintain during a violent storm or wonder why you are so peaceful when your life remains stressful.

⌛ *Read Galatians 5:22–23. Of the nine expressions of the fruit of the Spirit, which would you like to produce more abundantly in your life?*

A farmer is unable to harvest produce from a tree that refuses to bear fruit, and God will receive no glory from a life that is withered and fruitless. If you long to bear fruit and live a spiritually prosperous life, you will send your roots deeply into the rich soil of God. Your limbs should always be stretching toward heaven in worship and praise.

If you will send the roots of your life far down into God's Word, you will be able to withstand all the elements of different seasons in life.

⌛ *How did God's Word protect you during a particularly difficult season in life?*

⌛ *Was there a certain verse that sustained you during this season?*

This far-reaching root system will also protect the tree of your life from pestilence which may try to attack through the years. When anger or forgiveness attack your life, they will shrivel up and die because they are met with the power of God's Word. When shame or worry try to attach their ugly claws into your life, the unmistakable fragrance of the Holy Spirit will cause them to die a quick and painful death.

⧗ *What enemy of the soul has tried to attack your life over the years?*

⧗ *How does investing in God's Word help you overcome these enemies?*

Watering Your Life

The decision to live a life of gratitude is what waters the roots of our faith. A waterfall of praise should be obvious and refreshing to everyone who we encounter.

> *Having been firmly rooted and now being built up in Him and established in your faith, just as you were instructed, and overflowing with gratitude. (Colossians 2:7)*

Although I may not be the most musical Christian, I can be the most grateful. I may not have an academic grasp of Hebrew or Greek, but I can allow the streams of thanksgiving coming from my heart to flood the courts of God. I may not have large amounts of money to invest in the work of God, but I can choose to be a thankful Christian in a complaining generation.

Protected

As we choose to burrow our roots of faith deeply into the richness of all that God is and all that He provides for us, we will also discover we are protected from being taking captive by false teaching and heretical philosophy.

> *See to it that no one takes you captive through philosophy and empty deception, according to the tradition of men, according to the elementary principles of the world, rather than according to Christ. (Colossians 2:8)*

My friend, when you are beautifully rooted and firmly grounded in Christ, your faith will be immovable. You will have the ability to discern good from evil and right from wrong. You will live a peaceful life, remain steady through every storm, and be refreshed by the joy of His presence.

LIVING TREASURE

> *Therefore as you have received Christ Jesus the Lord, so walk in Him, having been firmly rooted and now being built up in Him and established in your faith, just as you were instructed, and overflowing with gratitude. (Colossians 2:6–7)*

PRAYER

> *Jesus, I declare today that I choose to firmly plant my roots in the soil of your kingdom. Thank you for the promise that You will keep me safe in the storms of life and that I will be a fruitful Christian who always brings glory to Your name. Amen.*

WORDS OF WISDOM

> *Men may not know how fruits grow, but they do know that they cannot grow in five minutes. Some lives have not even a stalk on which fruits could hang, even if they did grow in five minutes. Some have never planted one sound seed of Joy in all their lives; and others who may have planted a germ or two have lived so little in sunshine that they never could come to maturity.*

—Henry Drummond

Day 4

All You Need to Know

How wonderful to know Jesus has provided everything we need to live an abundant and fruitful life! He is the answer to all our questions and the solution to every problem we face. He holds the keys to forgiveness, peace, and eternity. It's true, my friend, Jesus is really all we need.

Even though I have known Jesus as my Lord and Savior since I was a mere wisp of a girl, I will admit there are still days when I question His goodness and His power and when I wonder if He hears my prayers. There are still days—after serving the Lord for sixty years—when I must take myself back to the basics of my faith. There is something incredibly restorative about reminding myself of the foundational truths of Scripture. On those days, when I go back to the very beginning of my faith walk, the hope returns, the joy is revived, and peace rushes in.

⧖ *List three foundational truths of Scripture that restore your joy:*

1. _____

2. _____

3. _____

A Flood

I firmly believe it is the desire of Christ to flood the lives of men and women in every generation with everything He has and everything He is. Jesus is not stingy, holding blessings back from His dear children. He lavishly pours on us His character, His power, and His wisdom. What a wonderful life we have been given!

> *For in Him all the fullness of Deity dwells in bodily form, and in Him you have been made complete, and He is the head over all rule and authority. (Colossians 2:9–10)*

You have been made complete in Jesus Christ, lacking nothing at all. Without Christ, you lack everything; but when you invite Him into your empty heart, you have access to absolutely everything you need in Christ Jesus. The fullness of God dwells in Jesus; Jesus brings all of God's fullness into you. It's simply amazing, isn't it?

Jesus is the head over every ruling power and governmental system. Jesus has more authority than the United Nations, the king of England, and the United States Congress. The jurisdiction of Christ far surpasses all spiritual domains and dominions. Christ reigns supreme now and forever more. His kingdom will have no end.

The word *complete* that Paul uses in this passage is, again, a picturesque word. *Complete* is a nautical term that implies that a believer in Christ is ready to set sail for the journey of life. You have been fully equipped and you lack nothing you might need for stormy seas, enormous waves, or days sailing with no wind at all. Whatever you need on the sea of life, you will find in Him.[22]

If we were to boil these two verses down into a powerful declaration, this is what we would ascertain: "I am complete, and He is in charge!" I lack nothing because of Christ and He holds all the power in eternity past or eternity yet to come.

My soul is at rest; is yours? I feel as if I should respond with these grateful words, "Whew. That is so good to know." My soul is no longer worried or clawing for certitude. I can rest on the foundational truth spilling over with peace: I am complete, and He is in charge.

⧖ *I hope you will say this phrase aloud several times today: "I am complete, and He is in charge."*

⧖ *What does it mean to you to know that you are complete in Christ?*

⧖ *What does it mean to you to know that He holds all authority and power?*

⧖ *How does this knowledge potentially change the way you will pray?*

The "C" Word

I was never interested in watching football on television until I married Craig. I never watched college basketball until our son, Matthew, became a teenager. I never enjoyed listening to classical guitar until our son, Christopher, majored in it at college. I never liked boating until I made a friend named Kim.

And I can assure you, I never was interested in circumcision until I met Jesus!

And in Him you were also circumcised with a circumcision made without hands, in the removal of the body of the flesh by the circumcision of Christ. (Colossians 2:11)

The subject of circumcision may not interest you at all, but you need to keep your heart and head in the lesson because it wouldn't be in the Bible if it wasn't applicable to our lives today. I thought about titling this section "Everything You Wanted to Know About Circumcision but Were Afraid to Ask" but I wasn't sure if that title was appropriate for a women's Bible study or not. Honestly, though, I would do almost anything to keep you interested because this is a topic we must not ignore.

Circumcision is the sign of a covenant between God and His people; when a man was circumcised it meant, "I belong to God the Father. I have been chosen as His very own."

The first time that circumcision is mentioned in the Bible is in the book of Genesis; Abram and God were having a heartfelt conversation. Can you imagine talking to God and hearing His audible voice? I have long wished that I could have the same type of conversation with God that Abram did in the desert one afternoon. This is a long passage, but please read every word because it is foundational to our understanding of the "c" word.

Now when Abram was ninety-nine years old, the LORD appeared to Abram and said to him,

> *"I am God Almighty;*
> *Walk before Me, and be blameless.*
> *"I will establish My covenant between Me and you,*
> *And I will multiply you exceedingly."*

Abram fell on his face, and God talked with him, saying,

> *"As for Me, behold, My covenant is with you,*
> *And you will be the father of a multitude of nations.*
> *"No longer shall your name be called Abram,*
> *But your name shall be Abraham;*
> *For I have made you the father of a multitude of nations.*

I will make you exceedingly fruitful, and I will make nations of you, and kings will come forth from you. I will establish My covenant between Me and you and your descendants after you throughout their generations for an everlasting covenant, to be God to you and to your descendants after you. I will give to you and to your descendants after you, the land of your sojournings, all the land of Canaan, for an everlasting possession; and I will be their God."

God said further to Abraham, "Now as for you, you shall keep My covenant, you and your descendants after you throughout their generations. This is My covenant, which you shall keep, between Me and you and your descendants after you: every male among you shall be circumcised. And you shall be circumcised in the flesh of your foreskin, and it shall be the sign of the covenant between Me and you." (Genesis 17:1–11)

God's covenant with His people has always been, and will always be, a covenant of blessing, multiplication, and fruitfulness. A covenant reflects who God is and how He treats His beloved children.

The word *circumcision* comes from two Latin words: *circum*, which means around, and *cise*, which means to cut. God required circumcision of His chosen

people for the purpose of cleanliness, to prevent certain diseases, and to protect the wife from diseases.

In the kingdom of God, we can be sure when God calls someone to the covenant of circumcision, He is requiring the cutting away of the old so the new and healthy tissue will remain. God knows what is best for His creation; His desire is that our lives would be abundant with all which is wholesome and productive.

⧖ *As you read the story of Abram and God in Genesis 17, think about the character and personality of God in this exchange. List three adjectives describing God as reflected in this conversation:*

1. _____

2. _____

3. _____

The New "C" Word

The Lord has forever been on a journey of pursuing His children and giving boundaries, not legalistic in nature, but those which will foster a life of joy, abundance, and power. So it is with circumcision; God did not enact this covenant to place men in horrific momentary pain, but to protect them from disease.

In Deuteronomy, God introduces a new type of circumcision that is not just for men but for everyone who loves the Lord:

> *Now, Israel, what does the LORD your God require from you, but to fear the LORD your God, to walk in all His ways and love Him, and to serve the LORD your God with all your heart and with all your soul, and to keep the LORD's commandments and His statutes which I am commanding you today for your good? Behold, to the LORD your God belong heaven and the highest heavens, the earth and all that is in it. Yet on your fathers did the LORD set His affection to love them, and He chose their descendants after them, even you above all peoples, as it is this day. So circumcise your heart, and stiffen your neck no longer. (Deuteronomy 10:12–16)*

God called His wandering, rebellious, opinionated children to enact a new and exacting type of circumcision; He invited them to partake of circumcision of the heart.

We must apply the principles of a physical circumcision now to the circumcision of the heart. God said to His people in Deuteronomy, "If you fear Me, and walk in my ways, and love Me and serve Me, you also need to circumcise your heart."

The Lord God gave His people a choice but passionately requested they participate in this much needed, initially painful but eventually joyful decision. He informed these wayward children if they chose not to circumcise their hearts, they would walk continually through life with a stiff neck.

The phrase *"stiffen your neck no longer"* can be translated to mean "to have a difficult labor, to make things harder, to make something heavier."

My friend, if you refuse to circumcise your heart, your life will be harder not easier. As we recall that circumcision means to cut away the excess or the old, we can apply this painful word to our hearts. We must slice out of our hearts all that remains from our old life before Christ. We must sever all ties with bitterness, sin, shame, and unforgiveness; the remnants of childhood pain should be eliminated under His fountain of love. Gossip, bad habits, busyness, and a critical spirit must be amputated from our character. You can keep those pieces of refuse if you desire, but your life will be infinitely more difficult and demanding.

> **Moreover the Lord your God will circumcise your heart and the heart of your descendants, to love the Lord your God with all your heart and with all your soul, so that you may live. (Deuteronomy 30:6)**

How wonderful to know the Lord will circumcise our hearts if we allow Him to do so! This one initially painful but eventually wonderful act increases our love for the Lord and guarantees a jubilant and peaceful life.

If you long to live with abundant joy and if your heart's desire is to love God more deeply every day, humbly ask God to circumcise your heart. Submit to the Father and allow Him to cut away the extraneous and the diseased. The result of this surgery will be an enthusiastic love for the Father and a life of unmatched blessing.

⧗ *What do you believe the Lord desires to circumcise from your life?*

1. _____

2. _____

3. _____

Do Not Ignore

One aspect of this teaching we must not ignore is God brought many of the principles of the Old Testament and highlighted them in a renewed dimension in the New Testament. Circumcision is one of those redemptive principles; He truly is making all things new, isn't He?

> *And He who sits on the throne said, "Behold, I am making all things new." And He said, "Write, for these words are faithful and true."*
> *(Revelation 21:5)*

Paul introduced the marvelous concept of a "circumcision without hands" in this chapter of Colossians. There is no earthly surgeon who will perform this much-needed and intricate surgery on your heart, but God Himself will remove the weakness of your flesh and replace it with the fullness of His Spirit. All you need to do is ask.

LIVING TREASURE

Therefore as you have received Christ Jesus the Lord, so walk in Him, having been firmly rooted and now being built up in Him and established in your faith, just as you were instructed, and overflowing with gratitude. (Colossians 2:6–7)

PRAYER

Father God, I come to You today and ask You to circumcise my heart. Cut away all that brings disease into my life. I trust You, Father, because You truly know what is best. In Jesus' name I pray. Amen.

WORDS OF WISDOM

The Bible will keep you from sin or sin will keep you from the Bible.

—Dwight L. Moody

Day 5

It Is Finished

The Jesus Revolution, in the late 1960s and early 1970s, brought a refreshing, nonreligious celebration into the soul of America's churches. The music of this youth revival lives on today in the hearts of all who remember. One of the astonishing aspects of this cataclysmic revival was the urge to be baptized as a symbol of new life in Christ.

I was baptized during my high-school years in a local pond by my beloved childhood pastor. Our small-town church was feeling the effects of this joyful revolution, and we were bursting at our Methodist seams. It only made sense to hold a baptismal service for anyone who had made a commitment to Christ or who had recommitted his or her life.

Baptism is one of the most beautiful and powerful pictures of what happens when a person decides to follow Jesus. My baptism that day in the farm pond illustrated how my old life was buried in Christ; as I came up out of the water, I pictured how I had become a glorious new person.

⧖ *Have you ever been baptized? Why or why not?*

⧖ *If you have been baptized, write your memory of the experience below.*

Dead and Gone

Baptism has been a vibrant aspect of Christian discipline since the day John the Baptist laid his hands on Jesus and placed him under the waters of the Jordan River. Baptism, in the days of the early church, was a celebration of the deliberate act of leaving one life for another. As the waters closed over the head of the one being baptized, it was as if the individual rose to a magnificent new life. The old life was left in the cold waters; it was dead and gone forever.[23]

> *Having been buried with Him in baptism, in which you were also raised up with Him through faith in the working of God, who raised Him from the dead. When you were dead in your transgressions and the uncircumcision of your flesh, He made you alive together with Him, having forgiven us all our transgressions. (Colossians 2:12–13)*

Baptism is a vivid symbolic act that represents our new life in Christ. However, we must seriously consider the fact that baptism only becomes a vibrant reality when those baptized have decided to wholeheartedly give their life to Jesus Christ. Baptism is not religious show or a rite of passage; it should not be taken lightly or done to please others. Baptism only does its projected inner work when a person believes Jesus was risen from the dead and now sits at the right hand of God the Father.

⧗ *Now that you have studied it, write out your understanding of the word baptism.*

No Longer Afraid

When Christians speak of the battle known as "spiritual warfare," some shrink back in fear, others don't believe it is a reality, while still others roll up their sleeves and declare, "Let me at 'im! I'll show that devil who's boss!"

Regardless of where you stand on the issue, Paul refused to ignore the conflict perpetually taking place in the heavenlies. However, this man of

gargantuan faith is also quick to remind all of Christendom we are undoubtedly on the winning team.

As we discuss the following verses, it is of vital importance to approach spiritual warfare with a godly attitude and a biblical theology. The death and resurrection of Jesus bestowed to His disciples the legal and spiritual authority to keep Satan under our feet. We must approach spiritual warfare as victors rather than as defeated victims.

> *Having canceled out the certificate of debt consisting of decrees against us, which was hostile to us; and He has taken it out of the way, having nailed it to the cross. When He had disarmed the rulers and authorities, He made a public display of them, having triumphed over them through Him. (Colossians 2:14–15)*

The invisible forces of hell have been defeated by the victory of Jesus on the cross of Calvary. These demonic troops have been legally and eternally stripped of their authority against the lives of believers in Jesus Christ. While it is true they continue to roam about the earth like a gang of juvenile delinquents looking for someone to bully and torment, we, as the blood-bought sons and daughters of God, have been given the authority to declare their defeat.

Prior to the cross and resurrection, Satan had a strong arsenal of spiritual weaponry intended to steal, kill, and destroy. Satan brandished weapons such as disease, lies, financial poverty, pride, hopelessness, and hatred. Jesus demolished every one of those items and more when he died on the cross.

> *The one who practices sin is of the devil; for the devil has sinned from the beginning. The Son of God appeared for this purpose, to destroy the works of the devil. (1 John 3:8)*

The precise reason Jesus came to earth was to destroy the works of the devil. When Jesus declared on the cross, "It is finished" (John 19:30), he wasn't stating merely that his life on earth was over. Jesus was declaring He had completed what he had come to accomplish: to destroy the works of the devil.

The enemy unrelentingly endeavors to convince Christians to give in to hopelessness, anger, or doubt. However, it is required of us to remind the enemy of his defeat by standing on the promises of God, declaring the Word of God, and keeping our eyes and hearts set on Jesus. You don't need to defeat the

devil or his evil wimps, but you do need to remind yourself and those wretched shadows of deceit that you walk in the victory Christ has already won on the cross.

⌛ *Are you in a battle today? When I am in a battle, I ask the Lord to give me a fighting scripture to memorize, pray, and declare. What is a fighting verse that will help you in your battle? Write it below.*

A Public Display

Jesus did not defeat the enemy quietly, but it was a public affair. Jesus courageously and valiantly exposed His defeated enemy, and I can imagine it was quiet a spectacular occasion in the heavenlies.

When He had disarmed the rulers and authorities, He made a public display of them, having triumphed over them through Him.
(Colossians 2:15)

The ancient culture of the early church could picture distinctly what Paul was endeavoring to communicate. At this time in history, when a general or an emperor returned home from an impressive victory, he led an exultant parade in which all the conquered spoils were on display. The prisoners, who had been taken captive, were dragged through the streets in chains. The commander of the winning troops led this procession, followed by the successful soldiers who were shouting and cheering. The victorious captain, dressed in royal garments, rode into the city with his crowned head held high. The city broke into massive rejoicing as the victory parade filled the city streets.

The weaponry and treasures they had captured were also on display. At the end of the grand procession came the defeated foreign ruler himself. He was bound in chains and was forced to walk in disgrace and mortification.

The paramount moment came when the general began to sing a rousing song of victory as he stepped in front of a massive set of stairs and walked up to the throne. This victorious champion regally walked up the steps, turned

toward the enthralled crowd, and sat down in his rightful place of authority. As you can imagine, the crowd roared as the king of the land sat upon the throne.[24]

⧗ *In what area of your life do you need victory today?*

⧗ *Write out a prayer thanking God for the victory in this area of your life.*

It's Time

My friend, it is time for you to cheer because your victorious King is sitting upon eternity's throne. He is the King of the Ages, and His victory has changed everything for you. Now, as a citizen of His unshakable kingdom, you are a member of the supreme choir whose voices will never be silenced. Sing loudly, my friend. Jesus is completely victorious, and the enemy is utterly defeated. It is finished!

⧗ *How did today's lesson stabilize your theology about the victory of Jesus on the cross?*

⧗ *How will you respond the next time you are discouraged and hopeless?*

The Result

Paul could have concluded his impassioned explanation at the climactic point where Christ triumphed over Satan for all of eternity. However, Paul longed for the early church, and therefore the church today, to understand the ramifications of everything Christ's victory assured. He knew unless believers in Christ appropriated this victory personally, there would be little to shout about.

The following passage is longer than usual, but it flows in such a manner that we must read it as a paragraph. So, take a deep breath and read on.

> *Therefore no one is to act as your judge in regard to food or drink or in respect to a festival or a new moon or a Sabbath day—things which are a mere shadow of what is to come; but the substance belongs to Christ. Let no one keep defrauding you of your prize by delighting in self-abasement and the worship of the angels, taking his stand on visions he has seen, inflated without cause by his fleshly mind, and not holding fast to the head, from whom the entire body, being supplied and held together by the joints and ligaments, grows with a growth which is from God.*
>
> *If you have died with Christ to the elementary principles of the world, why, as if you were living in the world, do you submit yourself to decrees, such as, "Do not handle, do not taste, do not touch!" (which all refer to things destined to perish with use)—in accordance with the commandments and teachings of men? These are matters which have, to be sure, the appearance of wisdom in self-made religion and self-abasement and severe treatment of the body, but are of no value against fleshly indulgence. (Colossians 2:16–23)*

Paul directly states we do not achieve our own salvation by following a list of rules, regulations, or legalistic expectations. I have heard it said, "Good people don't get into heaven. Forgiven people do." Paul begs the church to understand what the ultimate victory of Christ has accomplished; there is no need to be intimidated by those who endeavor to attach Christianity to a list of rights and wrongs. Legalism does not produce holiness; imitating Jesus produces holiness. Spending time with Jesus produces holiness; simply loving Him produces a holy life.

Outward behaviors are not the litmus test of a fulfilling walk in Christ; rather, it is the passionate inner love for the One who died for you that will bring meaning and contentment on earth.

⧗ *What is a rigid rule associated with Christianity that has little to do with biblical behavior?*

⧗ *What is your definition of legalism?*

LIVING TREASURE

Therefore as you have received Christ Jesus the Lord, so walk in Him, having been firmly rooted and now being built up in Him and established in your faith, just as you were instructed, and overflowing with gratitude. (Colossians 2:6–7)

PRAYER

Thank You, dear Jesus, that You always lead me in triumph. I will sing a song of praise to you even when I am discouraged or weary. I honor You as the victorious King upon the throne.

WORDS OF WISDOM

Outside of Christ, I am only a sinner, but in Christ, I am saved. Outside of Christ, I am empty; in Christ, I am full. Outside of Christ, I am weak; in Christ, I am strong. Outside of Christ, I cannot; in Christ, I am more than able. Outside of Christ, I have been defeated; in Christ, I am already victorious. How meaningful are the words, "in Christ."

—Watchman Nee

Week 5

Practical Paul

Day 1

The Key

I've already confessed that Colossians may be my favorite book in the Bible; if that is true, then Colossians 3 is likely my favorite chapter in Scripture. This is an incredible acknowledgement because, as you know, I love it all!

Thus far in our captivating study of Colossians, we have solely studied theology and its implications not only for the early church but also for the church of the twenty-first century. Throughout this study, one of my chief goals has been to apply theological truths with practical application to a believer's life in the twenty-first century.

In this week's lessons, we launch into purely practical instruction, which will help each one of us embrace a life that truly honors Christ. We will quickly discover that when we honor Christ with choices both large and small, we create the most wonderful life anyone could ever imagine. While it is true that initially you will be called to die to self, the eventual blessing of obedience will deliver an enormous upgrade to your standard of living.

Keep Seeking

We are about to study verses so unspeakably rich, my heart aches with complete joy and total surrender. My friend, this is the key to living a life of the grandest proportions known to mankind.

> *Therefore if you have been raised up with Christ, keep seeking the things above, where Christ is, seated at the right hand of God. Set your mind on the things above, not on the things that are on earth. (Colossians 3:1–2)*

You, as a believer in Jesus Christ, have indeed been raised up with Christ. Baptism symbolized the complete change that has transpired in you; the old life has passed away and you have been raised to new life in Christ. If this is your reality and your conviction, then you must keep seeking the things above. Paul writes this particular phrase in the imperative, communicating the

urgency of the matter. Seeking the things above is the most joyful assignment ever handed to you.

When my children were small, I daily asked that they place their dishes beside the kitchen sink after dinner. These tiny people, whom I loved more than life itself, had to make the choice whether they would arise from the table, gather their dishes, walk to the sink, gently place their dishes down, and with a smile walk away. It was not an optional request from their mother but an expected behavior. However, there were times when a child would choose to ignore my instructions and the result was not a happy one; consequences inevitably followed disobedience in our home.

Paul's request to "keep seeking the things above" and to "set your mind on things above" is much like the request I gave to my children all those years ago. While it is expected behavior, it is also a marvelous invitation to live the life of your dreams. This is not the only place in Scripture where believers are constrained to seek the riches of eternity rather than the materialism of time.

> **But seek first His kingdom and His righteousness, and all these things will be added to you. (Matthew 6:33)**

As Paul bids Christians to "seek" the things above, it is clear by the verb tense that seeking is not something you complete with only one attempt. Seeking is a lifestyle for the believer rather than a "one and done." Therefore, every day and every hour we must choose to seek a heavenly mindset with an eternal perspective.

ભ *Will you seek Him or seek self-ease?*

ભ *Will you seek righteousness or your preferences?*

ભ *Will you seek to be entertained or to serve?*

ભ *Will you seek what feels good or what is eternally good?*

The word Paul used to communicate "seeking" is the Greek word *zeteo*, from which we derive the English word *zealot*. The word *zeteo* describes a person who is so intent on finding something or someone, he will not take no for an answer. This person is consumed by the object of his or her search. *Zeteo* does not describe a casual seeker but one who is so intense that he puts his whole heart and effort into it.[25]

Paul is urging us to "set" and to "seek." Once we have decided to think about Jesus and to make a conscious effort to place our thought life only on Him and nothing else, then we must put our entire life behind the effort. We must redetermine the object of our affection and then refocus our thoughts and hearts on the incredible realization that we belong to the One who made us.

What a delight it is to look for the Lord every day in all the common areas of life! I am consciously aware of all the places in which He might surprise me. In a breathtaking sunset, a call from a dear friend, a baby's sweet giggle, or the first taste of morning coffee—He is there, and I must acknowledge His presence in the simple pleasures of an uncommon life.

I will also seek Him on the pages of my Bible, in brothers and sisters of the faith, and in a beloved hymn or a new worship song. I can assure you that as you intentionally and daily seek Him, you will find Him.

⧗ *What does it mean to you to "set your mind on things above"? Be practical in your response.*

⧗ *What does it mean to "seek" the Lord? Once again, be practical in your response.*

Mindset

We all have a particular mindset, don't we? Some folks are known for their Southern hospitality while others are known by their New England frugality. There are some who recall a Depression-era mindset, and I am well-acquainted with a Baby Boomer mindset. People are known by their mindset; and we, as the people of God, must be known for our heavenly mindset.

Set your mind on the things above, not on the things that are on earth.
For you have died and your life is hidden with Christ in God.

(Colossians 3:2–3)

There is a marked and obvious difference between setting your mind on things above and setting your mind on the things of this fleeting earth.

An earthly mindset, on the one hand, is consumed with self and materialism. Every waking moment is spent pondering my pain, what I want, what I don't have, or how people treat me. I am obsessed with what I need, what I think, and what I deserve. An earthly mindset is fixated on personal health, personal finances, weight, and personal opinions.

A heavenly mindset, on the other hand, is consumed with the character and glory of God. If you have embraced a heavenly mindset, you likely spend every waking moment thinking about Him, His goodness, and His faithfulness. You are undone by how extravagant His blessings are, His inexpressible joy, and His peace that surpasses all understanding. You fall asleep at night with a worship song playing on repeat in your mind, and you wake up in the morning with a promise in Scripture that stirs your soul.

Perhaps a simple way to determine whether your mindset is earthly or heavenly is by answering these questions:

⧗ *What is the first thing you think about in the morning?*

⧗ *What is the last thing you think about at night?*

⧗ *When trouble comes your way, what do you think about?*

⧗ *When someone hurts your feelings, what do you think about?*

⧗ *What you don't get your own way, what do you think about?*

Engraved in Stone

The phrase "set in stone" is a reference to the fact that when something has been engraved in a rock, it is not likely to change or be erased. My friend, you and I need to engrave Jesus on the walls of our mind so that He is ever with us, ever part of who we are, what we are thinking about, and what we are consistently seeking. The Word of God, our consummate trust in Him, and His unconditional love for us must be "set in stone" in our minds.

Circumstances may try to distract and coerce you to think about things other than the promises of God. The enemy will dangle your personal pain, a regrettable childhood, a broken marriage, or the stress of finances in front of your nose, convincing you to focus on the negative and certainly discouraging aspects of life. However, recognize them for what they are—distractions— and then return to your heavenly and engraved mindset. We all need to "think about what we are thinking about" and perpetually have the Word of God set as our default.

I have developed a power list of four actions that fight against lies and negativity when the enemy throws despair and melancholy my way. Perhaps this quartet of activities will help you to control what is going on in your mind as well:

1. I think about a favorite scripture and begin to quote the Word of God.
2. I start to sing a hymn of the faith or a favorite worship song.

3. I pray for someone else who is going through a difficult time.

4. I count my blessings and stir up a heart of gratitude for all that I have been given.

My friend, set your mind on those potent mental vitamins and don't look back. We all have moments when we are tempted to think damaging thoughts; for me, it is always when I am in bed at night and the lights are turned off. It is in those wakeful moments just before sleep arrives, when my mind drifts to worry, anxiety, and dismay. For you, it might happen when you are paying the bills every month or when walk into a doctor's office or when you are with a negative person. Recognize these awful moments for what they are—a distraction from the truth. We must default to Scripture and to singing a song of vibrant praise to our God.

⌛ *When are you most tempted to think inappropriate thoughts or worrisome thoughts?*

⌛ *How can you fight against these distractions that come from the enemy? Be practical.*

LIVING TREASURE

Therefore if you have been raised up with Christ, keep seeking the things above, where Christ is, seated at the right hand of God. Set your mind on

the things above, not on the things that are on earth. For you have died and your life is hidden with Christ in God. (Colossians 3:1–3)

PRAYER

Jesus, today I give my mind to You. I declare I will set my mind on You and on Your truth. I surrender my worries and my disappointment to You right now. In Jesus' name I pray. Amen.

WORDS OF WISDOM

It is not the busy skimming over religious books or the careless hastening through religious duties which makes for a strong Christian faith. Rather, it is unhurried meditation on the gospel truths and the exposing of our minds to these truths that yield the fruit of a sanctified character.

—Maurice Roberts

Day 2

The Startling Truth

Have you ever heard the phrase, "Well, she is just too heavenly minded to be of any earthly good"? I can assure you there is little or no truth in that statement; the startling truth is most of us are too earthly minded to be of any heavenly good! Think about that for a minute.

If you are truly heavenly minded, you will be of much earthly good. If your mind remains stayed on things above, you will be of so much good, the world around you will be forever changed. As your mind becomes a repository of righteousness, peace, and joy, you will be a walking demonstration of Jesus and His power.

I can assure you the devil does not want you to set your mind on things above, because he knows how potent that one decision is in the life of a believer. The enemy realizes if you adhere to this one Christian discipline—of setting your mind on things above—you will grow enormously in your Christian walk and you will carry the mantle of Christ everywhere you go.

The devil has no idea what you are thinking about because he is not omniscient and is unable to read the mind of a believer. Only God is omniscient; it is His singular power that He shares with no one. Satan is a great observer of the children of God, and he will eavesdrop on your conversations and watch your actions. He uses those considerations as a litmus test to determine what you are thinking about.

⧗ *Can you grade your thought life? Would you give yourself an A+? Perhaps a C?*

⧖ *Why do you believe the enemy is interested in your thought life?*

Today and Tomorrow

Yesterday, we began to study the effect our thought life has upon our faith. Paul has become practical in his approach to our walk in Christ, and his advice to us echoes through the ages:

> *Therefore if you have been raised up with Christ, keep seeking the things above, where Christ is, seated at the right hand of God. Set your mind on the things above, not on the things that are on earth. (Colossians 3:1–2)*

My father always reminded me of the inescapable wisdom of understanding the thoughts I think today become the reality of my tomorrow. If I think angry, bitter thoughts today, I will become an angry, bitter woman tomorrow. Conversely, if I choose to ponder joyful, peaceful thoughts today, that is the woman I will be tomorrow.

> *For as he thinks within himself, so he is. (Proverbs 23:7a)*

We know, because of Satan's confrontation in the wilderness with Jesus, the enemy knows Scripture and he is willing to twist it and use it against the people of God. The enemy clearly understands the awesome actuality that you, as a child of God, will eventually become what you have chosen to consistently think about. This one singular area is of vital importance to the enemy's tactics because if he can convince you to think inappropriate, detrimental thoughts, you will become the wrong person.

What you think about is one of the most crucial choices you make daily. What you choose to think about may be more important than how you spend your money, what you eat, or what you choose to do in your free time. What you think about matters greatly, knowing you become what you think about. I am sobered; are you? Oh! How I don't want to waste my life thinking wrong

thoughts so I will determine to *"set [my] mind on things above"* today and every day of my life.

⧖ *As you recall the thoughts you chose yesterday, do you see how it reflects in the person you have become today?*

⧖ *What is the one thought that truly torments you?*

⧖ *How can you have victory with that one thought?*

Hanging Out with Jesus

I have always loved being with my friends—whether it was in the classroom, at my home, in a dormitory room, or riding bikes together. There has been something both fulfilling and encouraging whenever I was simply hanging out with my friends.

I have realized over the years that Jesus loves to "hang out" with me infinitely more than I love being with my chosen friends. He calls me by my name to spend time in His presence.

For you have died and your life is hidden with Christ in God.
(Colossians 3:3)

Jesus has bid us die with Him and therefore to leave an earthly mindset in the watery grave of baptism. We have died to self-promotion, materialism, shame, worry, and fear. When we attempt to resurrect that which we have died to, it's symbolic of walking down the rows of tombstones at a cemetery, digging up the graves, and desiring to talk to the coffins.

Now, gloriously and eternally, your life is hidden with Christ in God. You and Jesus are "hanging out together" in the richness and fullness of God the Father. You are conferring with Jesus about the promises of God and smiling at His goodness. When Jesus reminds you of the faithfulness of the Father and you agree with a hearty, "Amen!" Jesus has given you access to the presence of God Himself, and you are safely hidden under the shadow of His mighty wings.

> *For You have been my help,*
> *And in the shadow of Your wings I sing for joy. (Psalm 63:7)*

This is the spectacular result of choosing to "hang out with Jesus"—He takes you to His Dad and you sing for Him. You are in the presence of the Father where there is always fullness of joy; what an absolute delight is yours!

> *You will make known to me the path of life;*
> *In Your presence is fullness of joy;*
> *In Your right hand there are pleasures forever. (Psalm 16:11)*

My friend, please do not allow the enemy to deprive you of this precious and strengthening experience of hanging out with Jesus. It is the greatest joy of my life to snuggle into the presence of God and enjoy time alone with Jesus, His Son. Satan would prefer you do anything at all rather than spending time enjoying the presence of God; he tries to withhold joy from your life by distracting you with busy-ness, weariness, discouragement, or entertainment. We must declare wholeheartedly, "I will not be distracted! I will spend time with Jesus!" And then we must follow that stirring declaration with our actions.

⏳ *What does it mean to you to "hang out with Jesus"?*

⧗ *How do you do this in a practical yet meaningful way?*

The Secret Place

There is a secret place in the heart of God the Father aching to be with you. This secret place holds treasures unknown that are yours simply when you spend time with Him. He longs to hide you in this place—far away from stress and loneliness. In this quiet place, you are complete in Him and have nothing to prove.

As you determine to set your mind on things above and linger with Jesus, the secret place will be yours perpetually. The only place where a person is able to tap into the resources that build an abundant life is in this secret place with God. I will meet you there!

⧗ *Have you been to the secret place in God? If so, how did you get there?*

⧗ *What is a treasure you have discovered in this secret place?*

LIVING TREASURE

Therefore if you have been raised up with Christ, keep seeking the things above, where Christ is, seated at the right hand of God. Set your mind on the things above, not on the things that are on earth. For you have died and your life is hidden with Christ in God. (Colossians 3:1–3)

PRAYER

Sweet Jesus, I choose today to spend time in the secret place with You and Your Father. Teach me Your ways and delight me with Your presence. In Jesus' name I pray. Amen.

WORDS OF WISDOM

We must remember God more often than we draw breath.

—Gregory of Nazianzus

Day 3

Something Stinks

Many years ago, we moved into a massive home that was just perfect for our large family. It had five bedrooms for our seven-person family, three and a half baths, and enough closet space for everyone. It was a dream come true for this mom who had for years fit my enormous family into homes that were much too small. This ginormous home needed lots of work, but I was thrilled with the space while not necessarily with the condition. I knew I would be content here for years and pictured my family having bonfires in the yard, eating Thanksgiving dinner in the huge dining room, and playing games at the kitchen table.

After we had lived in this home for only a week, I noticed an odor that was faint at first but gradually grew stronger and stronger by the day. It was a foul, putrid, horrible stench and my family was ready to move out. I had the carpets cleaned, I burned fragrant candles, I used bleach everywhere bleach could be used—but still that stink was winning in our home.

We sprayed aromatic spray in every closet and behind every door, and even had the plumber come to clean out all the drains and toilets. This malodor was becoming more expensive by the day, and we were desperate to find its source. The odor was finally so pervasive in our home that it was hard to eat, entertain guests, or even fall asleep at night. My children began to beg me to live with other people.

After we had lived with this odor for about ten days, the former owner knocked at my door. She wondered if we had seen her cat anywhere around the house or in the garage. I could honestly and humbly tell her, "No, I have not seen your cat anywhere. I am so sorry."

But I had smelled her cat! We had to engage the services of pest control to invade our vast basement, find the remains of the cat, and dispose of it. The scent of that cat lingered for weeks, but I never had the heart to tell the former owner what had happened.

My friend, you don't want something that is dead to be hanging around even in the basement of your heart. What is dead must go, never to be seen again.

What a List!

I, like Paul, love lists. I love Christmas lists, grocery lists, to-do lists, and shopping lists. I love lists of names, lists of books to read, and lists of places to visit. Paul begins his nonnegotiable list with those things that are supposed to be dead in us because we are alive in Christ.

> *When Christ, who is our life, is revealed, then you also will be revealed with Him in glory. Therefore consider the members of your earthly body as dead to immorality, impurity, passion, evil desire, and greed, which amounts to idolatry. (Colossians 3:4–5)*

This is your obituary column—the list of character traits that have been put to death the day Christ came alive in you. Not all of the items on this list will apply to you, but read through each one and remind yourself that this former sin is dead, gone, and buried—never to be seen again.

The first dead character trait on Paul's awful list is immorality or fornication, which is sex outside the bonds of marriage. The Greek word Paul uses to communicate this sin is *porneia*, from which we derive the English word *pornography*.[26] The ancient world was notorious for loose morals and sexual perversion; Paul reminds believers of every generation that we are to exhibit self-discipline and obedience to God knowing it is the only road to complete freedom and abundant life.

The second dead character trait is moral uncleanness. While a sexual act may not have taken place under the category of "impurity," the person guilty of this compromising choice demonstrates crudeness or coarseness regarding sexual behavior or speech. This behavior might include provocative dress, inappropriate movies, questionable books, music, filthy language, or one's thoughts.

The third deceased behavior is passion or uncontrolled lust. Although this may pertain to sexual activities, it can also refer to any habit over which you have no self-control such as eating, spending, gossiping, or showing anger.

An evil desire—the first character trait—is simply a thought or an impulse that precedes a lustful action.

The fifth trait, covetousness or greed, is the perpetual greedy desire to have more as well as to refuse to be content. Covetousness may also be defined as desperately craving what someone else has to the extent discontentment or bitterness simmers in your heart.

As we ponder these five attributes—immorality, impurity, passion, evil desire, and greed—that have no place in the life of a believer, we will quickly realize what they have in common. Each one of those prohibited behaviors is birthed in a life shaped by materialism and emotions rather than by the hand and heart of God.

⌛ *Have any of these five attributes been part of your life before Christ? If so, which ones?*

⌛ *Are any of these five attributes still a part of your life today?*

⌛ *How can you remove them from your heart and life?*

Practical Boundaries

Now that we understand we will become what we think about, we cannot afford to even think about these things on Paul's despicable list. We must not even entertain the thoughts of impurity, greed, or evil desire. Those characteristics are dead and buried and we have been born again. If we allow these

habits to raise out of the dead, we will realize, and so will others, that something stinks in our heart.

A very practical boundary for your renewed mind in Christ is to refuse to think about any one of these five fetid attributes.

Perhaps one of those traits formerly played a large role in who you were, but now that you know Christ and are alive in Him, that trait is dead and buried. My friend, please don't dig up what has been put to extinction under the watery grave of baptism.

It's preposterous to desire something that has been declared dead when we consider the wonderful life that is now ours in Christ. When a dead attitude is allowed to remain in your heart, the odor will be unbearable. People will not want to come close to you because of the stink that is pervasive, nor will they desire to eat any of your fruit. You were made to live a glorious life with no part of anything that is dead.

⧖ *Why do you believe it is so difficult to abstain from sinful behaviors that seemed so pleasurable before Christ?*

⧖ *What has worked for you? Is there a spiritual discipline or choice that has helped you to be victorious?*

LIVING TREASURE

Therefore if you have been raised up with Christ, keep seeking the things above, where Christ is, seated at the right hand of God. Set your mind on the things above, not on the things that are on earth. For you have died and your life is hidden with Christ in God. (Colossians 3:1–3)

PRAYER

Jesus, I pray You will help me keep the past in the past. I ask that You give me the strength to walk away from what is wrong and walk toward that which is honorable and true. Thank You for Your power. In Your name I pray. Amen.

WORDS OF WISDOM

Sin forsaken is one of the best evidences of sin forgiven.

—J. C. Ryle

Day 4

Nothing but the Truth

When my children all lived at home, when they came downstairs to a breakfast of donuts or pancakes nearly every Saturday morning, beside each one of their plates sat a list. We called it "Mama's Saturday Morning List." They knew on Saturday mornings, before they could play outside, watch television, go to a friend's home, or read a book, they had to complete their Saturday morning chore list.

I didn't give them a list to be mean or demanding but to ensure we all had the opportunity to serve the family and eventually have some fun. My Saturday morning list was tailored for each child's age and ability level but also for their preferences. I knew Christopher loved to clean out the car so that particular job was generally on his list. Joy enjoyed organizing so the jobs of sorting and arranging were given to her. We were a family. We loved like a family, worked as a family, and played as a family. "Mama's Saturday Morning List" made sure of it!

⧖ *What type of lists have you made over the years?*

⧖ *What is the advantage of using lists to accomplish various responsibilities?*

Paul's Second List

We studied one of Paul's lists yesterday, but being the list-maker that he was, one list for the church at Colossae was not sufficient for the pragmatic and detailed Paul. He gave another list to this floundering church who needed some healthy boundaries in their behavior.

> *For it is because of these things that the wrath of God will come upon the sons of disobedience, and in them you also once walked, when you were living in them. But now you also, put them all aside: anger, wrath, malice, slander, and abusive speech from your mouth. Do not lie to one another, since you laid aside the old self with its evil practices.*
>
> *(Colossians 3:6–9)*

When writing the first list, Paul instructed believers in Christ to bury those awful habits and never dig them up again. In this second list, however, Paul encourages Christians to "put them aside," as if removing dirty clothes after a long day working in the garden or perhaps running an arduous marathon. These are all filthy traits listed by Paul, not fitting for a man or woman who has been washed by the blood of the Lamb. As I consider the second list penned by Paul, I realize most of us probably still have one of these foul garments lingering in our emotional closets.

⧗ *Read over the second list written by Paul. Which one of these grimy attitudes has found its way into your emotional closet?*

- Anger is a smoldering hatred for someone or for their actions; this type of anger often violently erupts in passionate words or retribution.
- Wrath is different than anger; rather than smoldering, it is a sudden outburst of uncontrolled rage.
- Malice is wishing ill will toward someone.
- Slander is injuring a person's reputation.
- Abusive speech can be obscene but also includes any words that are unkind, cruel, or angry.

- Lying is telling something that is not true. The devil is the father of all lies (John 8:44); therefore, when we utter a falsehood, we are repeating what the enemy has whispered in our ears.

True or False

Although all six of the sins on the second list that Paul wrote are serious and troublesome, we will just focus on one of these actions of reprehensible behavior—lying.

Paul chose to use the Greek word *pseudomai*, which means any type of falsehood. It is a word picture of someone who presents a false image of himself or who deliberately walks in a pretense that is untrue. The word *pseudomai* could also describe a person who intentionally misrepresents the facts or what is known to be true.

Most people do not deliberately set out to lie, but when a moment of temptation arises, we are likely to misrepresent the truth about our abilities, our relationships, our finances, or our achievements. We might say something we don't actually know to be true, or we might slightly twist the facts to our own advantage. Some people might give in to the temptation to magnify a story to make themselves look better. Any of the scenarios I have used to describe *pseudomai* are what the Bible would classify as a lie.

⏳ *Is* pseudomai *a problem in your life? If so, how would you describe your tendency to embellish or falsify the truth?*

Pseudomai, or telling a falsehood, is clearly forbidden in the Bible so we must take off this putrid garment and burn it.

Truthfulness is of vital importance in the kingdom of God; Jesus identified Himself as *"the way, the truth and the life"* (John 14:6). When we settle for anything less than the pure truth, we are denying who Jesus is.

Foundational

Truth is the foundation for all successful relationships; a marriage must not be built upon lies. Caring, responsible parents will always tell their children

the truth as is appropriate for their age. Friends cannot lie to one another and expect to establish a trustworthy relationship. Children cannot lie to their parents and expect to live a life of blessing and peace.

We must always be truthful with the people in our life; it is nonnegotiable.

But speaking the truth in love, we are to grow up in all aspects into Him who is the head, even Christ. (Ephesians 4:15)

Speaking the truth is sincerely a sign of Christian maturity. How wonderful to know the Holy Spirit is available to help us in our weakness. He will give us the power to discern right from wrong and to tell the truth even when it is excruciatingly difficult. If you tend to lie or exaggerate, remind yourself there is no such thing as "a little white lie." All lies are black.

If you have hurt someone with your lies or exaggeration, ask that person to forgive you; you might also want to get on your knees and ask God to forgive you as well. My friend, the blessing will be enormous when you begin to tell the truth.

LIVING TREASURE

Therefore if you have been raised up with Christ, keep seeking the things above, where Christ is, seated at the right hand of God. Set your mind on the things above, not on the things that are on earth. For you have died and your life is hidden with Christ in God. (Colossians 3:1–3)

PRAYER

Jesus, I pray today You will help me take off my old wardrobe of anger, wrath, malice, slander, and abusive speech. Most of all, dear Lord, I pray You will help me tell the truth all the time. I sincerely want to honor You with my thought life and with my words. In Jesus' name I pray. Amen.

WORDS OF WISDOM

Everyone may be entitled to his own opinion, but everyone is not entitled to his own truth. Truth is but one.

—Doug Groothius

Day 5

Something New

Who doesn't love something brand-sparkling new? I love new furniture, new babies, and new books. Even though I don't like to spend money or go shopping, I will admit that I do love a new pair of shoes, a new dress, or a new scarf. I especially love new clothes when someone else has shopped for those clothes and paid for them. There is simply nothing like it!

I love a new season—when the frigid cold of winter turns to the warmth and color of spring, or when those hot days of summer ease into the cooler and more colorful days of autumn.

I so enjoy a new friend. When I am on an airplane or visiting a new group of women, I love to look into their eyes and just wonder, "Will this person be a new friend of mine? I hope so!"

I love to try new foods, travel to new places, and make precious new memories. There is something fresh and exciting about a new adventure or a new experience. I am so thankful when the Lord blesses me with something brand-spanking new!

⧗ *What "new" things do you love?*

⧗ *Do you have a hard time with transition? Would you prefer to keep the old?*

Put It On

Although the Lord never changes, He loves to stir up change and to make all things new in the lives of His beloved children.

And have put on the new self who is being renewed to a true knowledge according to the image of the One who created him—a renewal in which there is no distinction between Greek and Jew, circumcised and uncircumcised, barbarian, Scythian, slave and freeman, but Christ is all, and in all. (Colossians 3:10–11)

We are burying list number one that we studied on Day 3 of this week and now are putting off list number two we studied yesterday. Today, we are putting *on* the new self who has been renewed in Jesus Christ. As we look into the mirror of Christ, we see ourselves becoming more and more like Him.

Everything about you is new and improved because now you look like Christ, you talk like Him, you act like Him, and you are called to love like Him. Jesus has chosen the new you and has paid for it. All you must do is put it on.

There are other times in Scripture where we are instructed to put something on. We are also told by Paul to put on the full armor of God:

Put on the full armor of God, so that you will be able to stand firm against the schemes of the devil. (Ephesians 6:11)

The prophet Isaiah advised the children of God to put on the garment of praise:

To appoint unto them that mourn in Zion, to give unto them beauty for ashes, the oil of joy for mourning, the garment of praise for the spirit of heaviness; that they might be called trees of righteousness, the planting of the Lord, that he might be glorified. (Isaiah 61:3 KJV)

Everyone

Everyone can be a new creation in Christ, and everyone can be the beneficiary of a brand-new wardrobe. Everyone in Christ can choose to embrace a heavenly mindset. Everyone. How wonderful to know you are not left out of the "everything new" Christ has provided for the world!

A renewal in which there is no distinction between Greek and Jew, circumcised and uncircumcised, barbarian, Scythian, slave and freeman, but Christ is all, and in all. (Colossians 3:11)

It does not matter what your national heritage might be, what your past religious affiliations are, or what your cultural background is. Jesus takes no thought of your economic or social history. He longs to be part of your life regardless of who you are or what you have been. When you accept Jesus as your Lord and Savior, you become one of His very own; you now belong to Him.

Since we all have the same new nature in Christ as well as the same fresh wardrobe, we can no longer use our past as an excuse for unacceptable behavior. Perhaps you have heard comments like these over the years:

- I am Italian. We are yellers; our voices are just louder than anyone else's.
- I am Irish. We have tempers; get over it.
- I am Hispanic. We are just more passionate than most people.
- I am German. I don't need to show you how I feel. It's just who we are.

Now, my friend, you are defined by who you are in Christ not who you were before you knew Christ as your Savior. Every person who knows Christ, regardless of their emotional baggage, their heritage, or their past pain, can have a heavenly mindset and a new wardrobe. It's already been paid for!

⧖ *This week, as you ponder what you have learned in Week 5, default to thinking about Jesus rather than worrying.*

⧖ *What Bible verse will you think about this week?*

⧖ *What song will you sing to yourself this week?*

⏳ *Who will you pray for this week?*

⏳ *Count three of your blessings below and thank the Lord for them:*

1. _____

2. _____

3. _____

LIVING TREASURE

Therefore if you have been raised up with Christ, keep seeking the things above, where Christ is, seated at the right hand of God. Set your mind on the things above, not on the things that are on earth. For you have died and your life is hidden with Christ in God. (Colossians 3:1–3)

PRAYER

Jesus, I thank You that I am a new person in You! Thank you for my new mindset and my new wardrobe. I commit my past, my present, and my future to You. In Jesus' name I pray. Amen.

WORDS OF WISDOM

By reading the Scriptures I am so renewed that all nature seems renewed around me and with me. The sky seems to be a pure, a cooler blue, the trees a deeper green. The whole world is charged with the glory of God and I feel fire and music under my feet.

—Thomas Merton

Week 6

What a Difference He's Made!

Day 1

He's Crazy About Me

If I was asked to teach on the most valuable passage of scripture in the Bible for women, this next passage would be what I would likely select. The verses we are studying this week are vital for you, as a woman of God in the twenty-first century, to walk in your destiny in Christ. The following excerpt from the theologically sound book of Colossians reveals exactly what it takes for a man or a woman to live an abundant life of rare impact.

These verses also have the potential to maximize the legacy you will leave your family. In short, they have the God-charged capacity to enable you to out-live your life. This unforgettable passage of scripture holds the blueprint for joy, peace, hope, and victory in every area of your life.

⧗ *What do you think is the most valuable passage in Scripture for women?*

⧗ *If you are a new believer, and are unable to answer the above question, perhaps this would be a better question. If you could ask the Lord one specific question to help you live a life of joy and hope, what would that question be?*

Chosen

Every woman's heart's desire is to be chosen by someone. This longing to be "chosen" is initiated extremely young.

 Ᏻ *Little girls want to be chosen to be someone's BFF.*

 Ᏻ *School girls want to be chosen to be on the kickball team.*

 Ᏻ *Teenagers want to be chosen to go to the prom.*

 Ᏻ *Seniors in high school want to be chosen for the scholarship.*

 Ᏻ *Young adult women want to be chosen for the job.*

 Ᏻ *Women want to be chosen to be loved, engaged, and married.*

My friend, regardless of who has rejected you, ignored you, or overlooked you, you can rest assured knowing the God of the universe and creation has chosen you as His very own.

> **So, as those who have been chosen of God, holy and beloved, put on a heart of compassion, kindness, humility, gentleness and patience.**
> **(Colossians 3:12)**

The Father has specifically and intentionally chosen you to serve Him wholeheartedly at this moment in history. As God looked across the canyons of time, wondering who He could use at the first part of the twenty-first century, His eyes landed on you. You have been chosen by the One who knows you best and loves you most.

> **For the eyes of the LORD move to and fro throughout the earth that He may strongly support those whose heart is completely His.**
> **(2 Chronicles 16:9a)**

In the Bible, God's people are chosen for a specific purpose or destiny. God conceived of a redemptive plan of grace even before the creation of the world, and you are part of it. You have been set apart to live for God, to be a demonstration of the victory of the cross, and to bring the character of God to this generation. You have been chosen to demonstrate the power of God, to encourage others, and to pray for the sick. You have been chosen.

 ⧗ *Fill in the blank: I have been chosen to* _____

One of the most exciting aspects of the first twelve words of Colossians 3:12 is that it states clearly what God's opinion is of us. My friend, God is so in love with you that He summoned you to come to Him as His very own. When nobody else seems to want you, remind yourself daily that God wants you! He is head over heels in love with you and desires you as His very own.

The word for "chosen" Paul uses in this verse is the Greek word *eklektos*; this is a compound word made of the words *ek* and *lego*. *Ek* means "out" while *lego* is translated as "I say." When these two words are joined together, the new word means "Out! I say!"[27]

God cares about you so deeply that He called you out of the domain of darkness and He wooed you with His love. You, my friend, have been personally chosen by God.

The Holy Spirit in this verse, and in many other passages in Scripture, identifies chosen people with two adjectives, *holy* and *beloved*. Let's linger and take a piercing look at these two words that the Holy Spirit used to describe you.

Are you ready for a theological question? Here we go.

 03 *Does God choose everyone? Or does He just choose a select few?*

It's a challenging question that the greatest theological minds of every generation don't agree on. It's healthy for us to think about it, to pray about it, and to gather scriptures.

Precious Beyond Words

There are times when it is valuable to understand what a word does *not* mean before it is possible to ascertain its true meaning. This is one of those times. Holiness is not legalism, dressing like a pilgrim, refusing to wear makeup, or walking around like a prune. Holiness is not criticizing teenagers or coming across as grumpy and unbending. Holiness is not refusing to play cards, shunning nonbelievers, or dismissing work on Sundays.

Holy, as used in this verse, is the Greek word *agios*, meaning "things which on account of some connection to God possess a certain distinction and claim."[28]

My friend, the Holy Spirit wants you to know because of your connection to God, you possess a certain distinction. You are a distinguished woman of the faith.

Agios also carries with it the implication of something so hallowed that it must be considered precious. You are chosen by God and He considers you very precious to His kingdom.

Agios can also be translated as "persons whose services God employs."[29] You are chosen because of love, deemed as most precious and set apart for a specific reason in the kingdom of God. Your heavenly resume says "holy" on every page.

Finally, *agios* can mean "set apart for God . . . exclusively His."[30] God holds exclusive rights on your life, your service, and where you will spend eternity. The Father refuses to share you with the enemy, with selfishness, or with the culture. You belong to Him and to Him alone. Knowing God holds exclusive rights on your life, you must, in response, live a life exclusively given to the plans and purposes of God. My friend, do not waste your life for one minute by flirting with the world. Do no give your life to anger, bitterness, or a controlling nature. Allow your one glorious life to be a vivid demonstration of the holiness of God!

Holiness is not about the clothes you wear, the makeup you refuse to wear, or any other number of visible attributes, but it is who you are in Christ Jesus. Holiness is not even attached to what you do, but it is how God sees you and values you.

I belong to Jesus therefore my actions and my tongue are different. That is holiness.

When what I do flows out of who I know I am in Christ. That is holiness.

Because He chose me, I now choose differently. That is holiness.

⧗ *Write your personal definition of the word* holy.

⧗ *How has knowing that you are holy in God's eyes revolutionized the way you view yourself?*

Dearly Loved

Not only are you chosen, not only are you holy, but also you are dearly loved by God the Father, who is the Maker of heaven and earth. You are, quite simply, His beloved. My friend, I can assure you will love knowing you are dearly loved by the Lord.

The word Paul used to express "beloved" or "dearly loved" is the Greek word *agapao*, which is a dear and tender word in this ancient language. *Agapao* has several beautiful meanings, all of which I pray will nestle into your heart, so you begin to know the love of God intimately.

Agapao means "to welcome . . . to love dearly."[31] When God called you out and chose you as His very own, He opened His arms wide to welcome you into His presence and into His family. The Father loves you dearly, my friend. He loves you more than words can express or more than there are grains of sand on the ocean floor.

Agapao also can be translated as "to have a preference for [someone], wish well to."[32] Isn't it wonderful to know that God prefers you? He would rather spend time with you than anyone else; every time you talk to Him, He leans down and listens simply because you are His preference and priority. God wishes you well on your journey on earth; He has plans for you that are at once magnificent and wonderful. He is cheering for you as you walk along the pathways of life.

Agapao has one more interesting yet sobering meaning: "being willing to suffer for the other person's wellbeing"[33] God loves you so much that He was willing to send His only Son to suffer and die for you. If that's not being dearly loved, I don't know what is.

⧗ *Who has loved you the most, other than the Lord, in your lifetime?*

⧗ *How did this person express his or her love for you?*

⧗ *Who have you loved the most in your life?*

⧗ *How have you expressed your life for this person?*

LIVING TREASURE

Let the peace of Christ rule in your hearts, to which indeed you were called in one body; and be thankful. Let the word of Christ richly dwell within you, with all wisdom teaching and admonishing one another with psalms and hymns and spiritual songs, singing with thankfulness in your hearts to God. Whatever you do in word or deed, do all in the name of the Lord Jesus, giving thanks through Him to God the Father.

(Colossians 3:15–17)

PRAYER

Father, I thank You that I am chosen, holy, and dearly loved. Thank You for choosing me to serve you. Thank You that my life is a perfect fit for Your holy nature. Thank You, Jesus, for dearly loving me. In Your name I pray. Amen.

WORDS OF WISDOM

God loves each of us as if there were only one of us."

—Saint Augustine

Day 2

Are You a Put-On?

When I was growing up, if someone referred to you as being a "put-on," it was *not* a compliment. In our teenage vernacular, being a "put-on" was someone who was fake or pretended to be something they were not. No one wanted to be accused of being a put-on.

However, as we begin to read this next stirring passage of scripture, I believe being a put-on is exactly what Christ is hoping we will become. The virtue of being a put-on is determined by what you choose to "put on."

⧖ *When you read the phrase "being a put-on," what does it mean to you?*

⧖ *Write the names of two or three of your high school friends below and spend some time praying for them today:*

1. _____

2. _____

3. _____

Dressing Properly

As you determine how to dress for the day, you must look in your closet and choose the clothes most appropriate for the weather, your transportation, or what the occasion requires. As you assess what outfit will be most suitable for the day, you then must reach into the closet, take the clothes off the hangers, and put them on your body. As far as I know, clothes don't jump out of the closet, off the hanger, and onto your body! You, as the one who will be wearing them, must choose to put them on.

*So, as those who have been chosen of God, holy and beloved, put on a
heart of compassion, kindness, humility, gentleness and patience.*
(Colossians 3:12)

So it is with our spiritual wardrobe, my friend. You must choose what you
will wear on any given day. You should take into consideration who you will be
with, what the occasion requires, and what you know you shouldn't leave home
without. If you don't thoughtfully and intentionally choose the vital compo-
nents of your spiritual wardrobe, you will never put these divine traits on. You
will likely go into circumstances and deal with relationships ill prepared and
underdressed. You must put on all that God has advised and provided for. You
simply must.

Heart of Compassion

Oftentimes, what we put on our bodies first as we dress for the day might
not seem obvious to those around us, but we are fully aware what we have on
under skirts, blouses, slacks, dresses, and outerwear. We know what condition
those underlying garments are in, how clean they might be, and even if they fit
well or not. So it is with a heart of compassion.

It is impossible to pretend to be compassionate; you either are or you aren't.
Paul couples the attribute compassion with the word *heart*, which implies the
deepest part of you. Compassion always makes a profound and memorable dif-
ference in the life of the one who receives its benefit.

And of some have compassion, making a difference. (Jude 1:22 KJV)

Compassion, according to Scripture, is the deepest type of mercy. It is
opening your heart and allowing love, understanding, and mercy to flow
toward people. I have discovered this type of heartfelt compassion springs
naturally when I see a picture of children in Africa, or view the ravages of an
earthquake in Turkey, or listen to a missionary speak of those being persecuted
for their faith. What is more difficult for me is to ignite this same type of com-
passion for an ornery family member, a fractious person at work, or an unrea-
sonable neighbor.

We must decide to put on a heart of compassion daily in our homes, in
the workplace, and at church. We are called by the One who dearly loves us to
exhibit the same type of mercy and forgiveness that He gave to us.

I have also learned, it is not hard-hearted attitudes, indignation, or personal opinions that change a situation. Compassion makes a difference in every climate and at very occasion. It is a staple of our spiritual wardrobe, and we must never leave home without putting it on.

A critical tongue and a judgmental attitude will never soften anyone's heart to wisdom or much-needed change. Compassion from the heart makes a difference.

Yelling, demanding, whining, and pouting do not have the intrinsic power to instigate an adjustment. Deep, swelling compassion makes the difference.

⌛ *Are you naturally a compassionate person, or is this attitude difficult for you?*

⌛ *Why do you believe "a heart of compassion" is the first piece of spiritual clothing Paul calls us to put on?*

Kindness

Kindness is the ability to be adaptable or compliant to the needs of others; it is a willingness to serve and to embrace personal change for the purpose of meeting the needs of others. Kindness is the most attractive piece of spiritual clothing you will ever choose to put on. It is heartfelt kindness that turns an ordinary woman into a breathtakingly beautiful woman; kindness is the loveliest choice you will ever make.

⌛ *Who is the most beautiful woman you know?*

⧗ *What is it that makes her beautiful?*

I have known women who were physically gorgeous, but there was nothing captivating or appealing about them due to their lack of kindness. Conversely, I have known rather plain women over the years who were strikingly gorgeous just because they were kind.

The Bible instructs love is kind (1 Corinthians 13:4) so it follows that if you truly love someone, kindness will surely follow. Kindness is love in action; perhaps kindness is the final litmus test for love.

It's relatively easy to be kind and sweet to the people you greet at church on Sunday morning, but are you sincerely kind to your husband every day? Do you speak in a kind tone of voice to him? Do you show your love for him by generous actions of service?

Are you always kind to your mother? To your teenager? To your toddler? To your in-laws? Kindness is a nonnegotiable attribute for a woman of God who loves Jesus. Kindness is written on our hearts and we know of no other way to respond.

> **She opens her mouth in wisdom,**
> **And the teaching of kindness is on her tongue. (Proverbs 31:26)**

⧗ *Who is the kindest person you know?*

⧗ *Can you write a note to this person, telling how you appreciate him or her?*

Humility

Humility is the willingness to stoop down to any level that is needed; it is to be aware of one's own littleness.

As I think about that particular definition of the word *humility*, it scrapes against our twenty-first-century mindset like fingernails on the chalkboard of life, doesn't it? We are taught to "look out for number one" and to cultivate "the power of self." I can assure you that neither of those admonitions are biblically sound or spiritually accurate.

The word *humility* in ancient literature was used to describe servants who were on the lowest rung of society. Humility was not viewed as a positive attribute until the Holy Spirit captured this word and used it to describe Jesus and His followers. I hope you will quietly and attentively read the following passage of scripture that describes the humility of Jesus and the invitation to be humble like Him:

> *Do nothing from selfishness or empty conceit, but with humility of mind regard one another as more important than yourselves; do not merely look out for your own personal interests, but also for the interests of others. Have this attitude in yourselves which was also in Christ Jesus, who, although He existed in the form of God, did not regard equality with God a thing to be grasped, but emptied Himself, taking the form of a bond-servant, and being made in the likeness of men. Being found in appearance as a man, He humbled Himself by becoming obedient to the point of death, even death on a cross. For this reason also, God highly exalted Him, and bestowed on Him the name which is above every name, so that at the name of Jesus EVERY KNEE WILL BOW, of those who are in heaven and on earth and under the earth, and that every tongue will confess that Jesus Christ is Lord, to the glory of God the Father. (Philippians 2:3–11)*

⧖ *Who is the humblest person you know?*

⧗ *Why is it so difficult to put on humility?*

Gentleness

A gentle person has put on a mildness of disposition that is inviting to others. The character trait of gentleness, when applied to human relationships, implies begin adaptable to others. A gentle person is more apt to ask questions rather than to pontificate or boast of his or her opinions. Gentleness encourages one to listen more than one might talk.

Paul, although he was well-educated, an orator, and a leader, knew the value of possessing a gentle nature. He realized a gentle nature was more likely to change a person's life than was a stubborn forcefulness. Paul also wrote the following verses in Scripture; his heart is intent on being amenable in order to win people for Christ:

> *To the Jews I became as a Jew, so that I might win Jews; to those who are under the Law, as under the Law though not being myself under the Law, so that I might win those who are under the Law; to those who are without law, as without law, though not being without the law of God but under the law of Christ, so that I might win those who are without law. To the weak I became weak, that I might win the weak; I have become all things to all men, so that I may by all means save some.*
>
> *(1 Corinthians 9:20–22)*

Choosing to put on gentleness is contrary to what the flesh might tell you to do; the Holy Spirit rarely agrees with our fleshly responses. The Holy Spirit is famous for calling us away from the desires of the flesh and into God's highest and best for our lives. Gentleness is God's highest and best for your life.

Gentleness might ask these questions of you:

- How can I accommodate my desires to help this person?
- How can I change so that I can make life easier for you?
- How can I serve you and meet your needs more effectively?

Jesus denied His own comfort and adapted to human flesh so He could reach all mankind for all eternity. The Holy Spirit is intent on convincing us to put on gentleness due to the difference it will make in the lives of others.

- If you can put on gentleness, you might lead someone to repentance.
- If you can put on gentleness, you might lead someone to truth.
- If you can put on gentleness, you might help someone come to their senses.
- If you can put on gentleness, you might help someone escape from the snare of Satan.

⧗ *Do you believe a gentle person is showing strength of character or weakness of character? Explain your answer.*

Patience

When you have put on compassion, kindness, humility, and gentleness, then you must put on patience as an all-weather protective garment.

Patience means long-suffering; if we reverse those two words, it means to suffer long. I am sure no one reading these words is excited about the possibility of "suffering long." However, patience is an influential safeguarding piece of spiritual clothing that will give you the perseverance you need while you wait for others to change. When you put on patience, you are willing to wait a long time for a person or a situation to resolve itself.

You basically have two options, my friend: you can put on patience, or you can be frustrated. And while you wait patiently, you will continue to wear compassion, kindness, humility, and gentleness. God expects you to wait well and to be His show and to tell of these attractive and compelling spiritual garments.

⏳ *What are you waiting for today?*

⏳ *What does it mean to you to "wait well"?*

LIVING TREASURE

Let the peace of Christ rule in your hearts, to which indeed you were called in one body; and be thankful. Let the word of Christ richly dwell within you, with all wisdom teaching and admonishing one another with psalms and hymns and spiritual songs, singing with thankfulness in your hearts to God. Whatever you do in word or deed, do all in the name of the Lord Jesus, giving thanks through Him to God the Father. (Colossians 3:15–17)

PRAYER

Jesus, I want to be a put-on! I desire to intentionally put on the spiritual garments of compassion, kindness, humility, gentleness, and patience. When I am weak, Lord, I ask You to be strong in me. In Jesus' name I pray. Amen.

WORDS OF WISDOM

Wait on God and He will work, but don't wait in spiritual sulks because you cannot see an inch in front of you! Are we detached enough from our spiritual hysterics to wait on God? To wait is not to sit with folded hands, but to learn to do what we are told.

—Oswald Chambers

Day 3

The Finishing Touch

Early in our married life, when Craig and I only had two little boys, we were invited to a gala dinner to celebrate a visiting dignitary to our city. As the pastor of a growing church, Craig knew it was an honor to be invited to such an event; and we were both giddy with excitement as we readied ourselves for this once-in-a-lifetime event.

It was during the frigid days of January, and we lived in a city known for its harsh winters. The night of the banquet, I put on my prettiest dress, fixed my hair and makeup like a teenage girl going to the prom, and borrowed my mother's pearl earrings. As we prepared to go outside into the below-zero weather, I realized I had made a grave error in judgment. I only had one winter coat and it was stained with baby spit-up and was more appropriate for shoveling snow than going to a prestigious dinner. But it was all I had; there were no other options.

While what I was wearing under my winter coat was well-chosen and appropriate for the event, my winter coat was absolutely awful. Craig and I quietly got in the car together, drove downtown without saying a word, parked our car, and approached the five-star restaurant. Oh! How I wanted to leave my out-of-date, stained, casual jacket in the car, but it was too cold to even consider that option. In we walked, where women were bedecked in designer clothes from their head to their toes—and I looked like a bag lady. I mistakenly thought what I was wearing over my beautiful outfit wouldn't matter. But it did. It mattered very much.

How much more important it is to be dressed in the appropriate clothing spiritually.

Fortitude

Bearing with one another, and forgiving each other, whoever has a complaint against anyone; just as the Lord forgave you, so also should you.
(Colossians 3:13)

Is there someone who needs your God-given strength? Is there someone in your life who has endured disappointment after disappointment? This is the person you need to "bear with" even though the journey is long and arduous. The phrase "bearing with one another" means to endure with another or hold up one another. It can also mean to have fortitude with someone.

There have been many times in my life when I have been required to hold up others who felt they were out of strength or at the end of their faith. Often, I have been asked by the Lord to believe for someone who had no belief left in their heart.

I have discovered it is an honor to bear with those in my life who have gone through prolonged periods of suffering. It is a commendation from the Holy Spirit when He gently taps a man or a woman on the shoulder and quietly asks, "Will you stand in firm faith with this one? Will you continue to encourage this one although they are utterly discouraged?"

The stunning reality is there are times in life when we need others to bear with us so we should always be ready and willing to bear with others no matter how long or difficult the road.

⧖ *Who has been an example in your life of someone who has decided to "bear with one another"?*

⧖ *Who is the most difficult person you have ever had to bear with?*

⧖ *Why don't you pause, and pray for that challenging person right now?*

Forgiveness

Paul then reminded the church at Colossae of the necessity of forgiveness within the body of Christ. We have all been forgiven, therefore, we should all freely and generously offer forgiveness. As I recall the times I have been called

upon to forgive someone who deeply wounded me or hurt someone in my family, what I vividly remember is the Lord's grace and strength to do that which was difficult for me in my own flesh.

Bearing with one another, and forgiving each other, whoever has a complaint against anyone; just as the Lord forgave you, so also should you.
(Colossians 3:13)

Many times, the Lord has asked me to give beyond the forgiveness. He has encouraged me to bestow a blessing even beyond the forgiveness.

⧖ *What is your definition of the word* forgiveness?

⧖ *What does it mean to you to "bestow a blessing even beyond the forgiveness"?*

The Holy Spirit, through the pen of Paul, gave the conditions of this way of life known as "forgiveness." He said the condition is this, "*whoever has a complaint against anyone.*" That about covers it, doesn't it? If you have a complaint against *anyone*, the Holy Spirit's admonition is to forgive that person. My list is long; is yours? There are politicians I need to forgive, family members, drivers in traffic, the media, former teachers, acquaintances, spiritual leaders, and even myself. If you are able to complain, then you also must forgive.

⧖ *Make a list of at least five people whom you have a complaint against:*

1. _____

2. _____

3. _____

4. _____

5. _____

⌛ *How can you demonstrate the Lord's forgiveness in each of these people's lives?*

1. _____

2. _____

3. _____

4. _____

5. _____

Your Overcoat

As you already know, there was a moment in my life when I needed a spectacular overcoat, and I didn't have one. This obvious lack left me embarrassed and insecure. How wonderful to know that in Christ, you will never have that moment of shame if you choose to put on His overcoat:

> **Beyond all these things put on love, which is the perfect bond of unity. (Colossians 3:14)**

The finishing touch to your spiritual wardrobe is love—unconditional, enthusiastic, compassionate love. Love is what we should choose to wear on top of everything else because love is what shows to the world around us. When you choose to proactively love a difficult person, you are choosing to be a mountain-moving, miracle-chasing demonstration of the heart of the Father. When you choose to say, "I will love this person regardless of the cost," you are determining to join the family business, which is that of unconditional love.

⌛ *Take the time to read 1 Corinthians 13 today. It will remind you what true love looks like, talks like, and acts like.*

⌛ *After you read 1 Corinthians 13, answer the following questions.*

⌛ *How can I show love to a difficult person in my life?*

⧖ *What can I say that is filled with love to a challenging person in my life?*

LIVING TREASURE

Let the peace of Christ rule in your hearts, to which indeed you were called in one body; and be thankful. Let the word of Christ richly dwell within you, with all wisdom teaching and admonishing one another with psalms and hymns and spiritual songs, singing with thankfulness in your hearts to God. Whatever you do in word or deed, do all in the name of the Lord Jesus, giving thanks through Him to God the Father.

(Colossians 3:15–17)

PRAYER

Jesus, I pray You will help me love others the way You have loved me. Give me the grace and strength I need to love the difficult people in my life. In Jesus' loving name I pray. Amen.

WORDS OF WISDOM

The world does not understand theology or dogma, but it understands love and sympathy.

—D. L. Moody

Day 4

The Last Word

Have you ever had one of those days when there was so much confusion, so much busyness, and so much commotion, you honestly just felt like screaming? Have you ever been confronted with so many difficult entanglements, complicated relationships, looming deadlines, and relentless stress, you wanted to run away from home? Have you ever had so many people vying for your attention at one time, you wanted to pull your hair out?

There have been too many days to count in my life when I have wanted to shout at the top of my lungs, "Stop! Stop the world! I want to get off!" Do you know that feeling?

It is on those exact days when I have realized I need to make an intentional and strategic decision. It is vital on those days that I allow the Word of God to rule and reign in my heart and mind. I must license the Word of God to "step up to the plate" in my life and call the shots. I must permit the Word of God to have the last word.

⧗ *What did you do the last time you had a day like the one I described above?*

⧗ *What does it mean to you to allow the Word of God to "call the shots"?*

Let's Play Ball

Let the peace of Christ rule in your hearts, to which indeed you were called in one body; and be thankful. (Colossians 3:15)

Peace is a beautiful and strong aspect of our relationship in Jesus Christ. We may assume that peace is the absence of conflict, confusion, or discord, but that is not what it is at all. The peace of Christ is an assured rest within the storm or tranquility in the middle of the warzone of life. The peace the Lord gives to His children trumps every fray; divine peace is never dependent upon our circumstances but is always found in His promises.

The peace of Christ was given to you for a victorious and defining purpose. The peace of Christ is meant to act much like an umpire in the game of baseball or a referee in the game of basketball. The word *rule* in this passage is the Greek word *brabeuo*, which is translated "to be an umpire, to decide, determine."[34]

Athletic competitions were extremely popular in the ancient world, therefore the church at Colossae knew exactly what Paul meant with this reference. The peace of God was delivered into your life to act as an umpire or referee in your heart and in your mind. This divine umpire should always be allowed to call the shots and set the rules in your heart.

I have three sons, two of whom played on state football championship teams, and am very familiar with the role of the referee. When the game is not extremely competitive, the role of the ref is nearly unnoticeable. But when the game is highly competitive and there is much at stake, the role of the ref becomes vitally important. So it is in your life. On the easy days of life, we all likely take the peace of God for granted. But when all around is in upheaval and the stress is heavy with no end in sight, we then become desperate for the peace of God to call the shots in life.

We must never allow worry or anxiety to make the important life decisions, but we must default to the peace of God to cast the deciding vote.

The next time you feel overwhelmed by problems or by your emotions, you can simply yet definitively say, "Peace of Christ, take over!"

When you are experiencing a problematic day and it seems as if everything in the world is coming against you, you can simply yet definitively say, "Peace of Christ, set the boundaries!"

When your relationships are complicated and your financial resources are at an all-time low, you can simply yet definitively say, "Peace of Christ, make the call!"

I have learned the peace of Christ will never cast the deciding vote in my life unless I allow it to do so. When I am being attacked in life from every direction, I must stop for a minute and then deliberately set my heart and mind on the Word of God. Whenever I pause and think about a familiar and comforting Bible verse, the wonderful, conquering, powerful, and dominating peace of God arises within me and begins to call the shots. I can assure you it is nothing short of a miracle.

Peace always calls out, "Trust God," when anxiety creeps into the heart of a believer. You see, trust always precedes peace; you will never be the beneficiary of peace without the obedience of trust.

> *The steadfast of mind You will keep in perfect peace,*
> *Because he trusts in You. (Isaiah 26:3)*

⧗ *What causes stress or anxiety in your life?*

⧗ *What is your favorite Bible verse to deal with stress?*

Thanksgiving Is Not a Holiday

When you have decided to put on compassion, kindness, humility, gentleness, and patience; when you have stood firmly with a beloved brother or sister through an unremitting and fierce storm; when you have forgiven and given; when you have put on love and called on the Word of God to rule and reign in

your heart; when you have decided to trust regardless of your circumstances, what is there to do next? Is there anything we have forgotten or overlooked?

Let the peace of Christ rule in your hearts, to which indeed you were called in one body; and be thankful. (Colossians 3:15)

The one wonderful option left is to make a list of your undeserved blessings and then to thank the Lord loudly and often. A heart of thanksgiving is the quickest route to victory in every area of your wonderful life. Be effusive but sincere with your compliments; write thank-you notes, sweet text messages, and appreciative e-mails. Make phone calls that are filled with praise and gratitude for others in your life. Set coffee dates and lunch appointments for the express purpose of telling someone else how grateful you are for their life.

Be especially bold in your thanksgiving for family members, loved ones, and closest friends. There are times when we are guilty of taking for granted those for whom we should be the most grateful.

As believers in Jesus Christ, we should be the most thankful people on the planet. We should awake in the morning with a song of praise on our lips and go to bed at night counting our many blessings. Rather than focus on your troubles and lack, take a deep breath and begin to remember all God has done for you and in you.

Thankfulness is the most dynamic and authoritative choice a believer can make. Gratitude changes the atmosphere and wins victories. Acknowledgment of the goodness of God will set you in your destiny and open amazing doors of opportunity. When a son or daughter of God spends time in His presence and simply says, "Thank You, Dad," there will be strength for today and hope for tomorrow.

⏳ *We've done it before—let's do it again. Make a list of your blessings:*

1. _____

2. _____

3. _____

4. _____

5. _____

LIVING TREASURE

Let the peace of Christ rule in your hearts, to which indeed you were called in one body; and be thankful. Let the word of Christ richly dwell within you, with all wisdom teaching and admonishing one another with psalms and hymns and spiritual songs, singing with thankfulness in your hearts to God. Whatever you do in word or deed, do all in the name of the Lord Jesus, giving thanks through Him to God the Father.

(Colossians 3:15–17)

PRAYER

All I want to do is thank You, Lord. Thank You for Your goodness toward me and the many blessings You have given to me. Thank You for the Bible, for my home, and for my family. Thank You for food, provision, and my friends. Thank You for choosing me to belong to You. In Your wonderful name I pray. Amen.

WORDS OF WISDOM

It is only with gratitude that life becomes rich!

—Dietrich Bonhoeffer

Day 5

A Dream Come True

What is the biggest, most gargantuan dream you have ever had? Some folks dream about winning the lottery and never having to worry about money again, while others dream about traveling to exotic locations and filling their passport with stamps from around the world. Some people dream about immense homes, designer clothes, or expensive cars. I have a friend or two who still dream about meeting a handsome man of God and filling their homes with children, love, and laughter.

We all have dreams in our heart, don't we? We all have carried hopes and wishes since we were mere children. We all, somehow in some quiet way, long for life to be different than it currently is; we desire a richer, more fulfilling reality. My prayer for today's lesson is you will realize, as I have, we have already struck it rich!

⧗ *What would you do if you were rich? How would being wealthy change your lifestyle? It's okay to dream about this just a bit!*

A SPIRITUAL BILLIONAIRE

My friend, you and I have been given a treasure so rare that it will make boundless wealth accessible to us for the rest of our days.

Let the word of Christ richly dwell within you, with all wisdom teaching and admonishing one another with psalms and hymns and spiritual songs, singing with thankfulness in your hearts to God. (Colossians 3:16)

Paul used the Greek word *plousios* for "richly," which is a very old Greek word and is used only four times in the New Testament. If you welcome the vast riches of the Bible into your life, you will hit a vein of spiritual wealth so astounding that others will gasp in amazement. This is what *plousios* means:

- Incredible abundance
- Extreme wealth
- Enormous affluence
- Magnificent opulence
- Extravagant lavishness

If you will allow the Word of God to make its home in your heart, you will be a person of enormous spiritual affluence and extreme eternal wealth. If you are hospitable to the Word of God, invite it in often, and make room for its presence in your life, you will have the benefit of divine treasures and godly blessings others ignore.[35]

Some of us treat the Word of God as we do family members who are only welcome to join us once a year at a major holiday. Or we welcome the Word into our heart once a week and never think about it again until the next weekly visit. Others, sadly, have the audacity to kick the Word of God out when it presents something that challenges personal choices.

The Word of God will make you enormously wealthy when you choose to treasure it in the treasure vault of your heart. We need to welcome the Word with warmth, enthusiasm, and preparation. The Word of God should be invited to take up permanent residency inside our hearts, minds, and very lives.

I have never been wealthy, but I have observed enough truly moneyed people to know they live differently than I am able to live. However, I am the richest girl in town when it comes to spiritual affluence, and so I am able to live differently than others who don't welcome the Word as I do. My mind is flooded with wisdom, I can give words of encouragement away lavishly, and I have surround-sound joy because of the eternal fortune that is mine.

⧗ *How often do you read the Bible?*

⧗ *When you do read the Word, how long to you spend reading it?*

⧗ *What is your lifetime Bible verse?*

It Matters

Did you realize that God, your heavenly Father, is interested in absolutely everything you do? There isn't anything we think about it, talk about, choose to spend time doing, in which He is not interested. He longs to be involved in everything that matters to you. I have heard it said, "If it matters to you, it matters to God."

Whatever you do in word or deed, do all in the name of the Lord Jesus, giving thanks through Him to God the Father. (Colossians 3:17)

Everything we put our hand to or set our mind upon is to be done in God's power and for His glory. He longs to empower us for everything that is part of our daily life whether it is something extremely taxing or something incredibly easy. I have learned, over the years of my life, that often He asks me to do something I am unable to do in my own strength just so I will acknowledge my dependence upon Him. On those challenging and gut-wrenching days of life, when I am desperate for His strength, I am deeply aware of also giving all the glory to Him. Everything we must do in the daily-ness of life, He wishes to be involved in.

⧗ *How can you involve God in cleaning your kitchen?*

⧗ *How can you involve God in raising your children?*

⧗ *How can you involve God in the workplace?*

⧗ *How can you involve God in your marriage or in your singleness?*

⧗ *How can you involve God in your finances?*

I involve God in my driving; every time I stop at a red light, I can pray for someone who has asked me to pray for them. I literally "stop" and pray.

I involve God as I fold laundry; with each article of clothing I fold, I can pray for someone in my family and thank God for their life.

I involve God each day when I fix dinner as I turn on worship music and sing as I peel potatoes, warm up leftovers, or make a yummy salad.

Job Descriptions

How wonderful to know God has a job description for your specific role in life. The following verses state the job descriptions for five different groups of people:

> **Wives, be subject to your husbands, as is fitting in the Lord. Husbands, love your wives and do not be embittered against them. Children, be**

obedient to your parents in all things, for this is well-pleasing to the Lord. Fathers, do not exasperate your children, so that they will not lose heart. Slaves, in all things obey those who are your masters on earth, not with external service, as those who merely please men, but with sincerity of heart, fearing the Lord. (Colossians 3:18–22)

Wives are called by Paul and the Holy Spirit to submit to their husbands. Honestly, I could write an entire book on this topic, but for our purposes, I will try to keep it short and sweet. The word Paul used for "submit" was a Greek military term used to arrange the troops under the command of a leader. In a beautiful and Christ-like marriage, issues should be discussed thoroughly and in a kind manner; often the husband and wife in this type of marriage will then come to mutual agreement. If agreement over contentious issues is just not possible, the husband is the head of the home so he should therefore make the final decision. For those of you in a difficult marriage, make an appointment with a Christian counselor or your pastor and seek wise advice. Submission is never abusive; if you are being abused you need to leave the marriage immediately.

In other places in Scripture, the body of Christ is directed to submit to one another, which makes this topic not just a marital one but for the entire church.

And be subject to one another in the fear of Christ. (Ephesians 5:21)

Husbands were commanded by Paul and the Holy Spirit to love their wives, which was an entirely new thought at this ancient moment. Prior to the teaching of Jesus and that of the New Testament church, men were never encouraged to love their wives. This was the best news the wives at Colossae had ever heard! Paul instructed husbands to love their wives with kindness and gentleness. Being loved is the deepest heart cry of every woman; the Holy Spirit knows just what a woman needs.

Children are told to obey their parents. After raising five strong-willed children, my husband and I have often said the only theology a child needs until he or she is about ten years old are these two truths: Jesus loves you and obey your parents.

Fathers should never exasperate their children with high expectations, unreasonable demands, or an angry persona. Fathers are called to be

encouragers in the home and of the children under their watch. I have often thought it interesting Paul included this emotional caution to fathers. I believe the Holy Spirit, who knows our character so well, observed the reality that it is often men who lack nurturing skills when dealing with the unpredictable ways of children. Fathers need to practice a more tender way of dealing with children than anger affords.

Slaves were called to serve with their hearts and not just their actions. This verse can be used as a compass for those who serve Jesus; He wants more than just visible obedience through our actions. He also wants the unseen issues of our hearts.

⧗ *Which of the job description above applies to your life?*

Everyone and Whatever

Paul communicates a very specific job description for everyone, regardless of marital status, career, or family relationship:

> *Whatever you do, do your work heartily, as for the Lord rather than for men, knowing that from the Lord you will receive the reward of the inheritance. It is the Lord Christ whom you serve. For he who does wrong will receive the consequences of the wrong which he has done, and that without partiality. (Colossians 3:23–25)*

Every Christian's job description consists of not just the "what" but also the "how." We are all called to work with enthusiasm no matter who we are or what we do. My friend, don't just plod through life, bored with your job, unimpressed with your relationships, and settling for mediocrity.

Every morning when you wake up, eagerly thank the Lord for a brand-new day. Give Him your whole heart and ask for divine appointments as you walk through your day. Tell the Lord how thankful you are for the breath that fills your lungs and for His wonderful creation. Choose to love people extravagantly and celebrate life wholeheartedly.

The word *heartily* means to put your whole self into something.

If you are a trash collector, do it with joy.

If you are a lawyer, never forget you are working for the Lord.

If you are a teacher, breathe life into those little souls.

If you are a mother or grandmother, turn every day into a holiday.

If you are an administrator, do it with vision and purpose.

The mark of a Christian is that we are different from the world; we are different from the inside out and from the outside in. You and I were chosen by the God of the universe to be alive today and to serve Him wholeheartedly.

Let's resolve to live with unmatched kindness and compassion.

Let's resolve not to waste one day of our life with pessimism.

Let's resolve to be the kindest and most joyful generation of Christians ever to live.

Let's resolve to embrace every day with genuine enthusiasm and excitement.

Let's resolve that every person in our life will receive a grand dose of love from us.

Let's resolve that every day is an opportunity to be just like Jesus!

LIVING TREASURE

Let the peace of Christ rule in your hearts, to which indeed you were called in one body; and be thankful. Let the word of Christ richly dwell within you, with all wisdom teaching and admonishing one another with psalms and hymns and spiritual songs, singing with thankfulness in your hearts to God. Whatever you do in word or deed, do all in the name of the Lord Jesus, giving thanks through Him to God the Father.

(Colossians 3:15–17)

PRAYER

Jesus, I resolve to live wholeheartedly for You today. I promise that whatever I do today, I will do it with love and kindness for You. In Your name I pray. Amen.

WORDS OF WISDOM

The glory of God is man fully alive!

—St. Irenaeus

Week 7

People Are Important

Day 1

People and Prayer

This is our last week studying the collision that results in an inexpressible overflow. This stupendous collision happens when the purposes and truth of God collide with humanity and with culture. This brilliant collision is not for the faint of heart, but you must courageously allow it to blow to bits weak theology and misguided living. The most magnificent aspect of this incredible collision is that it will heal you rather than hurt you. Your life will be put back together rather than blown apart. What a glorious collision this is, which will cause you to overflow with unmatched joy and peace.

⌛ *What is the one premiere lesson you have learned thus far in our study of Colossians?*

⌛ *How has your heart been healed during this Bible study?*

Live It Out

How we treat others just may be the litmus test of the depth of our commitment to Christ. It is easy to treat those who are kind to us with boomerang kindness; there are, however, many people in life who will not be kind, nor will they be easy to sincerely love. How we respond to the more taxing and complicated relationships communicates our love for Christ. The words

of Jesus ricochet through the centuries as we understand his plan for human relationships:

By this all men will know that you are My disciples, if you have love for one another. (John 13:35)

As we begin this final chapter of Colossians, Paul is not finished with doling out job descriptions. He now speaks to those who have an authority role and how they should treat those who serve them. This passage, then, will most effectively be seen through the lens of how we treat those who serve us in some capacity. It might include waiters or waitresses, people who work in the fast-food industry, those whom you oversee at work and on committees, or anyone else who serves you in a practical manner.

Masters, grant to your slaves justice and fairness, knowing that you too have a Master in heaven. (Colossians 4:1)

As we consider how we treat those who are in a service profession or who personally serve us daily, we must always be mindful of how the Lord treats us. He is compassionate, kind, and forgiving; our Father is slow to anger, loves unconditionally, and is always ready to listen. This is the manner, then, in which we should treat those whom we pay for services or who look to us in an authority role.

Although we know this passage was written to those who owned slaves, we can translate it to our culture as well. Slavery was never God's idea; treating every person with dignity and respect remains a high priority to the Father. If you are an employer, you should remind yourself how Christ has treated you. Paul is applying the principles he taught earlier in Colossians to remind us how to treat others—no matter who the others are. We have put on the new self and are being renewed to a true knowledge according to the image of the One who created him (see Colossians 3:10). Paul has specifically instructed what a believer in Christ should wear as we go out into the world:

- A heart of compassion
- Kindness
- Humility
- Gentleness

- Patience
- Bearing with one another
- Forgiving one another
- Loving one another from the heart.

⧗ *As a leader, or someone in charge, what is the most important attribute you can show to those who serve you?*

⧗ *As someone who serves others, how can you demonstrate Christ to those in charge?*

Hopefully Devoted

We are all devoted to activities, interests, and people. We all cultivate devotions over the course of life:

A devotion is something you are utterly unable to live without.

A devotion is an activity, object, or person that has captured your heart in a captivating way.

A devotion is wholehearted commitment.

A devotion is when you lay aside other interests or relationships to be intensely committed to the object of your devotion.

A devotion is something you are affectionate toward.

⧗ *Be honest with yourself and list three of your devotions in life:*

1. _____

2. _____

3. _____

We each choose our own devotions; no other person dictates the deep affections of our hearts. We cannot blame our devotions on anyone but ourselves.

Devote yourselves to prayer, keeping alert in it with an attitude of thanksgiving. (Colossians 4:2)

Knowing that a devotion is a practice or habit by which we show affection, I am undone realizing I must be affectionate toward prayer. I must love prayer in the same way I love going on long walks in the sunshine, cheering for my favorite team on Sunday afternoon, or spending time with my sweet grandchildren. Prayer must stir my heart and cause it to beat with rapid anticipation just because I get to pray. I must long for prayer, practice prayer, focus on prayer, and love prayer. I simply must.

⏳ *Are you devoted to prayer? Why or why not?*

⏳ *What needs to change in your life so you fall in love with prayer?*

The word Paul employs to communicate "devoted" is one of my favorite Greek words in the New Testament: *proskartereo. Proskartereo* is not only a word of love and affection but also a word used by soldiers preparing for battle.

This diverse Greek word can be translated in an affectionate manner to mean:

- To adhere to one, to be devoted or constant to one.
- To be steadfastly attentive unto, to give unremitting care to a thing.[36]

These particular meanings of *proskartereo* warm my heart and fan the flame of love toward the discipline of prayer. It calls my heart to the throne room of God as I spend time in His presence where there is always fullness of joy. It stirs up attachment to all that He is and adoration of His goodness. I love being called by Paul and the Holy Spirit to love prayer.

However, there is also a stronger, more persistent definition of the meaningful word *proskartereo*:

- To persevere and not to faint.
- To show one's self courageous for.
- To persist in the siege.

We dare not merely love prayer as we do our morning cup of coffee, the flowers blooming in our spring gardens, or the new couch that completes our warm family room. We must understand when we are on our knees in prayer, a battle is taking place and we are committed to that battle until it is won. We must be forceful and bold in prayer as we fight for the right and demolish that which is wrong. We must fight for future generations, for a pure and holy church, and for the peace that passes all understanding.

> *The effective prayer of a righteous man can accomplish much.*
> *(James 5:16b)*

While it is true that prayer is something that should hold our deepest affections, we must also be committed to sweating, standing firm, and never giving in when called on to persist in the arena of prayer.

These two meanings collide when you understand that when you love something, you will fight for it. When you care deeply about a person or an activity, you will battle for the victory attached to it.

⧖ *What are you willing to fight for?*

⧖ *What are you currently praying for persistently?*

LIVING TREASURE

Conduct yourselves with wisdom toward outsiders, making the most of the opportunity. Let your speech always be with grace, as though seasoned with salt, so that you will know how you should respond to each person. (Colossians 4:5–6)

PRAYER

Jesus, will You light a fire in my heart for prayer? I want to love prayer and be devoted to pray for those in my life. Thank You, Lord, that You always hear me when I pray. In Jesus' name I pray. Amen.

WORDS OF WISDOM

God shapes the world by prayer. The more praying there is in the world the better the world will be, the mightier the forces against evil.

—E. M. Bounds

Day 2

What's Your Excuse?

We must not underestimate the potency of prayer nor the dynamic call it holds upon each of our lives. For that reason, we will spend one more day studying the verse in which Paul calls us to the devotion of prayer:

> **Devote yourselves to prayer, keeping alert in it with an attitude of thanksgiving. (Colossians 4:2)**

Let's Talk About Time

The most common excuse as to why a man or a woman does not persevere in prayer, is the pretext of not having enough time. Paul says our devotion should always be to prayer rather than to the other distractions in life. As you make a "to-do" list for the day, prayer should be your number one priority.

⧗ *Perhaps over the next few days, it would be a good idea to list how you spend your day. As you make the list, attach the length of time you spend on each activity.*

ରୁ *If you have time for social media and texting, you have time for prayer.*

ରୁ *If you have time for exercise and your favorite TV show, you have time for prayer.*

ରୁ *If you have time for ball games and gardening, you have time for prayer.*

ରୁ *If you have time for meeting friends for coffee, you have time for prayer.*

ରୁ *If you have time to watch the news, you have time for prayer.*

℺ *If you have time to listen to podcasts, you have time for prayer.*

℺ *If you have time for manicures and pedicures, you have time for prayer.*

℺ *If you have time for shopping, you have time for prayer.*

I can assure you choosing to spend time on any activity or interest is the petri dish in which devotions are born. I choose to make time for prayer every day or it has not been a good day; if I do not spend time in prayer, I will go to bed frustrated and unfulfilled.

I have also learned that prayer is one area of my life in which the enemy is most interested and occupied. The devil would take great glee if any one of us were devoted to all the wrong things rather than to eternal pursuits. The enemy is wily and understands if he can change our devotions from godly to temporary, he has a better chance of winning our emotions during times of intense battle.

We must not be foolish and ignore the fact that the enemy does not want the women of faith in this generation to have an impact on a generation yet to come. The devil is painfully aware that if you, as a woman of God, are devoted to prayer, you are able to revolutionize the culture, influence politics, and empower your family to walk in faith for decades. Few things scare Satan more than a courageous woman who is devoted to prayer.

Three Ws

Allow me to speak to young moms for just a moment. The rest of you can listen in. However, this section is specifically for those younger women whose days are filled with diapers, unending laundry, and macaroni and cheese. Are you ready for a heart-to-heart conversation from a sister in the faith who loves you dearly?

In our walk of faith, there are three Ws that guide us and guard us:

- Word
- Worship
- Warfare, also known as prayer

When I was a young mom in the season of spit-up, *Green Eggs and Ham*, and toddler tantrums, I knew it was nearly impossible for me to incorporate all three disciplines into my daily time of devotions. So, in those years, I chose to

do at least one of the Ws every day, whether I thought I had time for it or not. I always made the time for one W; it was my priority and my commitment.

On the "Word" day, I would read the Word throughout the day as I was able to do so. I kept my Bible open on the kitchen counter, on the dryer, or on my bedside table. I allowed my eyes to linger on the sacred pages of Scripture and read the words He has written just for me. How I loved the days when I was able to read the love letter my Savior had written!

On the "Worship" day, I worshipped loudly as I spent time in His presence where there is always fullness of joy. I listened to worship music as often as I could throughout the day and even was known to dance in His presence with my hands lifted high and tears running down my cheeks. Often, my toddlers danced with me while I had a baby in my arms. There is nothing like a worship day!

On the "Warfare" days, I went to battle on my knees for those I love and for situations that were blowing up around me. I often did this in the early morning hours, late at night, or when the children were napping. I declared the Word over the battles, and I fought fiercely in prayer for victories yet to come. The most productive days of my life were the days I spent contending for the Lord's will in my life.

And then, every Wednesday, which is a "W" day, I spent time in all three of the Ws. Wednesday was the day I worshipped, read the Word, and I engaged in warfare.

My sister, you will be a more loving mom, a tender wife, a caring sister, a compassionate daughter, and a faithful friend if you do a "W" a day.

⏳ *Look for time slots into which you can incorporate one of the three Ws. Make a conscious effort to list them below:*

1. _____

2. _____

3. _____

What a Difference!

Prayer is much like going to the gym when you are trying to lose weight or increase your muscle strength.

Let's be honest, the first day you go to the gym, it hurts; you don't see any visible difference on that first torturous day. On the second day, it likely hurts

even more. Your muscles are crying out in pain and you might wonder if exercise is even worth it. However, after a month of constant activity and exercise, your jeans become looser, and the scale is likely going down gradually. After two months of self-discipline at the gym, you are beginning to walk with a spring in your step as you feel more confident and healthier.

When we pray, rarely do we see a visible difference in the first few days. After a month of prayer, however, there will be a definite difference in the spiritual power in your life. After two months of daily prayer, you will be moving mountains by faith and leading people into the kingdom. After six months of personal prayer, you will be walking in resounding victory and making a difference in the world around you.

⧗ *List your three main prayer requests:*

1. _____

2. _____

3. _____

⧗ *Share these three prayer requests with a trusted sister in the Lord. Let's see what God will do!*

God Takes Your Call

We live in a world of intense communication, don't we? We have cell phones, e-mail, social media, Zoom, and FaceTime. We can communicate more quickly and efficiently than any other generation in the history of mankind. What a delight to be able to communicate with those we love dearly with only the press of one button even if they live an entire ocean away.

I am one of those moms who keeps her cell phone with her twenty-four hours a day and seven days a week. My cell phone is in my left hand all my waking hours; when I am sleeping, my phone is right beside my head so I can hear it easily in the middle of the night. If any one of my five children or ten grandchildren call me when I am otherwise involved, I will simply say, "Excuse me. I need to take this call." Whether it seems rude to others or not, I am answering every single call that comes from one of my beloved children and grandchildren.

> *The LORD has heard my supplication,*
> *The LORD receives my prayer. (Psalm 6:9)*

It is the heart of a parent to be in constant communication with their children whether they are newborns safely snuggled in your arms or adults who live a continent away. Parents are always available to listen to the concerns, frustrations, and news of their very own children.

My friend, God keeps His cell phone on all the time! He can't wait to hear from you and will always take your call. He is never too busy or distracted to spend time listening to your voice and cheering you on your way.

⌛ *Have you ever wondered if God hears you when you pray? Be honest.*

⌛ *As you reread Psalm 6:9, write down the two ways in which the Lord responds to your prayer:*

1. _____

2. _____

What God Values

When you walk into someone's home for the first time, it is easy to discern what this person values by what is on display within the walls of their home.

If heads of deer, moose, and fish are scattered around the living area, you will likely guess this family loves hunting and the great outdoors.

If you see sports memorabilia, trophies, and sports jerseys used as décor, you will know this family loves the world of sports, competition, and tournaments.

I have a friend who has no less than one thousand cookbooks displayed stunningly in her state-of-the-art kitchen. This friend is known for her fabulous cooking and generous hospitality. It's what she values.

When you come to my humble home, you will see pictures of my family in every room, on every wall, and on every shelf. I value my family more than anything else except my faith.

I have a friend who has a cross in every room of her home—including all four bathrooms. This friend values the forgiveness of Jesus and all that He has done for her.

The Bible tells us what God has on display in the grandeur of heaven:

> *When He had taken the book, the four living creatures and the twenty-four elders fell down before the Lamb, each one holding a harp and golden bowls full of incense, which are the prayers of the saints.*
> *(Revelation 5:8)*

God holds your prayers in a precious and beautiful spot; your prayers are what He values even in the glory known only to heaven. Every prayer you have prayed is displayed in a golden bowl because your prayers are one of God's prized possessions. Your prayers are what He values in the magnificence of eternity.

⏳ *Think about your home. If someone were to walk into your home for the first time, what would they discern that you value? Be honest.*

Open Doors

I believe we should daily be praying for those in ministry, for missionaries, and for evangelists. Praying for those who are on the front lines of ministry is a focused aspect of our assignment on earth. Paul reminded the church at Colossae this was part of their prayer assignment.

> *Praying at the same time for us as well, that God will open up to us a door for the word, so that we may speak forth the mystery of Christ, for which I have also been imprisoned; that I may make it clear in the way I ought to speak. (Colossians 4:3–4)*

Pray for your pastor weekly as he prepares his sermon.
Pray for your Sunday school teacher or Bible study leader.

Ask your pastor to give you a list of missionaries your church supports. Pray for them weekly.

Pray for other teachers and speakers to whom you listen on podcasts, TV, or the radio.

Pray for Christian authors who are telling the truth.

Pray for open doors for yourself to tell the story of Jesus.

⧗ *Make a list of people in ministry for whom you will pray weekly:*

1. _____

2. _____

3. _____

4. _____

5. _____

LIVING TREASURE

Conduct yourselves with wisdom toward outsiders, making the most of the opportunity. Let your speech always be with grace, as though seasoned with salt, so that you will know how you should respond to each person. (Colossians 4:5–6)

PRAYER

Jesus, will You light a fire in my heart for prayer? I want to love prayer and to be deeply committed to pray for those in my life. Thank You, Lord, that You always hear me when I pray. In Jesus' name I pray. Amen.

WORDS OF WISDOM

To be a Christian without prayer is no more possible than to be alive without breathing.

—Martin Luther

Day 3

Wise Conduct and Conversation

I love making new friends on airplanes, in the neighborhood, at the grocery store, or at the mall. Everywhere I go, I hope to have the opportunity to talk to someone about Jesus in a winsome, natural way. I don't want to come across as belligerent or as a bully, but I do like to share my faith in an enthusiastic, captivating manner. Sometimes I will share a Bible verse or a story from my life; other times I will ask if I can pray for my new friend.

One of the most productive and spontaneous ways I have learned to share my faith is at a restaurant. I always try to be sweet and cheerful with the waitress or waiter, knowing I have been given an opportunity to serve this person food that they likely "know not of"! I am intent on learning my server's name as well as just a little bit about them before I place my order. Then, before this new friend walks away from the table, I invariably say, "We will be praying for our food in just a minute. Is there any way we could also pray for you?"

At this point, the server usually bursts forth with a litany of prayer requests and it is my honor to pray for this new friend as he or she serves me. This restaurant strategy is simply called "making the most of the opportunity."

⧗ *How do you generally witness to someone who does not know Jesus?*

⧗ *Have you ever led someone to Christ? Pray you will have that opportunity this week.*

Pre-Christians

Paul has stunning and timely advice about how to interact with people who don't know Jesus. As you read the following two verses, although penned two thousand years ago, know that Paul was writing to you as you consider how to treat people who don't know Jesus yet.

> *Conduct yourselves with wisdom toward outsiders, making the most of the opportunity. Let your speech always be with grace, as though seasoned with salt, so that you will know how you should respond to each person.* (*Colossians 4:5–6*)

I sincerely hope you have relationships with those who do not yet know Jesus Christ. As we serve Jesus this side of heaven, it is vitally important to understand we all are evangelists and missionaries. Each one of us must accept the call to make hell smaller and heaven bigger. For most of us, the way we do this is through our daily relationships. We should all be praying for someone to be saved; we need to stunningly realize there are people to whom we have been assigned.

When our lives engage with those who do not know Jesus, we must stay keenly aware of how the Holy Spirit desires we treat pre-Christians. We must be in continual conversation with the Lord concerning the words we speak to those who have not yet joined the wonderful family of God.

I believe we have all been assigned to nonbelievers as a witness, an encourager, and as a truth-teller. Our evangelistic assignment certainly includes those in our immediate family, but it also encompasses those with whom we are in consistent contact such as the girl who does your hair, the pharmacist, your child's soccer coach, and your neighbor.

⧗ *List five people to whom you have been assigned at this season in life:*

1. _____

2. _____

3. _____

4. _____

5. _____

Wise Conduct

As I read Paul's advice to the church at Colossae concerning their treatment of those whose lives are not yet overflowing with all Jesus is, I find three significant habits to consider that are pertinent today.

First, Paul teaches to *"conduct yourselves with wisdom toward outsiders."* The word *conduct* is a vivid Greek word, *peripateo*, whose meanings are at once convicting and inspiring. *Peripateo* means "to tread all around, to walk at large (especially as proof of ability)." It can also be translated as "to live, deport oneself, . . . be occupied with, walk (about)."[37]

Paul is instructing the church at Colossae, and therefore the church of the twenty-first century, of the central truth that how you live your life matters to those who live outside faith. The choices you make, the words you use, and the activities you are engaged in are all part of your visible testimony. People should be attracted to Christ by your winsome behavior rather than repelled by your outlandish actions. My friend, please don't be foolish in your actions or weird in your behavior. Be a wise woman who conducts herself in a lovely and courageous manner.

⏳ *What does the word* conduct *mean to you?*

⏳ *How do you think "pre-Christians" evaluate your daily conduct?*

Paul then reminds this precious first-century church to *"[make] the most of the opportunity."* Every day is a high-alert day for a believer in Christ. Every morning when we awake, we should jump out of bed and say, "Use me, Lord! Use me today! Give me divine appointments and numerous opportunities to make much of You."

If your waitress is cranky, rather than neglecting to tip her, take a moment to encourage her. Leave an extra tip along with your promise to pray for her.

Witness while you are waiting in an unending line rather than becoming frustrated and impatient. Ask questions of others and raise the level of encouragement.

Don't just talk about yourself at a coffee date or a lunch appointment, but listen to the heart issues of the ones you are with.

Look people in the eye and make them feel cherished and valuable.

Every person in your world is a stunning and God-ordained opportunity to revolutionize someone's life for all eternity. Make the most of the opportunity.

Every chance encounter is a God-sized opportunity to transform and inspire a stranger's life forever. Make the most of the opportunity.

Every long-term relationship and treasured friendship is a miracle in the making. Make the most of the opportunity.

⧖ *What does it mean to you to "make the most of the opportunity"?*

And finally, did you realize your speech is of unmatched significance? Paul says, *"Let your speech always be with grace, as though seasoned with salt, so that you will know how you should respond to each person."*

Every word that leaves your mouth holds the intrinsic and God-given power to either bless or curse, to save or destroy, to encourage or discourage. Every single word carries with it the influence to heal or to wound, to offer peace or to offer confusion, to devastate or to build.

Paul coaches that our speech should be filled with grace rather than laced with judgmental statements, critical accusations, or negative input. Our words should always be gentle, tender, and filled with an encouragement so rare and so vital it brings heaven to its feet in applause. Speaking the truth comes out differently when your speech is grace-filled; truth becomes delicious and interesting when spoken with compassion and kindness.

Paul also states that our speech should be salty. Salt is a preservative as well as an agent of healing virtue. Salt also creates an instant thirst for the one who ingests it. Every word we speak should make the listener thirsty for Jesus!

By necessity, I have given myself strict verbal boundaries, so I am able to obey this riveting verse written by Paul two millennia ago. I have simply decided if I am unable to offer grace and words of healing in a conversation, then I just must stop talking.

⧗ *Who has the most grace-filled speech of anyone you know?*

⧗ *Choose two adjectives that describe your speech habits:*

1. _____

2. _____

LIVING TREASURE

Conduct yourselves with wisdom toward outsiders, making the most of the opportunity. Let your speech always be with grace, as though seasoned with salt, so that you will know how you should respond to each person. (Colossians 4:5–6)

PRAYER

Jesus, help me to make the most of every opportunity. I pray that my speech will be filled with grace and will make others thirsty for a big drink of Jesus! In Your beautiful name I pray. Amen.

WORDS OF WISDOM

God forbid that I should travel with anybody a quarter of an hour without speaking of Christ to them.

—George Whitefield

Day 4

People Are Important

My college roommate, Debby, and I have been best friends ever since the God-ordained day we met at a Christian university five decades ago. There have never been two girls quite as different as we who loved each other so dearly. She was from the South while I was a northern girl. She said, "Y'all," and I said, "You guys." My blonde hair reached to my waist while hers was short, dark, and curly. She was an extrovert on steroids while I was a creative introvert. She was the life of every party while I never even knew a party was happening. That was us—as different as can be yet kindred spirits for a lifetime.

The one essential ingredient we had in common was our love for the Word of God. Debby's mom died from cancer when she was twelve years old. Debby's dear pastor's wife said to the grieving preteen at the funeral, "Debby, the only way you will make it through grief is to fall in love with the Bible." That is exactly what Debby did: she fell in love with Scripture.

When we were roommates, she crept out of bed every morning at 5:30, put on her thick glasses, and sneaked into the hallway to read the Bible. We loved sharing with each other what the Lord was teaching us in Scripture, and it was a bond that knit our hearts together in unconditional and solid love.

We both married pastors and kept in touch over the years at Christmas and on birthdays. On April 30, 2005, Debby's husband, Steve, was tragically killed while on a men's retreat. When I spoke with Debby the next day, in typical Debby fashion, we laughed and cried together even on this day of trauma and grief. I said to Debby, before we ended our phone call, "Debby, did you read your Bible this morning?"

"Of course, I did," was her cheeky reply. "And, honestly, I got mad at the Holy Spirit," she continued. "I looked at my Bible reading plan to see where I was supposed to read this morning and it was 1 Chronicles 1–8. As I began reading, I realized for eight straight chapters, all I could see were unpronounceable names."

Debby, who is an enthusiastic talker, went on, "I said to the Holy Spirit, 'Really? This is where I am supposed to read the morning after my husband was killed? Is this the best You can do? Why couldn't I be reading in the Psalms or in the book of John today?'"

Of course, as Debby rattled away, I was thinking, *Well, Debby, you could have veered off your reading plan for just a day! The Holy Spirit would understand.*

"And you know what? I heard the Holy Spirit say to me, 'Yes, Debby, this is the best I could do,'" Debby quietly continued. "The sweet Holy Spirit told me He wanted to remind me that people are important to the Lord. Steve was important to the Lord and His name is written in the Lamb's Book of Life."

Between gulps, tears, and giggles, Debby then told me she read every single name in the first eight chapters of the book of 1 Chronicles while thanking the Lord for the life of her dear husband, Steve Edwards. People are important to God.

⧗ *What is the worst situation you have been through in life?*

⧗ *Is there a passage of scripture that has comforted you in your pain?*

⧗ *Do you have a longtime friend of the faith? Reach out and let them know how much you appreciate them as a faithful friend.*

Encouraged Hearts

In the closing verses of his epistle to the church at Colossae, Paul begins a magnificent list of those who cheered him on his way. He mentions by name the ones who labored with him to deliver this Holy Spirit–inspired letter to a needy group of believers.

> *As to all my affairs, Tychicus, our beloved brother and faithful servant and fellow bond-servant in the Lord, will bring you information. For I have sent him to you for this very purpose, that you may know about our circumstances and that he may encourage your hearts; and with him*

Onesimus, our faithful and beloved brother, who is one of your number.
They will inform you about the whole situation here. (Colossians 4:7–9)

Tychicus apparently delivered the letter as well as words of encouragement to this mixed-up but well-loved church. Onesimus was from Colossae and went with Tychicus to deliver the letter Paul had written from prison in Rome.

It is vital not to overlook the adjectives used in describing these two men whose lives intersected with the life of Paul the apostle. Paul refers to Tychicus as *"beloved," "faithful,"* and *"a fellow bondservant in the Lord"*; he refers to Onesimus as *"faithful"* and *"beloved."*

What a wonderful way to be remembered on the sacred pages of Scripture! As I read these two obscure names described by powerful adjectives, I am reminded the Holy Spirit is watching my life even today. I may feel obscure to the world, but the Holy Spirit knows me intimately and is aware of how I serve the church and the leaders in the church.

⧗ *Define the word* faithful.

⧗ *Who, in your life, would you describe as faithful?*

⧗ *Define the word* beloved.

⧗ *Who, in your life, would you describe as beloved?*

Paul descried Tychicus as a "bond-servant"; a bond-servant was a slave who had been set free but chose to stay and serve his or her master. Tychicus was a bond-servant of the Lord; he willingly, faithfully, and lovingly chose to serve the Lord regardless of other opportunities.

⧗ *Is it possible to be a "bond-servant of the Lord" in the twenty-first century?*

⧗ *Why or why not?*

⧗ *What are some of the choices a bond-servant of the Lord might make?*

Tychicus was sent by Paul to the church at Colossae to encourage their hearts. We all need someone who will encourage our hearts when the days of discouragement are long and painful. Everyone needs a friend who will simply say, "You're going to make it. You've got this." You and I are both frail human beings who need another one to strengthen our hearts along the journey of life. Apparently, Tychicus was just the man for this vital assignment and was known as an encourager.

⧗ *List three characteristics of an encourager:*

1. _____

2. _____

3. _____

⧗ *Who is the most encouraging person you know?*

VIPs

Paul continued his list of very important people with the names of Aristarchus, Mark, and Justus.

> *Aristarchus, my fellow prisoner, sends you his greetings; and also Barnabas's cousin Mark (about whom you received instructions; if he comes to you, welcome him); and also Jesus who is called Justus; these are the only fellow workers for the kingdom of God who are from the circumcision, and they have proved to be an encouragement to me.*
>
> *(Colossians 4:10–11)*

Aristarchus was likely in prison with Paul for preaching the gospel of Jesus Christ; Mark and Justus were Jewish believers. All three of these men partnered with Paul in reaching the Gentiles for Christ. Gentiles were regarded by the Jews as outcasts, heathens, and scum; most "good" Jews refused to be associated with a Gentile. These Jewish men by birth, yet Christian by choice, joined in the heroic cause of winning the Gentiles to Jesus.

⧗ *Who are the outcasts of our society today?*

⧗ *Could Christ be calling you to love and serve people whom everyone else ignores?*

Paul also noted that Aristarchus, Mark, and Justus were the men who were an encouragement to him while in prison. The word for "encouragement" can also be translated as "comfort." Paul used the Greek word *paregoria*; this is the singular time it is used in the New Testament. *Paregoria* can also be translated

as solace, relief, or consolation. These men, who knew the power of Jesus, were overflowing with exhortation for everyone they met. When you know Jesus and are being conformed to His likeness, the joy and compassion in you will inevitably spill out to a world in pain. Paul was informing the church at Colossae that this triumvirate of Hebrew men were refreshing to him; they had encouraged his soul when times were difficult.

⧖ *Who has comforted you when you were lonely or in difficult conditions?*

⧖ *Have you thanked this person for their comfort and concern?*

LIVING TREASURE

Conduct yourselves with wisdom toward outsiders, making the most of the opportunity. Let your speech always be with grace, as though seasoned with salt, so that you will know how you should respond to each person. (Colossians 4:5–6)

PRAYER

Lord Jesus, I long to encourage others who are in a difficult situation in life. Would you speak through me to those in pain? Lord, I want to be a Tychicus, Onesimus, Aristarchus, Mark, and Justus today. Lord, I thank You today that people are important to You. In Your loving name I pray. Amen.

WORDS OF WISDOM

To ease another's heartache is to forget one's own.

—Abraham Lincoln

Day 5

The Joy of the Journey

The end of a journey is always bittersweet, isn't it? As you look back down upon the road you have traveled, you see both highs and lows, as well as riveting views and challenging landscapes. Whenever I have gone on a long-awaited trip with my family, the final day of our travels is often the most meaningful as we remember the joy of our journey. While we are traveling down the familiar road to the homeplace, we talk about the events and days that will forever be found in the picture book of our hearts. As we turn the corner toward home, we are richer for the journey and are overflowing with the delight of family.

Today is such a day in our study of Colossians. We still have a bit of our journey to go, but most of all, we will be remembering what God has done and what He has said. We will recall the rich deposit of faith that the unforgettable book of Colossians has placed in the deepest parts of our spirit. Today is a day of heartfelt goodbyes and spectacular new beginnings.

⏳ *What has most surprised you in this complete Bible study?*

⏳ *Describe Paul in three words:*

 1. _____

 2. _____

 3. _____

A Man of Prayer

The portion of Scripture that we studied yesterday as well as the verses we will be digging into today might often be overlooked by the casual reader. The verses in Colossians 4:7–18 are ones we might be tempted to skim over or read briefly. However, after today's lesson, I pray we will never again give in to that temptation, being fully assured that every single verse holds a nugget of eternal gold.

> *Epaphras, who is one of your number, a bondslave of Jesus Christ, sends you his greetings, always laboring earnestly for you in his prayers, that you may stand perfect and fully assured in all the will of God. For I testify for him that he has a deep concern for you and for those who are in Laodicea and Hierapolis. (Colossians 4:12–13)*

Epaphras, who came from Colossae, was also identified by Paul as *"a bondslave of Jesus Christ."* This quiet yet passionate bondslave had determined the options of this world held no attraction for him. We read about the extraordinary man in the earliest verses of Colossians:

> *Just as you learned it from Epaphras, our beloved fellow bond-servant, who is a faithful servant of Christ on our behalf, and he also informed us of your love in the Spirit. (Colossians 1:7–8)*

Bible scholars wonder if Epaphras had initially approached Paul in Rome to obtain his advice concerning the false teachers in Colossae.[38] If this is true, and I believe it is, Paul's letter to the church at Colossae was written because of the sincere concern of a man by the name of Epaphras.

⏳ *Is there anyone in your life who loves you enough to confront you with truth?*

⧗ *Is there someone in your life who you need to pray about confronting with truth?*

Epaphras was a deeply invested believer who stayed on his knees for the church at Colossae. He did not pray carelessly, but he labored earnestly on his knees for the believers in Colossae. So deep was his concern for this first-century church that he never stopped praying, never ceased contending, and was always in an attitude of prayer for the waffling believers at Colossae. The prayer of Epaphras was that the Colossian church would mature in their faith as well as develop the discernment to know the will of God. The prayer of Epaphras should be our prayer for the church of the twenty-first century.

⧗ *Do you know someone who needs to mature in their faith? Take some time to pray for this person today.*

⧗ *Is it possible to be "fully assured in all the will of God" as Epaphras has prayed for the Colossian church? If so, how do we do it?*

Paul describes Epaphras as *"always laboring earnestly for you in his prayers."* The Greek word for "always" is *pantote,* which means "at all times, always, ever." Epaphras never grew weary in prayer and was at no time tempted to cease praying for his friends at Colossae. He was ever praying—morning, noon, and night. His prayers were perpetual as well as fierce.[39] Epaphras, although a minor character on the epic pages of Scripture, is a hero in my book. He cared and he prayed.

⧗ *Who are some of your heroes of the faith?*

⧗ *What does it take to be someone's hero?*

The phrase translated as *"laboring earnestly"* is from the Greek word *agonizomai*, from which we derive the English word *agony*.[40] This multilayered ancient word comes to life as we study its definition:

- to enter a contest: contend in the gymnastic games
- to contend with adversaries, fight
- metaph. to contend, struggle, with difficulties and dangers
- to endeavor with strenuous zeal, strive: to obtain something

When a man entered an athletic competition during ancient days, he had his eye on the prize. It wasn't just for honor's sake an athlete would choose to compete, but it was for the reward that would be given to the winner. Epaphras was contending for a prize in prayer; the prize upon which Epaphras had his eye was the maturity of the Colossian church and their ability to discern the will of God.

When we pray for someone who is dear to us, our eyes must be on the prize as well. We must contend in prayer just as someone who is giving every ounce of physical and mental strength to win a race. The prize at stake is the eternity of a human being. I will never stop praying for those I love. I will never throw in the towel of prayer or falsely believe it does not make a difference. Prayer, above all else, is the weapon of warfare that can bring a wandering soul back to the truth of God.

⧗ *Write out a prayer below for someone you love dearly who has strayed from the truth.*

⧗ *Is there an area in your life from which you have strayed from the truth? Ask the Holy Spirit to show you.*

A Support System

We all need friends, don't we? The Father has wired us with the intrinsic need for relationships with others. God never meant for His children to be "lone ranger" Christians but desired for each one of us to be involved in the lives of others.

Paul certainly had a marvelous and involved group of friends who took care of his personal and emotional needs.

> *Luke, the beloved physician, sends you his greetings, and also Demas. Greet the brethren who are in Laodicea and also Nympha and the church that is in her house. When this letter is read among you, have it also read in the church of the Laodiceans; and you, for your part read my letter that is coming from Laodicea. (Colossians 4:14–16)*

Luke, the beloved physician, is also the author of the Gospel of Luke as well as the book of Acts. He spent large amounts of time with Paul and likely acted as his personal physician through beatings, near drownings, and the austere living conditions of a Roman prison cell.

The church at Laodicea was about ten miles away from the church at Colossae; Paul was certain the Colossians would be willing to share this stabilizing yet convicting missive with their sister Laodicean church.

Nympha was a woman who had opened her home for the meeting of first-century Christians. It is interesting to me that Paul knew of her and desired to send his greetings to her. Paul encouraged both men and women in ministry and was thankful for their participation in the gospel.

⧗ *Who is your support system of brothers and sisters in Christ? List three to five names below:*

1. _____

2. _____

3. _____

4. _____

5. _____

⧗ *If you are a "lone ranger" Christian, who would you like to invite to be part of your support system?*

1. _____

2. _____

3. _____

⧗ *Now, intentionally take some steps to build relationships with these people.*

Life-Changing

There are verses in Scripture that, when expounded upon in a book or in a sermon, become life-changing to the listener. The following verse is one such verse for me. A sermon was preached on this verse when I was in college, and I can remember it to this very day, nearly fifty years later.

> *Say to Archippus, "Take heed to the ministry which you have received in the Lord, that you may fulfill it." (Colossians 4:17)*

I wonder who this fellow was by the name of Archippus, don't you? Was he young or old? Was he a committed believer or a merely a seeker? Did he have a

family? I wonder what was going on in his life and why Paul was so directive in his words concerning this unknown man.

What we do know is that Paul was unyielding in his opinion that everyone in the body of Christ had an assignment to complete. Perhaps Archippus needed personal encouragement, or perhaps he had been floundering in his faith. Maybe Archippus needed—as we all need from time to time—a gentle nudge to wholeheartedly serve the Lord. Archippus was a man who needed the reminder from a leader in the body of Christ to finish what he had started.

⧖ *What is your specific assignment in the body of Christ?*

⧖ *Are you working wholeheartedly at it?*

There is another mentioned of someone named Archippus in the book of Philemon and we can assume it is the same person:

Paul, a prisoner of Christ Jesus, and Timothy our brother, To Philemon our beloved brother and fellow worker, and to Apphia our sister, and to Archippus our fellow soldier, and to the church in your house.
(Philemon 1:1–2)

If Archippus had been settling for mediocrity in his Christian walk based on Paul's words in Colossians, Paul now calls this early believer a *"fellow soldier."* Paul apparently had seen something in Archippus that was worth calling out and Archippus had responded in a valiant fashion. Paul implied, "I will go to battle any day with Archippus."

As I pondered the life and attitudes of Archippus, I heard the Holy Spirit whisper in my ear, "Carol, you are Archippus." And, my friend, so are you. *You are Archippus.*

You are the one who needs to be reminded there is a call of God upon your life.

You are the one who needs a gentle nudge to wholeheartedly fulfill your call.

You are the one who needs to embrace the encouragement of Paul.

You are the one who needs to be reminded to finish what you have started.

You are needed for battle in the twenty-first-century church.

Remember

I, Paul, write this greeting with my own hand. Remember my imprisonment. Grace be with you. (Colossians 4:18)

Paul generally dictated his letters to a scribe who traveled with him, but he usually added a short note at the end in his own handwriting. This assured the ones receiving the letters that others were not writing and pretending to be Paul. It also inserted a personal and loving touch to those to whom Paul was writing.

Paul wanted to be remembered in prison; he longed for the prayers and provisions others could offer. He also was reminding the early church that he was in prison for the sake of the gospel of Jesus Christ. Paul refused to stop preaching, teaching, and ministering even while in prison. He was relentless in his call and refused to make excuses.

Some translations say, "*Remember my chains*" (NKJV). I can almost hear the heavy chains scraping across the parchment upon which Paul signed his name; can you? As he signed his name, I wonder if tears were also falling down his wizened face. The nineteenth-century dean of Canterbury, Henry Alford, comments movingly, "When we read of his chains we should not forget that they moved over the paper as he wrote his signature. His hand was chained to the soldier that kept him."[41]

Paul refused to allow a trivial matter like prison to prevent him from walking in his calling in Christ. He dismissed the possibility that his chains impeded his progress in serving the unshakable kingdom. Paul was relentless in his call and persistent in his assignment. You and I can do and be no less.

Not only are we called to be an Archippus, but also we are called to be a Paul at our moment in history.

⧗ *What chains have you allowed to impede your calling in Christ?*

⧗ *How can you move forward despite your chains?*

⧗ *How can you possibly be a modern-day Paul? Be specific.*

Wonderful Grace

Paul began his letter to the church at Colossae offering them the wonderful grace of God, and He closes his letter with the reminder of God's amazing grace.

We must remind ourselves when our faith is shaking, there is always grace.

We must be ever aware of God's marvelous grace.

We must acknowledge the fact that God's grace is more than sufficient. When we sin, we must run back to grace.

⧗ *Have you experienced the grace of the Father? In what way?*

⧗ *What is now your definition of the word grace?*

⧗ *Why was it essential for the church at Colossae to be ever mindful of God's grace?*

Amen

How can it be over? It seems we have barely started our rich study of Colossians, and now we have reached the conclusion of the book of Scripture written for the church at Colossae. Although this group of believers lived two thousand years prior to my existence, I feel an unconditional love for them and a kindred spirit with them. I want to throw my arms around their necks and say, "You can do it! You can believe the truth of Jesus!"

Since I am unable to travel through time to join the Colossian church, allow me to respond in such a manner to you. Although we are not in one another's physical presence, we have experienced a kindred love for Scripture, for the writings of Paul, for the truth of the Holy Spirit, and for the call of Christ. If I were with you this day, I would take you in my arms and we would both weep as I prayed this prayer over you:

> *Thank You, Lord, for my dear sister in Christ. Thank You that she has what it takes to serve You every day. Thank You that she is now overflowing with grace and kindness. Thank You that her theology is based not upon the whims of the culture but upon the eternal truth of Scripture. We say today and every day, "Jesus above all! Jesus!"*

LIVING TREASURE

Conduct yourselves with wisdom toward outsiders, making the most of the opportunity. Let your speech always be with grace, as though seasoned with salt, so that you will know how you should respond to each person. (Colossians 4:5–6)

PRAYER

Lord, I thank You for the book of Colossians. Thank You for every word, every verse, and every chapter. I pray, Father, that this amazing New Testament letter will bear fruit in each one of our lives. In Jesus' name I pray. Amen.

WORDS OF WISDOM

One who has been touched by grace will no longer look on those who stray as "those evil people" or "those poor people who need our help." Nor must we search for signs of "loveworthiness." Grace teaches us that God loves because of who God is, not because of who we are.

—Phillips Brooks

NOTES

1. James Strong, *Strong's Expanded Exhaustive Concordance of the Bible* (Nashville: Thomas Nelson, 2009), s.v. "nepes," https://www.blueletterbible.org/lexicon /h5315/kjv/tr/0-1/.

2. Jack W. Hayford, *Ephesians & Colossians*, Spirit-Filled Life New Testament Commentary Series, ed. Jack Hayford and David P. Seemuth (Nashville: Thomas Nelson, 2005), 133.

3. Hayford, *Ephesians & Colossians*, 138.

4. E. Stanley Jones, *The Christ of the Indian Road* (New York: Abingdon, 1925), 114.

5. Brennan Manning, *The Rabbi's Heartbeat* (Colorado Springs: NavPress, 2003).

6. Strong, *Strong's Concordance*, s.v. "dynamis," https://www.blueletterbible.org /lexicon/g1411/kjv/tr/0-1/.

7. Maxie D. Dunnam, *Galatians, Ephesians, Philippians, Colossian, Philemon*, vol. 8 of The Communicator's Commentary (Waco, TX: Word, 1982), 339.

8. Dunnam, *Galatians, Ephesians, Philippians, Colossian, Philemon*, 340.

9. Rick Renner, *Sparkling Gems from the Greek: 365 Greek Word Studies for Every Day of the Year to Sharpen Your Understanding of God's Word*, vol. 1 (Tulsa: Teach All Nations, 2003), 41.

10. Bruce B. Barton et al., *Life Application Bible Commentary: Philippians, Colossians and Philemon* (Wheaton, IL: Tyndale, 1995), 153.

11. "Andrew Fletcher of Saltoun: The Patriot," Truly Edinburgh, https://trulyedin burgh.com/famous-scots/andrew-fletcher/.

12. Barton et al., *Life Application Bible Commentary: Philippians, Colossians and Philemon*, 157.

13. Lambert Dolphin, "What Holds the Universe Together?", Koinonia House, January 1, 1997, https://www.khouse.org/articles/1997/60/.

14. Barton et al., *Life Application Bible Commentary: Philippians, Colossians and Philemon*, 160.

15. Kathy Collard Miller, *Paul and the Prison Epistles*, The Smart Guide to the Bible Series (Nashville: Thomas Nelson, 2008), 248.

16. H. M. Carson, *Colossians and Philemon*, Tyndale New Testament Commentaries (Downer's Grove, IL: InterVarsity, 1984), 46.

17. Carson, *Colossians and Philemon*, 47.

18. Strong, *Strong's Concordance*, s.v. "katangello," https://www.blueletterbible.org /lexicon/g2605/kjv/tr/0-1/.

19. Strong, *Strong's Concordance*, s.v. "katangello," https://www.blueletterbible.org /lexicon/g2605/kjv/tr/0-1/.

20. Strong, *Strong's Concordance*, s.v. "noutheteo," https://www.blueletterbible.org /lexicon/g3560/kjv/tr/0-1/.

21. Strong, *Strong's Concordance*, s.v. "rizoo," https://www.blueletterbible.org /lexicon/g4492/kjv/tr/0-1/.

22. Miller, *Paul and the Prison Epistles*, 266.

23. William Barclay, *The Letters to the Philippians, Colossians, and Thessalonians* (Louisville: Westminster John Knox, 2017), 162.

24. Renner, *Sparkling Gems from the Greek*, vol. 1, 74–75.

25. Rick Renner, *Sparkling Gems from the Greek: 365 New Gems to Equip and Empower You for Victory Every Day of the Year*, vol. 2 (Tulsa: Institute Books, 2016), 186.

26. Barton et al., *Life Application Bible Commentary: Philippians, Colossians and Philemon*, 202.

27. Renner, *Sparkling Gems from the Greek*, vol. 2, 427.

28. Strong, *Strong's Concordance*, s.v. "agios," https://www.blueletterbible.org /lexicon/g40/kjv/tr/0-1/.

29. Strong, *Strong's Concordance*, s.v. "agios," https://www.blueletterbible.org /lexicon/g40/kjv/tr/0-1/.

30. Strong, *Strong's Concordance*, s.v. "agios," https://www.blueletterbible.org /lexicon/g40/kjv/tr/0-1/.

31. Strong, *Strong's Concordance*, s.v. "agapao," https://www.blueletterbible.org /lexicon/g25/kjv/tr/0-1/.

32. Strong, *Strong's Concordance*, s.v. "agapao," https://www.blueletterbible.org /lexicon/g25/kjv/tr/0-1/.

33. Lightfoot [TK].

34. Strong, *Strong's Concordance*, s.v. "brabeuo," https://www.blueletterbible.org /lexicon/g1018/kjv/tr/0-1/.

35. Renner, *Sparkling Gems from the Greek*, vol. 1, 43–44.

36. Strong, *Strong's Concordance*, s.v. "proskartereo," https://www.blueletterbible .org/lexicon/g4342/kjv/tr/0-1/.

37. Strong, *Strong's Concordance*, s.v. "peripateo," https://www.blueletterbible.org/lexicon/g4043/kjv/tr/0-1/.

38. Barton et al., *Life Application Bible Commentary: Philippians, Colossians and Philemon*, 229.

39. Strong, *Strong's Concordance*, s.v. "pantote," https://www.blueletterbible.org/lexicon/g3842/kjv/tr/0-1/.

40. Strong, *Strong's Concordance*, s.v. "agonizomai," https://www.blueletterbible.org/lexicon/g75/kjv/tr/0-1/.

41. Barclay, *Letter to the Philippians, Colossians and Thessalonians*, 203.